A SQUARE MILE
AN ENGAGING IN
INTO THE CITY OF LONDON'S
TRADITIONS AND MODERN
RELEVANCE

A SQUARE MILE YEAR: AN ENGAGING INSIGHT INTO THE CITY OF LONDON'S TRADITIONS AND MODERN RELEVANCE

PETER WAINE

A DIARY BY A MASTER GARDENER

To the Lord Mayor and the Masters of my year

THE **BLACK SPRING**
PRESS GROUP

First published in 2023
An Eyewear Publishing book, The Black Spring Press Group
Maida Vale, London w9
United Kingdom

Typeset by User Design, Illustration and Typesetting, UK
Cover art by Nick Purser

ISBN-13 978-1-915406-50-7

This diary makes few claims. However, it is, I believe, unique. On occasion jejunus, but always a personal account of what it was like for me, at least, to be Master of one of the long established livery companies of the City of London.

I hope it will sit comfortably beside the official histories of the Worshipful Companies and of the City of London.

I made notes on every occasion and aimed to write each diary entry when they were still fresh and by the end of that day.

It is a glimpse of a privileged year. The abiding memory is of camaraderie, mixed with rich history, enhanced by charitable giving, in the company of wonderful new friends.

PREFACE

Alderman Vincent Keaveny
LORD MAYOR 2021-2022

The Civic City – the City within a City – resembles in many ways a magnificent theatrical production, perhaps at times a grand opera. The Lord Mayor, the Sheriffs, the Aldermen, Common Councillors, the Recorder, Common Serjeant and Judges of the Central Criminal Court, the Masters, Prime Wardens and Upper Bailiff of the City's Livery Companies and other holders of ancient offices comprise a changing cast that fills the stage on which the Civic year plays out. The great occasions of that year do not vary much but the production is constantly renewed by the changes in officeholders. As Peter notes early on in his account, in the City everybody is somebody, nobody is anybody.

Peter and I shared a special year in our respective roles in the 2021/22 version of this production, Peter as Master of the Worshipful Company of Gardeners while I enjoyed my tenancy of Mansion House as the 693rd Lord Mayor of London. We saw the return of the formal and not so formal events that the Covid 19 pandemic had prevented since early 2020. We celebrated Her Majesty's Platinum Jubilee. I planted trees in the City, Epping Forest and Leicestershire, and one in Madrid, to mark that wonderful anniversary. We got the show back on the road. I was delighted to see the

return of the Lord Mayor's Show at the start of my year in office and to visit over 20 countries in my role as ambassador for the UK's financial and professional services industries. Peter and the Gardeners were on their travels again too, visiting great gardens across the country and venturing to Rome for a Company trip abroad. That and much else is captured by Peter in this diary, with humour and his eye for the fascinating detail. His discipline in keeping this diary while busy with the many events of the year and the business of the Gardeners' Company is admirable.

The Gardeners and the Mayoralty are linked by a number of recent Lord Mayors' membership of the Company, although sadly that is not a privilege that I share. The Master Gardener and the Lord Mayor see a great deal of each other over their years in office, as Peter records. I enjoyed our encounters throughout my year, starting with the presentation of posies to me and my family on Lord Mayor's Show Day. Sadly, posies fade quickly, and memories too. But for this Lord Mayor, some sense of the great production that was the extraordinary year I shared with Peter and his fellow Livery Masters is caught by this diary. I am very grateful to Peter, the best of company throughout, for that.

GLOSSARY

For the benefit of those less familiar with the terms and governance of the City, including its livery companies, the following, though not intended to be complete, may be of help.

The City of London: The City is a city within a city, with origins going back to Roman times. Today there are 25 wards or electoral districts with ancient and wonderful names, not least Aldergate, Bassishaw, Candlewick, Farringdon Without, Farringdon Within. Representatives from each ward are voted in each year to the Court of Common Council.

Guildhall: The centre of the City's administration for over 1000 years, a complex of offices, assembly rooms, the Great Hall, a library and an art gallery. The buildings have seen many redevelopments; the present Great Hall, for example, begun in 1411, was damaged in the Great Fire and bombed in the Blitz. Previously a venue for high profile trials, including that of Lady Jane Grey, who learned her fate there in 1553.

The Governance of the City: Reference to Aldermen dates back to the 12th century with one for each of the 25 wards of the City. Their Court is primarily occupied with concerns of City elections, freedoms, livery companies, new guilds and ceremonial.

The Corporation of London: the Corporation is older than Parliament. It is a metamorphosis of ancient tradition, ceremony and modern local government against the backdrop of the financial heart of Britain. Operating from Guildhall, on a non-party political basis, included among its many responsibilities are planning and building, maintaining highways, environmental services, upkeep of over 150 gardens and open spaces such as Epping Forest and Burnham Beeches, administering four London bridges (Tower, London, Southwark and Blackfriars) at no cost to the taxpayer, and the supervision of the ancient markets of Smithfield, Billingsgate and Leadenhall. Its motto in English is 'Lord, Direct Us'.

The Lord Mayor: The office was established in 1189 and, until about 1500, was termed as Mayor only (to date, there have been only two women who have held the office). The Lord Mayor ranks in precedence immediately after the Sovereign in the City. The Lord Mayor is Chief Magistrate of the City, presides over the Courts of Common Council and Aldermen, and is patron or equivalent of numerous charitable organisations. Although now largely ceremonial, the Lord Mayor is regarded as a persuasive envoy of the City's business and traditions. An office limited to one year only, in the past, some were Mayor for two or more years, Dick Whittington being Mayor for a record four times. The Lord Mayor's year starts with a spectacular bang in November – The Lord Mayor's Show. In its early years, the mayoralty was dominated by the most powerful livery

companies, including the Mercers, Drapers, Ironmongers and Grocers. Between the first Mayor and the death of Whittington in 1423, relatively few companies supplied 21 mayors serving a total of 39 years.

The Sheriffs : Two are elected annually, Aldermanic and Lay. They constitute the oldest office in the City, attend to the Lord Mayor in the discharge of his/her official functions, and one of them, the Aldermanic, is the testing ground for an aspirant Lord Mayor.

Court of Common Council: The effective government of the City, a sort of town council dating back to the 13th century, today with two functions: the work of an ordinary local authority and the care of the City's traditions and status.

The Chamberlain: A local government chief officer – a role dating back to 1237, custodian of insignia and seals, trustee of funds, responsible for admissions to the freedom, and playing a significant part in City ceremonials. The Chamberlain's Court is the department which administers the freedom.

Declaration of the Freedom: Dating back to medieval times, this ceremony is almost timeless in its format. There are over 1800 admissions on average yearly. One entry to the freedom still pursued by some liveries is via apprenticeships. The apprentices have historically been often a riotous bunch – in the late 16th century, hundreds of apprentices marched intending to seize the Lord Mayor and whip him in retaliation for the Lord Mayor disciplining one of

their rowdy comrades. Some were ultimately convicted of high treason. All this happened despite their declaration, which includes the words, 'He shall not haunt Taverns nor Playhouses'. When the ceremony is concluded, the Clerk to the Chamberlain announces that he or she is our 'youngest freeman' – meaning the most recent, a label valid, usually, for only a few minutes. The Declaration Books, volumes of them, must now constitute the largest and most impressive autograph collection of all – Kings, Prime Ministers, celebrities and many others, all sign, all complete the same ceremony.

Liveries: The origins for the trade and craft associations, full of tradition, activities, and responsibilities. Liverymen assemble annually in Common Hall to elect the City's government. New livery companies are constantly being added: at present, there are 110. There is an order of precedence established. Since the 20th century, new companies representing modern professions have been regularly granted their charters. Some liveries will accept only trade associated members, others, often through necessity, will be open to a wider constituency. From medieval times to the mid 19th century, the freedom of the City and the livery went hand in hand – liverymen had to be freemen. The earliest companies protected their customers, employers and employees, checked standards of work, weights and measures and imposed penalties, trained apprentices and cared for their old and sick. Their membership ranges from between 100 and 400. Although some liveries have merged

and a few disappeared over the millennium, the very essence of a livery company is its permanence. Progress through the companies has remained largely the same for centuries – Court, Lower Warden, Middle Warden, Upper Warden, Master. In the case of the Gardeners – Spade Bearer, Renter Warden, Upper Warden, Master. Liveries are referred to as 'Worshipful', a corruption of 'worthy-full'. The opportunity for women to join liveries has been available since early times.

The Great Twelve: These are the highest ranking liveries, previously particularly powerful and influential. They are in order of precedence: The Mercers, Grocers, Drapers, Fishmongers, Goldsmiths, Merchant Taylors, Skinners, Haberdashers, Salters, Ironmongers, Vintners, Clothworkers. They were given their pecking order in 1516 by the then Lord Mayor.

The Wet Ten: Other liveries also have loose groupings. For instance, the Wet Ten, of which the Gardeners is a member, and include the Plumbers, Farmers, Launderers. They collectively promote awareness of the importance of water, focusing attention on the challenges relating to water resources, highlighting inadequate sanitation in other parts of the world and showing that inappropriate usage can contribute to climate change.

Livery halls: As the companies grew and prospered between the 14th and 16th centuries, many built splendid halls in order to settle trade, bind apprentices, elect Masters etc, and to socialise. A few medieval halls survived the

Great Fire, only to be largely destroyed by the Blitz and mostly rebuilt. Elements of some medieval, even Roman remains, are incorporated in some halls. Several of the 38 halls in existence today were rebuilt, often on their original medieval sites.

Charity and education: Livery companies continue their fine tradition of devoting much effort to raising large sums for charitable and educational purposes.

6 July
INSTALLATION

Joy. The Mastership. I feel like the Lone Ranger breaking forth, 'A fiery horse with the speed of light, a cloud of dust and a hearty, 'Hi-ho, Silver'.

Mind you, underneath this façade, I am jelly, armed with only one piece of advice for my year, 'What's an inexpensive alternative when you can't afford a bath for your dog? Throw a stick through a carwash'.

Even before this magic moment, I was asked the usual question, 'Do I have any dietary requirements?' No – but I remember when I hosted another function, I got one reply, 'No garlic, cheese, aubergines, courgettes, peppers, cucumber, shellfish, raw onion, chives, peanuts, nothing with grapes, sultanas or raisins, white bread and nothing raw or rare'. Must have been trying to tell me he was a cannibal.

This morning for breakfast, there were some blueberries for me to eat. The Mistress Gardener only offers them when the best before date has passed, otherwise they are for her guinea pigs. She has announced that hitherto she wishes to be referred to as 'Consort' as 'Mistress Gardener' is old fashioned.

With the shadow of the pandemic, there was still some hesitation and unwillingness to travel and mix with others. The dinner was switched to a lunch and only for members of Court. The event was restricted to around 30 rather than

the usual 120 plus. A disappointment, but great relief that at least we were meeting in some form after so long.

I am grateful to my predecessor, who agreed to do two years, both greatly curtailed in their activities due to Covid. I know she had a terrific programme she had formulated for our enjoyment. However, by happy coincidence for me the Covid restrictions have been lifted almost as if to coincide with my Installation.

At the Court, the timeless ceremony of the Transfer of the Mastership, the current Master said:

> *'By the unanimous vote of the Court... it is my pleasant duty to call upon him [me] to make and subscribe the proscribed Declaration of Office... I call upon the Gallant and Learned Clerk to read the Declaration of the Master.'*

The Clerk then read:

> *'You shall declare that you will be faithful and true to our Sovereign Lady The Queen...'*

Then there was the disrobing and the robing between the outgoing Master and yours truly. Further pleasantries followed by the outgoing Master saying:

> *'I can say from happy experience that you can wear it with pride [the Master's Chain and Badge], well knowing that it honours you and at the same time we your Brother Gardeners know you will add lustre to it.'*

The outgoing Master then concluded:

'I extend to you the right hand of fellowship...'

Heady stuff!

The lunch was at Ironmongers Hall, our recently established London base since we, the Gardeners Company, don't have our own hall.

In my speech, after the lunch, I said that the deeds of Past Masters are recorded on the hides of long dead sheep. I thanked our retiring honorary photographer and his wife, who were my personal guests. I thanked my Steward for the previous year and welcomed my new one for the year ahead. Then I reassured the men present, that, following two women as Masters, I was confirmation that we men can break the glass ceiling. I noted that from various histories of horticulture, women in our profession had to struggle to be recognised. (When living there was a guide at Cobham Hall. Key was to ensure that your group never got close to another group in case two guides were saying completely different made up stories.)

I continued:

'Let a marriageable virgin, bare-footed, nude, without clothes, her hair down and with a cock in her arms, go in circles around the affected spot and immediately the dodder will let go and the legumes will be reinforced, maybe because the dodder fears the cock,' (Geoponika circa 950 AD).

I have been repeating to myself to be on my best behaviour, especially in respect of my female predecessors.

However, I count my blessings that I was not a contemporary of the great female horticulturalist Ellen Willmott, who, although long since dead (she died in 1934), kept a revolver in her handbag and a brass knuckle duster in a drawer and is said to have carried a pocket full of seeds of a particular invasive, giant sea-holly Eryngium Gigantium to sprinkle in the gardens of fellow horticulturalists. Yet Gertrude Jekyll, until that moment one of my idols, described Willmott as, 'The greatest of all living gardeners'. Will I complete my year alive?

I think I might adopt a double barrelled name as both my predecessors have them. Initially I thought of Sweet-Pea, Peter Sweet-Pea or perhaps Peter Ground-Elder. Pray silence for your Master Peter Ground-Elder.

You will find with my speeches, that the audience will either go away stimulated or wake up refreshed.

Those who still don't know me well – I hope that is either none, or merely a few – my formal education pivoted around a quote high on the frieze of my prep school library, a library built and adorned by Pugin. When I was a Governor there, the chairman invariably sat me in the same chair and above me was the quote, 'It is better to be silent than to speak foolishly'. Of course, that is rubbish, and to think my parents paid good money for their son to be thus brainwashed. The good news is that I have ignored the advice. If I hadn't, I wouldn't be here before you today as your Master.

Joseph Banks, a former President of the Royal Society,

said, 'No trade conceals so many trades, so many branches of knowledge as that of a gardener.' No wonder we love our livery, our Company, and the company of others and the changing expectations of each new season which in their turn bring hope, challenges, and disappointments, but all under an English heaven.

A lot of the pleasure of gardening is the anticipation of what will happen next season, next year, as a result of one's endeavours. There will be anticipation for my year. I will try hard not to let you down.

Everybody is somebody. Nobody is anybody! I will serve you and hopefully add to the office of Master Gardener.

Enough from me. I am aware of Shakespeare's words – by the way, a very knowledgeable horticulturalist, 'Sweet flowers are slow, but weeds make haste'.

Despite all the ceremony and the enjoyment of the moment, I could not help but reflect that I am rather surprised that I have made it to the Mastership. Many years ago, when asked to welcome the guests at a dinner in Guildhall, in the presence of our then Master, Prince Edward, the Lord Mayor, many dignitaries and my daughter, I said about one guest who happened to be a former Chief Executive of the UK Independence Party and also Master Fruiterer, that if you eat more than five a day it can have an adverse effect. As I left the hall, the former Master Haberdasher said the speech was one of the best he had heard for that difficult slot. I noted I had spilt some wine on the official programme for the evening

and contacted the Clerk to ask if he had a pristine version. He did and said that Prince Edward and the Lord Mayor were both laughing during my speech.

The next day, I got a call from the chairman of the Protocol Committee – could he come and see me. Thinking it was to compliment me, I invited him to my club. He asked if I had cleared the speech with anybody. I said the office had had it for some time. He said, 'You should not have mentioned politics.' I racked my brain to recall whether I had or not. Rather upsetting. This was a cautionary note. Since then, whenever I have thought that a comment might be misunderstood or appreciated by most but not all, I check with the office. Another practical lesson came out of this little saga. I quoted a poem in my speech which, apparently, Andrew Parker Bowles, the next speaker, was also going to quote. Neither of us had any idea that was the case. It is important that speeches for an evening are checked to prevent such a happening. He was very good about it. I rather enjoyed the moment when we gave a toast to the Duchess of Cornwall – I watched as the said Principal Speaker raised a glass to his former wife!

Actually, this was the second of such incidents, based on a little misunderstanding, within a fortnight. At the AGM of CPRE after I finished my second four year term as chairman, I quoted a poem from Shelley which referred in a less than flattering way to some inhabitants of Devon. I had had a spot of trouble with that branch; I felt their office

holders needed to be replaced with new blood despite their worthy record. At the end of my speech, one came up to me and said, 'Do you know where I come from?' I said, 'Of course.' He said, 'Your comments have put back progress by at least a decade.' Of course, I hadn't. Sir Andrew Motion, our then President and a former Poet Laureate, overheard the conversation. He said that it was a very good poem and a very good point!

But I am here, and I am now Master of the Worshipful Company of Gardeners.

Over coffee, in conversation with the honorary photographer, we spoke about Beth Chatto and her garden in Essex, which is near to where he lives, a dry garden with the emphasis on plants which can adapt to such conditions. He said he had the pleasure of knowing Beth soon after he started his photographic career in 1968 and had photographed all her nine gold medal gardens at RHS Chelsea. He kindly wished me well as Master of a most friendly and active organisation. Later, the Master Ironmonger asked if we could help liven up his tubs at the entrance to his hall. I said we would certainly look into this for him.

As I walked away, I reflected on the first time I was asked to consider the prospect of the Mastership. It was many years ago, on a visit to the gardens of southern Ireland, blessed by the Gulf Stream. Before the commencement of the official visit, I had visited Blarney Castle to kiss the Blarney Stone. A fortuitous happening!

9 July

Some lovely thank you emails and cards from Gardeners and others reflecting on the fun and the gravitas of my Installation. One, from the Master Ironmonger, made reference to our conversation at lunch of our shared love for Gilbert and Sullivan. He wrote, 'The operettas are a great passion of mine. A passion tempered by marriage to a wonderful girl who can't stand them!' He reflected on the link between his livery and ours, 'It was, after all, the iron plough and spade which surely opened up our largely forested island for a wider range of plants and landscapes'. I'm not sure actually how forested our land ever was.

Another wrote, 'They also serve, who stand and wait', referring, of course, to the year's delay due to Covid, adding, 'And you have stood and waited with grace. Congratulations, your time has come, and I look forward to serving you'.

10 July
YEARBOOK

Request for a photo of the Master and Consort to be incorporated in the Pan Livery Yearbook. Also, an invitation to all 6-9-year-olds from the families of Masters for their children or grandchildren to enjoy a Christmas party at the Mansion House. Our younger granddaughter still qualifies by only four days, but her sister does not. Consort said that

was unfair and so neither should go. I said, 'That is life, and life can be unfair.'

12 July

There have been a few frustrations wearing my livery hat, which I reflected upon whilst gardening today. I have mulled over a sad little saga which is still playing out. It concerns a friend of many years, a school pal, the friend who originally invited me into the livery. We have fallen out over the composition of the committees for my year. I had recommended him to be chair of one particular committee, thought I could swing it, but after consultation was advised not to recommend him. This was despite the fact he had been Master and chair of all the other committees and he wanted this position so much. Since then he has ignored me, cutting me off. This whole saga is a challenge, as I don't understand why anyone should be that fussed. Indeed, the advice I have been given is that a Master, after his or her year of office, should stand back and allow the new Masters to establish their identities.

I have been pondering on whether there are too many Past Masters on Court. They give valuable insights and contributions. I have asked Protocol to look into our practice and to compare it with that of other Companies. From comments made thus far, I don't think it is going to be possible to change anything.

As I write, I reflect over the succession, knowing who the next three likely successors will be. They are all different

and will all add lustre to the livery. But I know in our livery and in talking to those in other liveries that some, when approached, decline to go for higher office. It is not for everyone: the time commitment, the nature of the position, the skills required, the expense, even though it is only for a year which will pass very quickly. A year which will have the rewards of making new friends and special memories. But perhaps for some, these rewards would not compensate. Also, it is difficult for the Consorts, who do not choose this position, and who are required to play a somewhat old fashioned yet pivotal role, with only limited choice of what not to attend.

16 July

I am rather taken by the mottos of the various livery companies. Ours is as good as any, 'In the sweat of thy brows shalt thou eate thy bread'. It is better than one of my school mottos, 'Iron Sharpeneth Iron'. I never knew what it meant. Whilst another was, 'By Love Serve One Another'. It was lucky I never intended to join the SAS.

18 July

Informed today that my Master's badge has been cleaned and revalued up. It was noted that the gold is 18 carat and that many embellishments have been added over the years including a 60 point diamond to celebrate the Diamond Jubilee and a Garter seal to celebrate Prince Edward being a

Royal Master. I will wear it with even more pride, knowing now what I do.

20 July

A selection of photos from Installation has arrived via the Spadebearer, who said, 'I think the one of you as the newly installed Master is splendid – you look distinguished and rather debonair, a difficult combination to achieve.' Actually, I think I look a plonker.

24 July

Felt inclined to dip into the history of my own livery, having read it many years previously. In 1345, 'We petitioned to suffer and to maintain that the said gardeners may stand in peace in the same place where they have been wont in times of old in front of the Church of St Austin, at the side of the gate of St Paul's Churchyard... there to sell the garden produce of their said masters... as heretofore been in their said place molested.' We were given short shrift. 'The place aforesaid... is such a nuisance to the Priests who are singing Matins and Mass... and to others serving God, as also to other persons passing there both on foot and horseback, as well as to the people dwelling in the houses of reputable persons there, who by the scurrility, clamour, and nuisance of the Gardeners and their servants, there selling pulse, cherries, vegetables and other wares to their trade pertaining, are daily disturbed.' And so it goes on and on, too painful to relate. Mind you, not half as bad as the

Brewers. Twice in Whittington's time, they were caught intimidating landlords, having a fine disregard for statues, watering down ale and the shortening of measures. I must remind the Master Brewer next time I see him.

We had our bleak moments. In 1777 one became Master but never got round to being sworn in, nor attended his duties, so he forfeited the position, only to be re-elected Master at the next Court. This was at a time when attendance at Court began to decline. In July 1782, no one attended. In October of that year, only the Master and Wardens. In January 1783, only two Assistants, and in April 1783 nil attendance, with nil attendance in January 1784. It happened more than once in the 19th century too, 'No member present, although summoned'. It didn't stop one new Clerk being appointed in 1872, in spite of there being no one present to elect him. Better times lay just around the corner. In 1891 the Lord Mayor, who was not even one of our liverymen, agreed to become Master Gardener – he was already a Goldsmith, a Clockmaker, a Shipwright and a Poulter, was Master three times for the Clockmakers, became a Baronet for being Lord Mayor and also began concurrently his second year as Master Clockmaker. He served as an MP. His was a speedy elevation. In 1891 he was elected to our livery, then the Court, and then as Master without payment.

We have ended up number 66 in the rankings, which is a bit strange; the Fruiterers got their charter after us, yet are placed 33rd, and we claim they were formed by us.

Apparently, all James II's fault – the most useless monarch of a useless dynasty. However, it hasn't stopped us having the last laugh. We had more Lord Mayors in the 19th century than any other livery, and in the 20th the first female one.

Oh, we glorious labourers, yokels, rustics all!

25 July

My Steward has come early for tomorrow's visit. She is staying the night. In the afternoon, another Gardener who lives locally and who is a great help to me, joined us to finalise the arrangements. This included putting together the packs of information for attendees.

Afterwards, the three of us visited the Palladian Church a few fields away. The then Lord of the Manor had built this church as a symbol of his power and so that he could see it from his manor. He and his wife had a mutual disliking. He blamed the Church for bringing them together in lifetime and said it was not going to keep them together in death. So he built two mini pavilions either side of the portico, as far away from each as possible, one for his urn and one for hers.

Back home, my Steward, who collects teddies, announced that she had brought two of them with her and they sat beside her on the sofa. Consort said she had a much loved one from her childhood, which she brought down to meet our guest teddies. Apparently, the teddies got on well together. My Steward, encouraged by this, showed pictures

of some of her other teddies, 'This one is good at cooking, this one at gardening, this one at knitting.'

Consort told our guest she believes the house is haunted by the ghost of her ancestor whose portrait hangs on the landing wall. On one occasion, when I was being disrespectful about the portrait of her, it promptly fell off the wall and nearly killed me. This ancestor was a descendant of Edward iv and Lady Eleanor Talbot's illegitimate son. I have been respectful to her ever since.

26 July
WELWYN GARDEN CITY VISIT

This has been an encouraging start to my year. A very happy day. After the frustrations of the lockdowns, we felt liberated and able to enjoy the fraternity of livery in surroundings conducive to our love for open spaces, beautiful gardens and learning something new.

I chose a visit to my home town as the first visit of my year, knowing that it is to many a hidden treasure, a place passed on the motorway, assumed to be a conventional new town, but, as the Lord Lieutenant said to me during the recent centenary celebrations, he only got to know the town himself about eight years ago when his son moved into the area.

We had great fun planning this unconventional offering. We hired one of the original buildings, now the United Reformed Church, a lovely period piece. I gave a brief resumé of the recent centenary celebrations. A local

historian outlined the history of the garden city movement and its influence on a global scale, with over 140 places worldwide claiming to be influenced by the concept, the marriage of town and country, offering the best of both.

I took the appreciative group down part of the mile long boulevard, which the Queen Mother said was the best urban landscape anywhere. She was perhaps a little biased, having spent most of her childhood nearby. We passed the Coronation Fountain, installed in 1953, and now possibly the only one still in working order – and we saw the recently unveiled statue of Ebenezer Howard with an introductory talk by its sculptor. We visited the newly established Centenary Woodland Garden. There was the choice of either walking with our Wood Wardens through part of the 200 acre hornbeam woods which lead almost to the doors of John Lewis, or a guided walk to note some of the 20,000 specimen trees planted, constantly added to, over the last hundred years which have made the town a UN City of Trees.

A surprise, but a flattering one, was when I was asked to plant a tree in the centre to commemorate this visit as Master of the Gardeners' Company and my role as chairman of the recently concluded centenary celebrations.

Strolling back, one Past Master said I might have to say nice things during my year when I didn't necessarily want to. I said I hope I never plummeted to the depths that Blair did at his last Cabinet meeting, when he thanked John Prescott for his, 'intelligence and shrewdness'.

Chatted with the person who helped me considerably, who lives locally, and hopes to join the livery shortly; we adjourned to a pub, the cottage hospital in the early period of the town, to reflect on the day. I will be relying on her heavily going forward.

27 July

Sudden panic/reflection – was I offering enough of a programme as Master? I knew I was and that I had promised Protocol that I would start a trend of reducing the programme of a Master. In recent years each Master seemed to have competed in a friendly way to outsmart his or her predecessor. I had already broken my promise. I remembered one Gardener has suggested the Savill Gardens in Windsor Great Park. I had already thought of that option ever since staying in Dartmouth with friends, getting up early before breakfast to explore the town, finding in the municipal gardens a plaque to Private Veale vc who, in the First World War, had heard of a wounded officer and at the fourth attempt rescued him but it meant going within 50 yards of the enemy line during the Battle of the Somme. For that, he was awarded the vc. The officer he rescued was Eric Savill, who became the King's Head Ranger at Windsor, founded the Savill Gardens, one of the greatest woodland gardens in the world, and was knighted. He established the National Magnolia Collection and four of those specimens adorn these gardens in Dartmouth,

acting as a poignant link and memorial to two very different great men.

2 August

I have been given a copy of the history of the livery companies by somebody I worked with during the Welwyn Garden City Centenary. A fascinating book. The Corporation had its highs and lows, and some of the lows were very low indeed. Disraeli said, 'We must remember that the country is not governed by logic but by Parliament.' To which the Herbert Commission on Local Government in Greater London replied, 'But logic has its limits and the position of the City lies outside them.'

On another occasion, in 1833, the Corporation was described as, 'Our corrupt, rotting, robbing, infamous Corporation of London', and its Court of Aldermen, 'Old men – no, old women, gossiping, guzzling, drinking, cheating, old chandlers – shop women, elected for life'.

And there's more of the same from that low period:

'As they know with sorrow, is all the while consuming its vital. Were it not for their vivifying presence, the rotten carcass would before now have been consigned to quicklime, amidst a universal holding of noses'.

3 August

Met up with a Gardener to chat about the forthcoming Welsh trip. He can't attend, but knows some of the

gardens well. We sat in a café at Victoria Station, crowds milling and flowing past endlessly. Like an island in their midst sat a blind man with his guide dog, collecting for their cause. Only two bothered to give money and one other gave the dog a pat on its head. How little time we have for the less fortunate. Then there was a commotion. A young man was shouting, almost sparring with a young woman. Two security personnel appeared from nowhere. Next, a member of the public interceded. The man was slowly quietened down, the woman looked confused, and the two were kept well apart. Strangely, I began to feel sorry for the man. He appeared to be the instigator, the activator from hell, who had never grown up and couldn't control his waywardness. There was something in the way he pleaded, though, with his restrainers, that made me wonder whether he had a case or was seeking help and that not all the blame, therefore, was to be placed at his door.

9 August

We are staying the night with the member of Court who has arranged our Oxford Gardens visit tomorrow. Her lovely house has a superb garden extending down to the river where there is a lock and weir and fascinating covered bridge. On a previous visit, to reconnoitre for tomorrow, was taken to the Grade I church next door to our host, to admire its John Piper window, with its owl, lamb and bird depictions. The old and the new combining to perfection. A wow factor.

Over dinner, a car alarm went off in the quiet village street. No one cared to stop it. I said, surely the owner knows it is his? Oh, dear. It was mine. A courtesy car. Unfortunately, yet again, my car is in for body repairs. Each time not my fault. Now when people ask how old the car is, I say it depends on which part they are referring to. I stopped the alarm and returned to supper, but the wretched thing went off again. This time I left the vehicle unlocked and I won't lock it again until I return it. I will only tell the Consort of my ingenious solution when the car is safely returned – if it is.

10 August
OXFORD GARDENS VISIT

What a day!

To Oxford to visit the Botanical Gardens which are celebrating their 400th anniversary and therefore the oldest botanical gardens in Britain. Our livery has a special link. John Tradescant the Elder was appointed the first Keeper of the Garden, although it appears he never took up the post. Lucky that they were planted over a mediaeval burial ground, plenty of bonemeal there. They possess one of Fairchild's Mules – the original hybrid between a carnation and sweet william. Plenty of levels of interpretation during this visit conducted by the Director and the Assistant Director, both distinguished, the latter sometimes on 'Gardeners' Question Time'. Often seeds germinating here are found in very specific and local areas

around the world. It seemed that the relationship between the university authorities and the Botanical Gardens was not always an easy one. Bought a book in their shop – plants in Shakespeare's works. Sat beside a guest having coffee and recommended the book. Lucky I was complimentary, because she had written it.

I said I would try and get funding for one of the young gardeners I met, who was tending a newly configured area, hoping to acquire additional plants from the Mediterranean region.

Next, we visited Worcester College, which boasts one of the best college gardens, and unique in Oxford in that they are landscaped in a naturalistic manner. We lunched in their hall, admired the east side of Main Quad and the many other constituent buildings which are a rare survival of medieval vernacular. A notice saying, 'No man shall walk on the grass'. This was a rule from the Provost in 1785, and that rule remains.

11 August
THE TREE COUNCIL – ZOOM LECTURE

I was always keen to have a zoom presentation by the Tree Council, being a former chairman and also as they do such interesting and important work, not least their seasonal events, National Tree Week, when the planting happens, Seed Gather Day, Hedgerow Week, and managing their 7000 tree wardens. I was particularly proud of instigating a day to check on previous plantings (Aftercare Day)

as hitherto many newly planted trees had died from neglect, depressing for all concerned.

The topic I chose for today was ancient trees. The definition of an ancient tree is broad. One qualified because it was planted by a knight returning from the Crusades in 1178, another with tenuous associations with the legendary Robin Hood, another so venerable but somehow always surviving. In 1805 an oak was described as 'In the same state of decay since the memory of the oldest inhabitants and their ancestors'. It is probably 1000 years old. Henry VIII was said to have met Anne Boleyn under one tree, and another, a yew tree in Scotland, which is probably the oldest living thing in Europe with possible associations with Pontius Pilate whose father might have been part of a legion located in its vicinity.

Twenty years ago, I was keen to register some of these fine specimens, to highlight their plight and to increase their chances of protection. We have more such specimens than any other country. Despite an excellent book by the person giving the zoom presentation tonight, little progress has been made to protect these trees, and yet extending protection to them can hardly be deemed controversial. The current situation is quite daft. It upsets me and annoys me in equal measure. The speaker spoke so well, explaining how the whole process of ascertaining the best and most significant trees of various species was concocted. Only those specimens seen from a public space are covered by Tree Preservation Orders and most, by reason of their

history, are tucked away in a rolling private parkland or woodland. Owners won't purposefully damage these ancient wonders, but they might do so through ignorance.

15 August

Received an invitation from a Master to attend a formal dinner. This is the second time he has asked me, and alas, on both occasions, I simply could not make it. I thought it best to telephone. Just finished the call. Interesting conversation. He had made a lot of money in his life and had recently returned to this country, due to a divorce, from six years of boredom in Marbella. He said he woke up in paradise and wondered why he was there. His paradise – condominium, combined with natural beauty, supplemented with the company of the mega-rich, was not for him. A day on Ailsa Craig off the west coast of Scotland, home to 56,000 pairs of gannets and many more slow worms – that would be my paradise unchained.

25 August

Today I received an email from the Past Master who was Master at the time of the Golden Jubilee. He said the livery gave the Queen a mulberry tree to add to her considerable mulberry collection at Buckingham Palace, suggesting it would be a good idea if I was to do likewise for next year's Platinum Jubilee. With enthusiasm, I contacted the livery member who is responsible for the Royal Gardens. He has replied already, telling me to write to the Keeper of the Privy

Purse. I shall do so this evening. Apparently, the letter will then be taken officially overnight to Balmoral.

26 August

I have just been told off. The Immediate Past Master has informed me that she has already initiated the plan to gift a mulberry tree to the Queen and that I should have checked with her first. How was I to know?

30 August

The Queen has replied! Or rather the Keeper of the Privy Purse. 'I am pleased to inform you that the Queen would be delighted to accept your gift.' I have the letter in front of me out of direct sunlight.

3 September

I get regular missives from the Almoner, sometimes joyous, often to celebrate the significant birthday of a fellow Gardener, but also inevitably, to lament the death of one of our Company. He always asks for our prayers, and often against the odds, little and large miracles happen. Not least in the case of the health of the Almoner himself, a true Christian. Each time he addresses us, it is, 'Master, Your Highness, Your Graces, My Lords and Ladies and Gardeners all.' I note that I come even before Prince Edward, royalty and a former illustrious Past Master.

7 September
TRIP TO WELSH GARDENS

We all met in the car park at Cardiff station for what I know will be a wonderful few days exploring Welsh gardens that are well known, unknown, recreated, rediscovered or new, with the prospect of special insights from the gardeners or the owners. So often we ignore the Welsh horticultural delights despite them being on our doorstep.

I started planning this trip two years ago by taking advantage of being on the board of the Gardens Trust, which has a Welsh representative who could assist me (we have a statutory right and obligation to consider all planning applications which might adversely affect the listing of a designed landscape). The Welsh representative subsequently became an MP and passed the remit to help plan this programme to another. She has been excellent.

My suitcase is filled with livery company shields as gifts to the hosts of each garden we will visit. A gesture I will continue throughout my year. I am surprised there is room for anything else.

There was little time for pleasantries before making our way to Alt-y-Bella in a forgotten valley in Monmouthshire – one of the oldest manor houses in Wales, long abandoned, but saved by Arne Maynard and his partner. The garden was designed by Maynard, one of our very best contemporary garden designers. It is his current home. We were taken around by his partner. An utter gem of a garden with the

backdrop of an almost tangerine-coloured manor house with the Welsh valleys and mountains beyond. The book on Maynard's work looked so inviting that I was about to buy it when a member of the Gardeners whispered that they had just bought a copy for me as a present.

Then on to a country house hotel set in mature grounds and overlooking the river Usk.

Invited the chair of Kew, an American who lived across the valley, as our principal guest at dinner. She had to leave at the crack of dawn to attend the funeral of her godmother in the US, but not before she had regaled us with the work of Kew. She said that the dried leaves in the collections would be one of the savings of biodiversity including, helping crops to increase their diversity and in so doing become more disease resistant, reversing a trend which has left many vulnerable to disease. Also, via the collection, Kew will be able to re-establish the coffee crop in civil war torn Ethiopia.

8 September

Early start to visit three Arts and Crafts masterpieces by H. Avery Tipping, architectural editor of *Country Life* in the 1920s. He is a special favourite of mine, designing both the house and the garden in each case.

The first house High Glanau Manor, Tipping's last home, restored by the current owner, whose book was published by the publishing house on whose board I sat as non-executive director. Over lunch and later tea, distant views of the Brecon Beacons 40 miles away. Then on to

Mounton House, a grand country house, again a garden restoration by the current owners, who were quite happy to spend £25,000 on each mature tree, some of which sadly have died. One fellow Gardener confided that had they bought a younger specimen at greatly reduced prices, the plants would have survived and would have soon reached the same height.

The third garden visited today, Wyncliffe Court, was, coincidently, featured in this week's *Country Life*. Here the owner, in conjunction with the designer of the gardens for the 2012 Olympics, offered yet another horticultural delight.

We concluded the day with a dinner at Usk castle, now amongst other things a wedding venue, where couples are happy, apparently, to be blessed where heads once rolled and innocent people were tortured. I discovered that the person opposite at dinner was a great friend of the Consort's first cousin and had visited many of what were then rarely visited places behind the Iron Curtain during their schooldays.

9 September

Today we visited the Physic Garden in Cowbridge. A recreation, each flowerbed packed with herbs appropriate for treating specific parts of the human body – limbs, heart etc, and all found in Britain before 1800. A lovely walled oasis in a fashionable little town.

Then to Dyffryn, a huge empty house with vast gardens (88 acres) designed by Thomas Mawson, one of the great

Edwardian designers who will feature again in this visit and in my year. He was the great grandfather of a former member of our Court and also at one time of our livery as was his client, the owner of Dyffryn. Neither became Master! Taken round by the head gardener.

10 September

Another early start. Today we headed to Aberglasney, an intriguing place, saved from total neglect, a unique Elizabethan cloistered garden. Our guide told us that in 2009 he had received an award from the Gardeners and regarded it as one of the highlights of his distinguished career.

A long day was completed with a visit to Powis Castle, standing high on its rocky domain with its magnificent series of terraces. Rightly well known to a wide audience. Staying the night at Lake Vyrnwy Hotel overlooking the reservoir which involved the demolition of a church, two chapels, three inns, ten farmhouses and 37 houses. Hotel built in the style of the former British Rail hotels – large, rambling, baronial, faded glory, the lake appeared mysterious and deep with a gothic jetty. Used now for filming.

At dinner, spoke to our principal guest, chair of the Welsh Conservative Party and a former MP. Told me with the proposed reduction in MPs for Wales, just decided today, he thought my original contact from the Welsh Gardens Trust will struggle to keep his seat.

11 September

Leaving the hotel, we passed the dam built of enormous blocks of stone in the 1880s, somehow dragged by pack animals. It seemed impossible.

Gwydir Castle – an extraordinary moment. The castle and gardens were once lost in time but were saved by a young couple who had bought this truly ancient pile. Most recently, it had been a nightclub. Why the couple with no money and no relevant experience took up this challenge is remarkable and unfathomable, but thankfully they did, and they intend to leave it to a trust for posterity. With persistent detective work, they managed to track down and acquire items originally from the building, including the wood panelling which once adorned the dining room, bought by Randolph Hearst in the 1920s, boxed and shipped to the US, found by the couple still unopened in a secure container in the Bronx and managed to acquire and reinstate it in its original location, the castle dining room, each piece fitting perfectly like a jigsaw. Prince Charles heard about the project, was keen to see it, and the couple, with local help, worked around the clock, literally throughout the previous night, so that all was complete on the day of the royal visit.

Heard about the ghost. Despite a sunny day, pretty frightening. When removing a fireplace, noxious gases were released and one of the couple stumbled violently, felt a hand on his shoulder pushing him forwards with

'enormous strength'. Drills suddenly started up and spun around in circles and a CD player, 'flared up into life in full volume'. His wife's engagement ring vanished for a week and suddenly reappeared one morning in the bathroom sink. He had a repeat experience of his shoulder being pushed hard down, this time in the direction of a spiral staircase. When these things happened he said, 'There was a subtle shift in the atmosphere of the house. Day after day, I sensed the waiting, watching presence, lurking in the shadows.' If I wasn't Master they wouldn't have seen me for dust.

However, we also came to see their garden which had trees planted over 350 years ago to commemorate the engagement of the future Charles II, the lord of the manor being one of the group who visited Spain to seek a suitable bride for a future king.

No time to recover! On to Bodnant, like Powis, a well-known treasure, home to four national collections of plants and much else , in this Grade I listed paradise. The views from The Terraces to the mountains beyond, is a view which I will for evermore recall in an overcrowded Tube to keep me sane. Now we are at Bodysgallen Hall for our last night. This too has magnificent gardens. Sadly, the head gardener predicted that the great canopy of ash trees, so integral to the backdrop and beauty, will all die – and soon. He showed me the corner of a garden where a volunteer with a terminal illness had spent happy final moments.

At dinner, principal guest said that every five years he writes a report on the state of National Trust gardens.

He said the trend is to plant to impress a modern audience rather than to stay true to the original planting regime. He was critical of Bodnant for that reason.

12 September

As we left this morning for the long journey through Wales, a small country but a mountainous one and difficult to traverse, we passed two oak trees; one from an acorn brought back from the trenches of the First World War by the son of the house, planted where he and other locals gathered before, in the case of most, marching to their deaths; and the second, again from the same area on the Western Front, planted in 2018, the centenary of the conclusion of that conflict. Reflecting on the two oak trees, I once read how the war poets often wrote in a light-hearted vein in order to boost their comrades' spirits or in order to avoid conveying the sheer awfulness of the reality to those back home. Interestingly, when the din of guns silenced, birdsong soon returned and the many amateur naturalists of that era in the trenches continued to observe and note the changing seasons, of nature offering a touch, a semblance of reality, of normality, a thin thread to sanity.

18 September

Getting feedback on the video for the Livery Schools Link initiative for which each Master records his own special piece for his year. Apparently nothing wrong with the content, but it would have been better had it been

produced professionally. I will endeavour to secure funding for a professionally produced version for my successor. I was keen to cover the great diversity of careers under the general heading of horticulture, which included medicine, chemistry, vaccines, plant-photography, writing, and many more.

26 September

The Sheep Drive and Wool and Livery Fair was today, so disappointed I couldn't attend. A fun occasion in aid of the Lord Mayor's Appeal. Origins go back into the mists of time; partly to celebrate, or so the legend implies, that Freemen were excused the bridge toll when driving their sheep across London Bridge, a ceremony quaintly reincarnated in recent times, hosted by the Worshipful Company of Woolmen with various stores offered by over 20 livery companies.

28 September
GOLDSMITHS FAIR

Invited to the preview of the Annual Goldsmiths Fair – truly spectacular, spoilt for choice. Consort bought a ring whilst I was talking at another stand. The woman I was talking to seemed to think it was a leap year or about to be one. She felt that generally people don't notice the innate sexism that infests this tradition. Can it really be true, she asked, that every day, other than February 29, women are still waiting for men to ask them to marry them, as though

they were still princesses and men were knights in shining armour? I don't reckon she sold many engagement rings tonight.

29 September

A tricky email exchange with a fellow Gardener. I think I have placated him, despite his thoughts about one aspect of our beloved livery, I don't bear a grudge against him. Still have only two real dislikes – HS2 and Morris Dancers.

6 October
CONCERT AT ST PAUL'S

I spoke to the Master Musician. I said I had been a trustee of the Royal Opera House even though I was tone deaf and once had a minor part in Britten's *Noyes Fludde* at my school. I had dragged my parents up to see/hear it. I still feel guilty, late, possibly too late, but a candid apology. I said that I had noted that 27 from his livery had died in the previous year, was it that dangerous being a musician? He said they had an especially large number of Freemen.

As I was edging towards the tombs of long dead generals, admirals and colonial governors to make my exit, I was introduced by a musician whom I had spoken to earlier to another musician. We talked about the language of music which transcends nationalities.

7 October
HARVEST FESTIVAL

The service was at All Hallows by the Tower, the oldest church in the Square Mile, with a tiny garden tucked between church and wall, filled with rescued plants, all lovingly cared for by volunteers. A haven of solitude. Totally excluded from the intrusions of the 21st century, easy to imagine that the garden is adjacent to an old parish church, somewhere hidden, despite the bustle of a contemporary metropolis.

The lecture, in place of the sermon, given by a member of the Linnean Society on the subject of plants in major religions. She certainly met her brief.

At the back of the church, a carving by Grindling Gibbons, exquisite, delicate, intricate.

Lunch at Watermen's Hall. Typical of the quaintness of much of what goes on in the liveries and the guilds, if one digs a little deeper. The meaning of the Watermen badge and Company is a marvel and subject in itself. Their full title is 'The Company of Watermen and Lightermen of the River Thames'. They go back to 1555. Their purpose is to maintain a standard of navigation, plying for hire on the tidal Thames above Gravesend. Their arms, granted in 1585, need a touch of explaining, 'Argent, in base barry wavey of six azure and argent a boat proper, on a chief azure two oars in saltire or between two cushions argent fretted gules trimmed argent tasselled or'. And that is only half of it! Nice

motto, 'At commandment of our Superiors'. Will show that to the Consort!

As I ascended the stairs to the reception, I glanced at the very ugly portrait of a former Master – actually they are not technically a livery – and on the basis that most portraits flatter, I wonder, therefore, what he must have really looked like. He seems an endearing soul, full of character, and having seen him before, I regard him almost as a friend. Reminded of that previous occasion at Watermens', when behind me sat a former Master Gardener who had been Lord Mayor but died suddenly days later, and beside me sat another former Lord Mayor, who was in situ at the time of the 2012 London Olympics. I said we had watched the opening ceremony on TV with friends, was somewhat embarrassed by the approach adopted – so much about the NHS, rather unbalanced, but with some extraordinary moments and had gone to bed dissatisfied, only to wake to find how universally popular the opening ceremony had been. I thought I detected that my lunch companion shared some of those sentiments.

We agreed that London had an easier ride this time compared to 1948 when it previously hosted the Games, to say nothing of the one prior to that! In 1948, the organizing committee had a mere two years to put everything in place, Arabs and Israelis were bombing each other, the Soviet Union was blockading Berlin and both food and clothing were rationed. Improvisation was the name of the game. Competitors brought their own towels. For sponsorship, the organisers turned to a cigarette company.

About the only thing given free were Y-front underpants. New Zealand arrived after a five week sea trip, seasick and unfit. Some of the best athletes had been killed in the war and few competitors were given paid leave. Some nations bought their own rations, the Mexicans brought tripe.

Our reception today was in a small but beautiful room. It was packed and not easy to circulate.

I sat beside the speaker at lunch and enjoyed more insights. An elegant woman, beautifully dressed.

In my speech after lunch, I said:

I like to think that we Gardeners, unlike many fellow humans, are not the destroyers of God's creation, but rather its custodians, even its enhancers with the hybrid plants. Fairchild is but one example within our ranks of that contribution. Mind you, by producing the first hybrid between a carnation and a Sweet William, he thought he was playing God and so wouldn't go to heaven. An annual lecture in his honour is there to reassure him.

We are blessed in this country with awesome gardens up and down the land, cultivated by the wealthy, protected by great gardeners and with other, more modest, numberless, anonymous delights which add equally to the mix. I have recently visited the gardens at Alnwick, a prime example of where a major addition adds to and compliments the ancient castle.

We Gardeners have even reintroduced specimens and endeavour to preserve hybrids out of fashion.

I theorise that plants may not be God's most popular creation, but rather insects and more specifically, beetles. One in four animal species are beetles, and I suggest that most of us can name two – ladybirds and stagbeetles. No wonder that for every botanist there are 500 others studying animals.

However, we horticulturalists attract some of the very best. R.D. *Blackmore, author of* Lorna Doone, *won first prize for his swedes in a local horticultural show and said he wished to be remembered for that and not as the author of* Lorna Doone. *Thomas Jefferson said, 'Though an old man, I am a young gardener.' It is little surprise that one poet – I forget who – described gardens as, 'God's poetry.' '*

7 October
THE LONDON GARDENS' SOCIETY

To Guildhall to present the trophies for the London Gardens' Society which encourage organisations to brighten up gardens in hospitals, council areas, hospices, almshouses and squares. Asked to present 93 awards and certificates. A steady stream came to the stage. I pressed the flesh of the Assistant Director of the London Ambulance Service, Assistant Commissioner, the London Fire Brigade and those representing a plethora of disparate organisations including Marylebone Almshouses, Walthamstow Almshouses, Lady Micho's Almshouses etc and the many hospitals, hospices, ambulance and fire stations. Later, met the wife of a former Lord Mayor. We discussed Boris.

She did not share my support for him and rather dismissed me as a consequence. Then she went off, returning shortly and presumably was briefed as to who I was, and now could not have been nicer to me.

9 October
MILTON'S COTTAGE

Invited to Milton's Cottage to assess the appropriateness of including a reference to Milton in our planned National Book Day event next March. The cottage is the only surviving home of Milton. The garden has been recreated to reflect a garden of his time. I was offered the chance to hold a first edition of *Paradise Lost* once owned by the great man. Apparently, he was lucky to keep his head and die of natural causes because of the political volatility of the Civil War years. I can't quite enthuse over Milton, great though he undoubtedly was. His writing seems to be so dated – too much an echo of a past beyond my comprehension, although he made up and added more words to the English language than did Shakespeare. But he still doesn't get my vote. This is an example of his horticultural effort:

> 'Full forty days he pass'd whether on hill
> Sometimes, anon, in shady veil
> Under the covet of some ancient Oak
> Or Cedar to defend him from the dew.'

I left the lunch with the chair of the trustees still questioning whether it was worth including Milton in our National

Book Day programme. But as my Steward, who is also associated with the Milton Cottage Trust, was keen, I think I shall agree. I don't want to be savaged by a teddy bear.

12 October
WIZARDRY IN WOOD

Invited to a private viewing at Carpenters' Hall by the Worshipful Company of Turners. Was welcomed by an array of extraordinary workmanship. Many items surely will become tomorrow's heritage. I thought the prices were relatively modest, considering the hours needed to produce the pieces. In its way, it was as impressive as the workmanship on display at Goldsmiths.

13 October

Gang of Five zoom. Idea initiated by my immediate predecessor. Office holders only, free discussion and proves very useful.

14 October

Today would have been my father's birthday, he would have been 111.

AWARD CEREMONY OF THE LONDON CHILDREN'S' FLOWER SOCIETY

At Guildhall, joined Alan Titchmarsh, President, in giving out the awards. One thing proved immediately – that he is as nice as his public persona, effortlessly engaging with

a wide age range of children. The Society was founded just after the last war to encourage horticultural activities in primary schools, nurseries and in special needs schools. Varied array of awards: best display of spring bulbs, most environmentally friendly, of greatest educational value, achievement under difficult conditions, etc. Twenty-seven schools won an award, each school had at least 20 attending. Later, about a dozen of us, including a Past Master Gardener who had also been Lord Mayor, went to a private lunch. The latter entertained me with stories of his period of Lord Mayor and I encouraged him to write it all down.

As the official photographer was absent, the format for the morning was shorter and the children said they preferred that. Interestingly, many children told me that gardening and bee-keeping were calming influences. They have learnt early.

Met the Pearly Queen. Actually, she introduced herself. She told me she was one of a few colourful, cockney charity characters. Larger than life, she was a fun person. Invited me to her place if I was in that vicinity.

Outside, a well-groomed woman, perhaps in her 30s, was on her mobile. She knocked into me. I waited for an apology. Instead, she swore at me like a trooper. I said, 'Can't you do better than that?' Shaken, I walked on.

BROGDALE – ZOOM LECTURE

Brogdale is the location of the National Fruit Collection. I was once their chairman. Over 2000 varieties of apple,

some ancient, others famous – such as Newton's apple tree. Many varieties have their origins in the efforts of Anglican clergy in the 18th century. The collection is a ready source for those intending to re-establish orchards at stately homes, ensuring they have the right variety for the period in question. Brogdale possesses all fruits except tomatoes. I like to tell people that tomatoes are fruit. Originally established by Henry VIII. In my time, bullied by a local developer whose land encircled our 50-acre plot and he wanted to build over the collection, a collection only recently saved by Prince Charles. We resisted and won the day. When we were unable to afford to maintain the whole collection, 1000 rare apple varieties were transferred to Highgrove where they are thriving. I will look out for them when we visit later in my year.

Before the lecture, spoke to the speaker, who was not around in my time. I said that when chair I had wanted to encourage developers to plant local apple varieties in their new housing estates in order to allow the young to scrump. I encouraged local schools to take some of the produce, knowing that it would benefit all and change the behaviour of some. I used to encourage friends to consider giving a fruit sapling, apple, cherry etc, as gifts. If they chose a sapling originating from the area where the person receiving the gift lives, the sapling would flourish in its local, natural environment.

The lecture, although poorly attended, was very interesting.

20 October
DECLARATION OF THE FREEDOM

Invited to attend a Declaration of the Freedom. Many members of her family attending. A timeless ceremony. I felt part of history and was grateful to have been invited. I haven't told our 'youngest freeman' that she still can't drive sheep over London Bridge, nor have the luxury of being hanged by a silken rope, be drunk in the City without fear of arrest, or relieve herself in public without fear of arrest, or go about the City with a drawn sword. Shown the exhibits in the room. Of course, I'd seen most before at my own admission. An eclectic range, including a sword presented by Nelson taken from a defeated French Admiral – Nelson had a low opinion of both his sovereign and of the Admiralty, so he gave the sword to the City. Florence Nightingale's lamp, a pioneering design, with its retractable yellow sides, was also there. There was no gift from the Gardeners. I said to the Clerk that I would rectify that and present a shield. On the wall, a list of all the Chamberlains going back to 1237.

LINNEAN SOCIETY LECTURE AND SUPPER

After a jolly lunch, I moved on to one of my events I've been really looking forward to – the Linnean Society Lecture and Supper. It's a recent annual addition to our programme. This year the lecture given by a forensic botanist and the author of the book *Murder Most Florid*. He helps the police

unlock hitherto unsolved crimes, from murder to arson, burglary to abduction. Apparently, no point in doing any dastardly deeds near thistles as their pollen is carried on your clothes! Unfortunately, the Home Office is cutting back on the budget for this service despite its extraordinary success, nor do the police help, as they often cut back the vegetation around the scene of a crime. He explained how he can solve hitherto unsolvable crimes by studying the regrowth patterns of the remaining stems of plants, and how he can tell how long a body has been in situ by the growth of young sycamore or ash or bramble. He added that skulls are beautiful things, 'The biology of decay is incredibly intricate', 'The remains of the dead are extraordinary and complex'. I made notes on where and where not to carry out a blood-curdling crime.

We left the lecture hall, under the gaze of both Darwin and Wallace, the latter apparently relatively unknown despite his almost equal contribution to the theory of evolution. Interesting in respect of Darwin and Wallace. They had presented jointly their initial thinking on evolution to the Society. The President, summing up that year, said no papers of note had been presented!!

One Past Master arrived late, she had been attending another City commitment. This is unfortunate, but then the City's diary is very full.

Then over the road to supper with less appetite after the gruesome content of the lecture. A rather long wait before being ushered into a private room. One guest, a man

of French-Scottish-German parentage, 'entertained' me. At age 11, his father became bankrupt, hitherto paying guests for the family's shoot would pat him on the head and compliment him. After the bankruptcy, only three of the dozen or so close family friends kept in touch. It taught him to be self-sufficient, to realise that change can happen suddenly, that appearances can be unreliable. He said, 'Something I can tell you in a brief way', 'I am a Protestant', 'I make long stories short', 'I will answer the question in an indirect way, but I will still answer your question', 'To be right before is not helpful', 'Let me be blunt'.

I told him that I had once met a person who was at a shoot in Wiltshire when his host said that only two of them out of a dozen or so were worth less than £200m each and that some were worth considerably more.

At last, we were called into supper. It was as if the staff were surprised we were there to dine, following all the months of lockdowns.

Asked by a guest if I would give a speech in Bratislava. I thought it was part of former Yugoslavia – not a good start, especially when the said person told me he had chosen Bratislava because his second wife, soon to be his former wife, used to live there. He asked if I would want wine for my efforts or a donation to a chosen charity – a clever psychological trap.

As we left, the heavens opened. Good for the garden but not for us.

On returning home, clearer skies and a large Hunter

moon. Got out my telescope, saw an object move across the moon's craters. Scary. It was my eyebrow.

22 October

Informed that I am, and presumably have been for some time, Ambassador of the Great British Garden Festival. I am excited to learn more.

3 November
LUNCH AT CARPENTERS' HALL

Guest of the Master Carpenter. Sat beside a Carpenter who had climbed Everest. He said North West Nepal has 2800 mountains above 6000 metres, of which 300 have been climbed, and therefore 88% have not. Gave me ideas, but they soon passed. I said I once heard that a fossil fish was found at the top of Everest – it must have been on the ocean bed before Everest was formed. Of course, he knew that. The same Carpenter was shortly to be presented with a livery award for his outstanding work. He explained the characteristics of the wood in front of us, of how its lovely pattern was in fact caused by disease. He said his father had been a Circuit Judge in the 1950s/60s and didn't believe in putting so many in prison. He sent one to do community service at Geffrye Museum. He ended up as Head of Security!

Another guest, now retired, said he once had 215,000 employees and had calculated that if he met ten a day, seven days a week, it would have taken him 70 years to have met

all of them. The conversation was very eclectic. I said I once met Eric Morecombe with the Consort. I made some joke which he appeared to like, and he said, 'That's good. Can I include it in my next show?' I answered, 'Of course.' He died before the recording, and neither I, nor the Consort, can remember the joke. One spoke of his most embarrassing moment. Clearly worse for wear following a livery dinner, he had returned to the house he had previously owned, attempted to enter using the keys to his current house. I said my most embarrassing moment was when my niece and boyfriend were visiting and our two cats brought in a live shrew which we tried to corner and save. Couldn't find it. I said, 'I think it has shot up inside my trouser leg and is now in my pants!' I had to take down my trousers in front of my niece and her boyfriend. Not the sort of memory an uncle wishes to leave behind. Despite that, he married her and became part of such a family.

We adjourned for coffee. I was surrounded by three Past Master Carpenters, all typically friendly and welcoming. It's a bit of a blank what followed, but I do recall one saying that half of Oxford applicants put Balliol as their first choice and that Balliol will only consider an applicant if they did so. Blair and Clinton were both rejected, presumably for that reason. This Master was a banker, that much I do remember. He said never do business with anyone who has a Porsche, a flagpole in their front garden and a fountain. Why do people think I need such advice?

On the train home, I decided to change trains at

Finsbury Park for a faster train. On the platform, changed my mind, and got back on in a different carriage. Lucky I did because I left some papers and my mobile on the seat I was previously occupying. At least I was now on the same train. But returning to that seat I found that all had gone. I walked up the carriage, asking if anybody might have my mobile. One person did, smiling reassuringly, and said he was going to hand it to the ticket inspector. He had the papers too. He is a saint and I am a fool.

4 November
AUTUMN COURT AND DINNER

Just before leaving home this morning, looking at the list of those who have occupied my house over the years – being a former rectory the list is readily available – I noted that this year we will be the 9th longest occupant since Hugh the Clerk in 1155 beating, in the process, amongst others, those who had names such as Eckland Downs and Affabell Battell.

My first full-sized formal event as Master, Installation being so reduced because of Covid.

A sense of arrival sitting in the large chair, a heavy gown, regalia, full of atmosphere.

Plenty of acronyms to grasp in the minutes and the agenda: SPM, EMAC, LMBCL, LCAG, PLT, MHB, ESG, FIC. Oh dear!

The meeting covered the usual eclectic range of subjects. Some bought forward, some new, others included Court

attendance, patronage of major dinners, our display in the Guildhall Yard, whether to support the Camden Highline or not. I reminded Court of the project's credentials. London needs a green corridor in order to support the biodiversity as well as supporting, to use a modern phrase, nature based solutions for the management of water and flooding. It will also provide a good green space for the communities through which it passes and thereby support well being. In short, it will provide a shared back garden for all local people and is located in some of the most deprived areas of London, with high density housing estates. It will be a platform for community activity, providing opportunities for play, cooking and events.

Awards for students, our possible support of the Woolwich Garrison Church by re-establishing its community garden with a special emphasis on commemorating the contribution in wartime of the Ghurkhas, and discussion on the ESG statement on gender, diversity and other matters of inclusion. We have few ethnic minority Gardeners but we have been well represented with women Masters. I had been looking at the documentation that needs to be covered for diversity. It is pretty confusing and overwhelming and might even become counterproductive. Inequality can be defined as sexism, ciss-sexism, hetrosexism, classism, Islamophobia, antisemitism, racism, disablism. One document refers to those living with multiple oppressions, which come together to create 'different compound particularistic lived experiences'. The

documents say that privilege is invisible to those who have it, and many of us see the world in a biased way. We see it through the lens of privilege. It goes on in a similar vein about unearned advantages.

Later, before dinner, rather sad – talking to a member of the livery whom I have known for over 20 years but now has the early stages of Alzheimer's. She asked, 'Was I a member?' She must have asked the same question many more times during the evening.

In my speech, I asked if those present would like to know what had just been exchanged between the Beadle and me? 'Would you like to speak now, or shall we let them go on enjoying themselves a little longer?'

I said:

'Today, we gave our annual livery awards. These awards mean a lot to the livery and to the recipients. One former winner is Head Gardener at Aberglasney, which we visited recently in Wales. When we were there, he told us that despite his subsequent distinguished career, he is especially proud of that youthful achievement. I urge you, winners tonight, to regard us Gardeners as your confidants and mentors over the coming years.

We are a friendly fraternity. The Upper Warden, just before dinner, told me he attends my events to see how not to do things! I don't know how many Uppers never made it to the Mastership since 1345, but I can name perhaps one.

We have just enjoyed some wonderful singing. I chose these songs for no other reason than I like them. You will all know the song made famous by Doris Day, 'Que Sera Sera.' It is especially poignant for me; when I was a lad of eight, we sang this, waiting to be collected to go to school. What happened to that little band? Alas, one died when only 15. Another became Master Gardener.

I once had a German penfriend when at school. We were getting on rather well until she asked for a photograph of me. I haven't heard from her since. I note that one of our award winners comes from Germany; could I ask that you do me a favour? If you see her, tell her I still miss her.

Talking of our five a day, may I suggest that we horticulturalists/ gardeners are more careful? On my packet of radishes at home, it says grown by Scott Watson (that sounds like a member of the American Ryder Cup team), then it says, 'One of your five a day equals ten radishes.' Ten! You would end up in A & E after five and be dead after ten.

I have just presided over my first Court. Interesting. Did you know that many of the pioneering plant hunters combined that with spying? My name is Poinsettia, James Poinsettia. I collect poison plants, but No Time To Die.

I should have realised this connection sooner. I asked one Court Assistant to join a committee; he said, 'I will have to consult the Kremlin.'

I ought to end on a high, philosophical note, especially in the presence of our young friends. As Boris said – or was it Confucius? – 'I buy rice and flowers. I buy rice to live and flowers so that I have something to live for.' I always thought Confucius was a creep.'

8 November
GARDEN OF REMEMBRANCE SERVICE

To St Paul's and the Cenotaph, the one in front of the Royal Exchange. Coming up by train, read in the newspaper an article about ex-Etonians at Balliol pre-First World War and how they threw cases of wine and crockery down the stairs just for fun, one saying to a poor undergraduate, 'I can pay with money God's plebs like you don't have. I can do what I like.' Both ended up soon after on the Western Front, often dying on the same day, equal in the mud.

First, breakfast at Ironmongers Hall and robing. Approached by one person who introduced herself as somebody I was supposed to know and said that I was her former boss. She was now Clerk to a livery company, hence being here today. She remembered that El Cid was one of my idols. I said, having read a detailed account of the complicated reconquest of Moorish Spain since then I think I might have jumped up and down on the tomb of the wrong Yusuf and I am not sure if El Cid deserves my unqualified support.

We congregated at Plaisteres' Hall. Plenty of medals worn by others. I had none. Asked my Clerk what they

were for. He said most were CDM, adding with a wry smile, 'Cadbury's Dairy Milk.'

Speaking to various Masters, it is interesting what their backgrounds or day jobs were. For instance, the Master Musician is a former ambassador, the Master Girdler a General and the Master Gardener (me) Lance Corporal school CCF. I spoke to one Clerk and mentioned the mess created by developers near Glaziers Hall – roads, concrete confusion, windy tunnels. He recalled the mess created by wartime bombs in that area. A mess has replaced a mess. Another Clerk came from Leicester. I said the Consort's family also came from that city, and he asked whether I knew that their city council had once contemplated erecting a statue. The choice was between Gandhi and Gary Lineker. I said, 'Why not choose between Churchill and Eeyore?' I don't think he understood me.

At St Paul's Green, adjacent to the cathedral, we were told they had been watering the grass so that we could each place our Company's cross more easily when we processed a little later. One Master said the Gardeners should be the number one livery being 'the oldest profession.' I don't know what evidence he has. I told him that we gardeners were bound by a love of all things horticultural and, as their Master, I was only concerned with what they did in flowerbeds, not in other beds. My Clerk told me a brother of that Master had been saved from the wreck of HMS Gallagher in the Falklands War, only to be killed later in a car crash. Another Master told me his office was in the

Cheesegrater building and that a recent American visitor had said that building was greater than St Paul's. My new friend, the Master, corrected him:

> 'One was designed by computers, the other by a human genius.'

The Master Butcher chatted to me, asking me for advice on plant holders for Butchers' Hall. I told her I was the least qualified but that I would contact my colleagues. I asked if she was worried about the trend away from eating meat. She said that the campaigns were funded by Silicon Valley and no-one can compete with their money and clout, adding that plant based foods also need plenty of water and where was that to come from? She said January is suggested as a no meat month, and asked whether the aviation industry would champion a no fly month.

A long wait, but the time for the ceremony finally arrived. Watched as others higher up the hierarchy went forth to plant their cross in front of the large number that had congregated. Noted that the base of the speaker jutted out and might trip one of us up. I said to one Master, 'Be careful otherwise you might be one of the Fallen.'

My time arrived to place my cross on behalf of the Gardeners'. Walked past the Lord Mayor, other City dignitaries, representatives from schools, the Armed Forces et al. Placing it whilst the band of the Grenadier Guards played appropriate pieces of music. Those immortal words, 'They shall grow not old... and when you go home, tell them...' They always turn me into an emotional jelly.

We then had the words, 'I once was lost but now am found'. I thought this especially poignant today having read, also in the newspaper on the train this morning, that about 1/3 of pupils are wasted, being told they are failures so young and for the rest of their life. When will we ever learn?

One of the officers in the formal parade had the best pair of legs ever seen. One of the British Legion was a cross-dresser.

When time to sing the National Anthem, all but one bright spark looked down to sing the second verse. Wanted to ask him if he was that clever whether he knew the words for the third verse? Perhaps he can quote the dates of all the Kings and Queens from 1066 like I can?

At the conclusion of the ceremony, my Clerk said he would catch a bus home to Sussex, which will require only one change. I said our former cleaner, originally from Poland, would catch a bus from a roundabout near our home with only one bus change to Warsaw.

When I returned home, still feeling reflective, I dipped into my cheap copy of the medieval manuscript of the *Luttrell Psalter*, as I knew it summarises the transitory and challenging nature of the human experience.

10 November
CHILDREN'S FLOWER SOCIETY

A zoom meeting. One of those present, a teacher from a primary school, had to leave briefly because of a knife incident. She didn't seem unduly flummoxed. Compare that

with my beloved Jennings and Derbyshire books. I took the added precaution of remaining on mute until the saga had ended. The discussion then covered the problem that some schools wanted our bulbs but didn't want to participate in the competition. Ofsted says schools will recover quickly from Covid but not the view of most present, and hence our bulbs will not be the top priority for the next few weeks; and school budgets have been cut, so our bulbs are sinking with not much trace.

In the meeting, it was noted how great the queues were for Alan Titchmarsh's signature and if it was noted that nobody queued for mine, they were kind enough not to record that in the minutes.

13 November
LORD MAYOR'S SHOW

By tradition, the Master Gardener makes his/her way accompanied by the Upper Warden and one other to the Mansion House prior to the commencement of the show to present a posy to the Lord Mayor and to the Lady Mayoress and, today, additional ones for the proud parents of the Mayor – such was the tender age of the new incumbent. The streets were cordoned off. It had the appearance of a film set with sawdust strewn for the benefit of the horses, traditional carriages with horses filling all the side streets. Plenty of activity preparing for the day ahead.

On the way, was told the origin of the term floats. Apparently, originally, the Lord Mayor's show was held on the river, hence the name.

Entered the Mansion House, ushered through to the private quarters. The Swordbearer, looking every bit the part, apologised, saying the Lord Mayor would be one minute late; he was having difficulty putting on his tights.

Being November, the posies were herbs. One of those accompanying me suggested the Lady Mayoress might make it into a soup.

Conversation with the Lord Mayor and his family very relaxed and chatty. Age wise, I had more in common with his parents. His mother said they had always watched the Lord Mayor's show on TV when the children were growing up in Ireland. I turned to the Lord Mayor and said, 'You are now part of that history.' He said he found it hard to think that he and the Lady Mayoress would be the centre of all the activities today – the tradition and festivities, the show and speeches. He reminded me of the origins of the phrase, 'Keep it under your hat'. Yesterday, he had attended the Silent Ceremony, the penultimate act of ceremony in preparing for today. The key to St Bartholomew's Hospital is given to him and to be kept under his hat. Others might claim a different origin, but not me.

We talked briefly of how Lord Mayors used to invariably receive a knighthood. He said one of his great grandfathers had become Lord Mayor of a northern town in around 1900. I asked cheekily if he got a knighthood for that – no, only a tin box of chocolates, which the family still has – the tin only I hope.

I had mugged up on the history of the Mayoralty and

I didn't spoil the occasion by telling the Lord Mayor that there were moments when the position of the Corporation and the Mayoralty were at a very low ebb, especially in the early 19th century, when one observer commented, 'Call him Lord if you like it, but no shows, no parade, no feasts, no fooleries'. Or that one Mayor, Nicholas Brembre, was executed for some awful misdemeanour in 1388. I am sure he was more than aware.

The Lord Mayor's Show today may not attract the attention of our greatest contemporary dramatists as it did in the time of Middleton and Webster in the golden age of the early 17th century when such literary persona created elaborate allegorical fantasies. One commentator in this so-called golden age hoped that the then Lord Mayor, 'Would be aware of the silent burden of expectation as he carries and hopefully adds to the legacy of his office, of ever maintaining unimpaired and if possible unquestioned the high and ancient privileges of the City, as with them and under them London has become the first and greatest City in the world'.

I thought my new best friend, the current Lord Mayor, should not believe, as one of his headstrong predecessors did, that he is Master of all the livery companies. There is a balance of self interest and mutual respect to maintain.

Some living in the mid-19th century, when the hitherto distinguished office of Lord Mayor and the Corporation had sunk to a dangerously low reputation, would be surprised no doubt that there was a Lord Mayor's Show

on today. They would have thought, I suspect, that all the wonders and rigmarole of today would have been consigned long ago to history. As one observer writing at the time stated, 'I declare that the whole parade is the subject of the most contemptuous sneering, even amongst children... surely the pantomime and clownish display of civic barbarisms, can no longer be cherished', and suggested that, 'with the stage coach hopefully bespoken by Madame Tussaud's and Gog and Magog doing duty as humble fire wood, will frown no more over turtle and champagne'.

I left after presenting the posies and didn't watch the show, but I did glance at the Lord Mayor's coach. It's a stunner.

14 November
REMEMBRANCE DAY

Destination St Paul's Cathedral. Early start, writing up the diary in a café near Moorgate, unearthly hour and supposed to be retired and it's Sunday.

On the way to St Paul's Cathedral, saw some cobbles that had not been replaced following work by a utility; this is one of my bête-noires. I campaigned for six years to get six cobbles replaced off Oxford Street. We are quite hopeless in this country in this respect, unlike cities such as Bruges.

At St Paul's, no place reserved to deposit our coats and baggage. Met my friend the Master Scrivener, who said the new Lord Mayor was supporting the charity Lazarus, which raises money to fight leprosy. Always seems a biblical illness

but still current in parts of the world. Told him that there is a stone window incorporated in a church near my home, which was requisitioned from a leprosy colony adjacent to that ancient place of worship. Sitting near to a monument to Lord Cornwallis who apparently distinguished himself 'by his conduct, skill and courage' and thereby added greatly to victory at Trafalgar; 'Long and distinguished life', brilliant victories usually over the French. Also keeping me company, were the tombs of Earl Howe, Lord Heathfield and Sir Ralph Abercromby.

Even though I am a quarter into my year, there still are many Masters I haven't met before. Of course, it is a constant flow of office holders, with many different starting and finishing dates throughout the year for Masters at other liveries. Also, because of Covid, most of my events will be packed into the second half of my Master's year.

We were told to be in our places early, so there was plenty of time for conversation. And there was laughter, despite the purpose of the service. One Master treated me to a story of his prep school closing and that the real estate value of the site was 12 times greater than anything that could be achieved as a going concern. He told me that one contemporary was almost indecently treated by a school master. A fellow Master wrote to the mother saying that the Bursar, and referring to him as a Brigadier, had rescued her child. The mother replied, pointing out that the Bursar was not a Brigadier but was a Wing Commander, and made no further reference to the incident. Subsequently, the said boy

became famous – I know the boy, and the school – now a residential development, but my lips are sealed.

Sat behind a Clerk, who had been one for five years, said that was the average duration, and he said that the Clerks exchange views on their respective Masters! He lived in the Hundred Acre Wood of Pooh fame. I thought only Christopher Robin, Piglet and Kanga etc live there, but it seems that livery Clerks do as well. He said the wood was actually five hundred acres. I was about to tell him that London was 400,000 acres and with its ratio of open spaces to built environment, was technically a forest. He said he had met Christopher Robin – he meant Christopher Milne. I said I had once written the first draft of a book about Winnie-the-Pooh. In my version Pooh was drunk and Piglet was gay. I have always regretted this little saga as I have loved these characters. Heaven knows why I even attempted this version. A university friend, who wrote for the *Times*, put it in the newspaper without my prior knowledge, and, the next moment all hell let loose. Two strangers appeared at our gate, said the original manuscripts were not out of copyright. I said after 50 years, I thought they were. One said the time had been extended to 75 years under EU legislation and I must destroy my draft. That lunch time, I was interviewed by the BBC World at One, despite being the day John Major announced a General Election and that evening, I was on another programme with people telephoning in saying how bad I was. One person, aged eight, telephoned at 11pm, I said she should be in bed by

now, wishing I could be as well. She said, 'I'm telephoning from Canada and it's 5pm.'

The Master on the other side of me borrowed my pen to fill in his tax charity giving envelope, returned the pen, saying he wasn't sure if he earns enough to qualify, adding that his wife still works. We talked about floats for the Lord Mayor's Show, I said the Gardeners weren't having one this year, he said nor were they, as it cost his livery £30,000 three years ago. He said he was in one of the carriages at the show yesterday, despite it not being his livery's turn, but because another Master wasn't attending. He saw a Master of the Great 12, who qualify automatically, in a café that morning with her grandchildren and reckoned she wouldn't make the show in time.

Another, nearby, said his son had taught Prince Edward's children the piano. I said he was a former Master Gardener – I got that in again. Both of us reflected on how genuinely nice he is, as equally is the Countess, and that both work extraordinarily hard but just below the parapet of exposure as far as the public were concerned, and hence they don't always get the full credit they deserve. Once asked my Royal Master what he was doing next after a long livery day – going down to the University of Bath, where he is their Chancellor. He plays Real Tennis, describing the game as playing chess with a ball.

We managed to be silent before the scheduled reading of, 'A mortal, born of woman, few of days, and few of trouble, comes up like a flower and withers, flees like a shadow and

does not last'. Typical from the Book of Job. Would he have been any happier had he won the Euro Jackpot? I doubt it.

I noticed Prince Michael of Kent, and I whispered to one Master that when the Prince was Patron of the Tree Council and I walked through a wood with him, he didn't utter a single word.

The Last Post was sounded as the clock struck 11. The Lord Mayor was in his stride, even though he had only just taken up that role. He seemed to somehow combine due deference with almost a bouncy gait (could it be being Irish and that the Irish beat the All Blacks yesterday?) The Dean of St Paul's was the preacher and he preached an incredibly sensitive and appropriate address, saying that war is the failure of everything, that living memory is no more than roughly 100 years, but we have a responsibility to keep memories alive. We might forget the people who have died, but God never will. He said he met a woman in St Paul's who was looking for the name of a boy aged 15, a relative five generations back, who had died in the mid nineteenth century, a name on a stone plaque, one of many but with much meaning for her.

After the service, walking to the Cenotaph outside the Royal Exchange, I was in conversation with the Chief Executive of the scheme that helps Journeymen, that is the young, under 40, to become involved in the livery movement, but who also helps to draw up nominations for peerages, under the independent label. I was on my best behaviour, toadying and thought I'd done well and

was even sketching in my mind a possible coat of arms. Apparently no need to hand over any money either under that scheme.

This part of the ceremony was standing, and I was behind the Master Fanmaker – a mistake, as he is rather tall! The military band was competing with the seagulls and with the announcements filtering up from Monument Tube station below – 'mind the gap' – diluting the solemnity of the occasion. One young soldier looked decidedly dodgy and was clearly about to faint. But another, with military precision, as if pre-rehearsed, removed his colleague with the minimum amount of attention.

Unlike many others, I didn't book a lunch at one of the livery halls following this morning's service. I popped into WH Smith to see if they are stocking my book on Housman strapline, 'Finding a Path to Flourish'. The person asked if I was Housman, and then asked how to spell flourish. She said she only had *A Shropshire Lad* in stock and couldn't pronounce Shropshire. Did I want to order my book? No, I wrote it.

16 November

Got a very nice letter from the Lord Mayor following my presenting of a posy, just a few herbs out of season and will no doubt shortly fade. 'Dear Master, Dear Peter... it is sure to be a day I will remember for the rest of my life', and he goes on to thank me for the posy.

19 November
TRIAL OF PYX

To Goldsmiths Hall as part of the ancient ceremony on checking that the coinage of the realm has not been adulterated and therefore devalued.

Before arriving, caught up with some emails, one from my financial adviser and when I told him that I was shortly off to the Trial of Pyx he replied that the only coins he still used were for supermarket trollies.

On arrival, spoke to one Master, only the second to be Master of his livery since it converted from being a Guild. Although, after another drink, he said it was still technically a Guild, so he wasn't technically a Master. Said he wrote the constitution for his Guild. We were then joined by the newly appointed Master Haberdasher, who'd only been Master since the night before. He was chaplain to Harrow School, and knowing a few former pupils, I thought that would be a full time job and he wouldn't therefore have time to be Master. I kept my thoughts to myself. He said he was formally of the armed services and had attended the college which was now the home of Prince Edward, one of its many usages over the years was to be the home of the Royal Army Chaplains' Department. I said when the Prince was our Master, we were invited to his house and garden and by the lake is the message, 'Please do not walk on the water'.

Next, my Master's badge fell off – clip broken. Said that would be fine if we were with the Needlemaker, a comment

lost on those around me. One kind soul, in a gesture typical of the liveries, gave me a safety pin.

Then chatted to the Master Fishmonger, who commented on how small his own badge was. I thought of all liveries, they could afford the largest. He told me about the Pietro Annigoni portrait of the Queen in his hall. So wonderful, a favourite of mine and of many others. He said the sovereign usually only offers three sittings, but on that occasion, she offered more. I think many of the portraits of the Queen are rather sub-standard, perhaps they are because she offered too few sittings? Said Prince Philip was jealous of the portrait, so when the artist painted the Prince, he gave him a slightly sour expression. Both portraits have similar backgrounds, but in the case of the Queen, there is fishing on the lake. In his portrait, the Prince, the fishermen are walking up a slope with a catch. I have never seen his portrait and have no idea where it hangs. One of the Clerks, whom I think must have been involved with the Kipling Society, as he was somewhat of an expert, certainly an enthusiast. He said, 'Read *Kim*,' and then walked away. I will do as he bids.

Now down to the serious stuff. We were reminded that in the past, the currency was subject to filings, chippings, debasing and that even the suffragettes by stamping, 'Votes for Women' on coins, had debased the currency. The ceremony goes back to Saxon times. Very dangerous to debase the currency. Some, when found guilty, had their hands chopped off, and when Isaac Newton was in charge of the Royal Mint, he took his role very seriously, even visiting

taverns in disguise. It is tradition to invite a senior Treasury minister to the ceremony. On one occasion, the Maundy Money was overweight – erring on the side of generosity! The then Chancellor, Nigel Lawson, who was officiating, waived it through, saying he was on the side of the poor. Churchill, when Chancellor, attended every one in the five years he was eligible to attend, enjoying the occasion so much.

The person to my left worked for the Royal Mint. I suggested there was less need now for coinage and that other countries could surely mint their own, and that was the reason why the Royal Mint produced commemorative coins for Peter Rabbit, to commemorate the Year of the Rat, and for Cleopatra, they could boost revenue and profits when demand for legal tender currencies was in sharp decline. He said, surprisingly, 7 million adults still use coins in this country and reminded me that commemorative coins are often of great beauty, examples of fine designs executed in miniature. I told him I could remember the day Britain turned to decimalisation. He said they were bringing out a coin to celebrate the anniversary. I mentioned the elderly lady who was interviewed on the day. When asked if she had mastered the new currency, she replied no, because she thought it wouldn't catch on. I asked about the Empress Marie-Thérèse and the coin I bought as a young lad when skiing in Austria, wondering why Austria still issues that coin on a regular basis. He said, 'She had a good cleavage, so the Middle East liked it.'

On my right, one of the judges for the Trial last year. Said she didn't even know there was a Gardeners' Company. I could have put her on my compost heap. Not a good start.

Opposite, was the Assistant Private Secretary to the Economic Secretary – the principal guest today. I thought he was so young that he must be somebody's son invited on this occasion.

We discussed the theme of debasing the currency. In the past, even the aristocracy was often hard pressed for a bob or two, as the novels of Thackeray and Dickens amongst many express. Their attempts to escape their creditors are the stuff of a good few novels. In 1698, 20% of the coinage was counterfeit. We were then given the reassurance from the Chair of the Jury, 'Members of the Jury, I thank you all on behalf of Her Majesty's Government and on behalf of the Government of New Zealand (no idea why they were included) for your work and your expert skill, which have led to the proclamation of the satisfactory verdicts which you have found.' I could detect much relief all round, palpably so. 'Members of the Jury, I accordingly discharge you from your duties and declare this trial concluded.'

22 November
ST BARTHOLOMEW THE GREAT

On the train going into London this morning, I was reading *Kim*. By page 66 there had been 81 notes to refer to. I must have fallen asleep because I dropped the book.

Invited by our Hon. Chaplain to St Bartholomew's with

a dozen others to discuss that great church's next 900 years, my role perhaps being to re-establish the herb garden to link again with St Bartholomew's hospital next door, to resonate on the link between the religious foundation, herbs, healing and a modern NHS hospital.

Only a third of St Bartholomew's church and cloisters are still standing, but what remains is impressive, atmospheric, vast and medieval – so very rare in our ever changing city. When at full size, and in a much smaller city, with St Paul's Cathedral nearby and with other ecclesiastical buildings, the impression must have been of an overwhelming sense of the Church dominating all. No wonder Henry VIII dissolved the monasteries, even if not for altruistic reasons. As darkness fell, the atmosphere heightened. Were told that the organ doesn't work and that they rely on piped music. The vicar 'read' the fabric all around us. Near the altar, he told us, is a ridge and decolourisation, evidence of the last restoration in 1405. At the time, war with France going badly, so built a wall to mitigate the form of the apse, which was regarded as too French. Now removed but with this detectable trace of that historical gesture. Font where Hogarth was christened. In the Lady Chapel, Benjamin Franklin learnt his printing skills. In the aisle, a 21st century depiction of St Bartholomew by Damien Hirst, an acquired taste, but I rather liked it. In the cloister, a filial had the date 1928 on it. The Countess of Lascelles had opened the then revamped cloister. I said she was a royal. Puffed myself up, others didn't

know that fact, but the chief fundraiser trumped me – one of his teachers was a Lascelles, 19th in line to the throne. Quietly, I thanked the Almighty for punishing me for my arrogance.

Often live services to the US. There is a strong American attachment to this great church, services beamed across the Atlantic, first to the East Coast, then, as time zones change, to the West Coast, with donations from the latter at least five times as great.

Chatted to the others in the cloister afterwards. One woman, 80++ but must have been a great beauty as she still had a wonderful bone structure, had had a hip replacement 11 years ago by a woman who was once a man. The surgeon had a very good reputation. The Queen Mother had had the same person, said she didn't mind whether he was a she or a he. Another who had had a knee replacement (his partner had had a heart operation) said he knew of someone who had had both hips replaced and by the same excellent surgeon. One when he was a he and the other when he was a she, adding that he thought she was considering reverting to being a he. I helped myself to a glass of wine.

The building was very warm despite only one boiler working. Serious stuff now on the agenda: how to celebrate the next 900 years. Three ideas: the first to open up the balconies – one has chairs stacked, the original chairs untouched and unseen since 1990, the other has six bags of human bones from the churchyard, now with no labels; the second, to install a lift; the third, to reinstate the herb

garden. I said I thought the bones could be used as excellent fertiliser. Apparently not allowed by law. I asked the vicar about costings. He said that as a humble man of God, he didn't know and he would ask another. He turned to another, the fundraiser, and I am now committed to doing all I can to establish that herb garden. Shown the spot, tucked around the back and side of the building, in a wild overgrown abandoned spot, adjacent to flats and modern London, but secret, special and full of atmosphere. Overall, the aim is to raise £10 million for the church's projects. Currently, the church is often used for films. Two years ago, it doubled as a market in Lahore, also featured in *Four Weddings and Funeral* etc. The building survived the Great Fire and the Blitz – so rare. Pepys, in his diary calling the Great Fire 'That most horrid, malicious, bloody flame.' Indeed 44 halls were destroyed in that bloody flame – 41 subsequently rebuilt.

Founded by Henry I's Court Jester, who, according to the vicar, was a 'total creep', sliming his way up the court hierarchy; was in the ship that didn't sink when the White Ship went down, wiping out most of the then royal family. In gratitude for his own survival, he went on a pilgrimage to Rome, returning to found this church, given the cheapest and most foul plot of land where butchers plied their trade and likewise the executioners.

A great evening.

On the way home by train this evening, I recommended reading *Kim* and found myself on page 48 and so had reread

what I had read this morning without realising it. Not a good sign.

23 November

Lunch with a Gardener at his favourite quirky venue – Chelsea Art Club. The club cat was having its lunch on the billiard table, and I wasn't sure what sex the barman/woman was. Throughout lunch, a staff member appeared to be carrying a wooden garden seat around outside. The lunch was excellent. On my way home, saw a gardener chasing a single leaf with a noisy leaf blower.

26 November

Have decided to give up on *Kim*.

3 December
SAINTS AND SINNERS

Kindly invited by the husband of a member of the livery – although I knew him many years ago in business. At the Savoy. An event founded in 1947 copying a similar event in New York. An 'association of gentlemen connected with industry, literature, art, science, the theatre and learned professions'. Membership limited to 100. Separation into saints and sinners which is left to individual conscience; saints wear white carnations, sinners red. Prime object not charity but it has raised £2 million to date for good causes. Chose to wear a red carnation.

Savoy in full Christmas splendour. A couple booking

in at reception; woman clearly the man's girlfriend, age gap wide, somehow not the attitude of husband and wife. Staff professional throughout.

At pre-drinks, overlooking Embankment Gardens, my host pointed out an ornament in the garden, a large, globe-shaped, modern, solid item and said that last time he ended up cracking his head on it. Seemed to me, at this stage of the proceedings, to be nigh impossible. At one stage, I tried to drink my champagne still wearing my facemask.

When I entered the dining room, the fellow guest walking with me said last time his daughter lunched here in this very room, dust started falling from the ceiling, then the roof fell in.

Long grace – the Chaplain said we all needed sound theology.

Sat beside a former PWC partner. He said he was the only partner with the record of opening and closing the same office, which he did once in Kent.

Jokes galore, often very good, solid formula, various diners got up, it seemed at random, said their joke and sat down. Typical:

'Winston Churchill in the loo with Attlee in the House of Commons, Winston kept his distance, why asked Attlee. Because when you see something big, you want to nationalise it.'

Another guest did National Service in the Tank Regiment. In those days, they had to experience the actual gun noise.

As a result, he has had partial hearing ever since. Not easy sitting beside him in a crowded room. Another guest said last time he was invited, Ronnie Corbett and Terry Wogan were there and added that Wogan was one of the best at such functions. I can believe that. Ex-king Constantine a member. Used to pass him daily on my walk from Kings Cross to my West End office. Neither of us acknowledged the other for years, then one day, one of us did, and at each and every time thereafter, a friendly wave and smile.

One guest at my table enjoys salmon fishing in Scotland, bad at present but said salmon fishing is good in Russia but refuses to go there on principle. When in business, in retail, he put a circus in the basement of his department store – in those days, a department store was a place of excitement and experience, perhaps more so than today. Another guest knew Colin Cowdrey, the cricketer who married into the family of the Dukes of Norfolk (I once saw him wandering through Arundel, that lovely town). Told that when he died, his estate was valued at only £300,000. His career was in the days before TV etc. I opined that the small estate could also be because he mixed with those with money, being a legendary cricket captain and felt he needed to reciprocate at the same level of hospitality which his resources couldn't sustain. I have seen that before elsewhere. The guest also knew the widow of the equally legendary cricketer Peter May. The widow was bitter because May had lost most of his money in a Lloyds syndicate and the chair of that syndicate became chair of Surrey County Cricket Club. I said I

once met Peter May at a lunch he was hosting when he was front of staff at an insurance company. Stupidly, I said I had always wanted to meet him – an obvious comment from a schoolboy of my vintage. Actually, he was rather disappointing.

Another guest on the table had once been chairman of Surrey County Cricket Club. I asked how did Surrey do so well winning the championship for seven consecutive years in the 1950s. He said that achievement was almost unrepeatable today. No chance of inculcating a team spirit with all the England call-ups for different formats of the game. In Surrey's glory days, their captain didn't play for England, so he was the constant, the anchor.

Tim Rice got up. He said *Jesus Christ Superstar* was once on in Sydney at the same time as the Ashes Test Match. He asked a person if he would like tickets, the person didn't recognise him and said 'no.' Why not? asked Rice. The answer? 'The show was f* awful. Would like tickets for the Test.'

Another on my table, a business man I had admired from a distance and met once or twice, former Master Glover. On the adjacent table Sir Andrew Strauss. He didn't recognise me despite my 5–10 bowling against a prep school in 1963, which surely is still talked about. I pretended I didn't recognise him.

Another guest said he once played golf in Hong Kong, was on his own, a group of golfers reminded him that the rule was to let others through if he was playing by himself.

He said, actually he wasn't alone, his wife was three holes ahead of him.

Time for songs; half a dozen guests from stage and screen entertained us with well known songs but with change of words. For example, 'Twelve days of Christmas: Four rubber gloves, three PPES...' Another was, 'Oh, Little Town of Wuhan.'

No women at Saints and Sinners. Reminded me of a debate at my then London Club on whether to allow women as members. Failed. The opening argument in favour didn't help, 'I like women. My mother's a woman.'

As I left, I repeated to myself I must avoid the Embankment Gardens, because of its obstacles.

CAVALRY AND GUARDS CLUB

This evening dined at the Cavalry and Guards Club at the invitation of my Steward to celebrate the 222 years of the founding of the Linnean Club in 1811. Our table was composed of fellow Gardeners. A jolly occasion despite one painting on the wall being of a pile of dead soldiers – all French, but still not nice.

4 December

I was hoping for a quiet morning following yesterday's enjoyable excesses. Alas, it is not to be. Just received a copy of the livery Christmas card, which I had painted of Adam digging in the snow. The printed version shows the snow as blue! The version I signed off had white snow. I am both cross and upset as there is nothing now I can do about it.

Also received an email from my Steward, whose family comes from Lapland. She was eulogising about the way I have captured the true colours of snow in Lapland at that time of year, a scene so familiar to her, and it brought back emotional and poignant memories. She talked about her sleigh rides through the blue snow, under such a sky, across frozen lakes and when they drill holes in the ice with at least two litres of vodka to help them. It was all so brilliant. She said she is going to frame the card! She says nobody hitherto has managed to capture on canvas the exact blue that I had managed to achieve. I said, 'These things don't just happen. I spent a long time determined to capture the very essence of that special scene.' I think she believes me.

5 December

Still thinking about how I mixed my palette and captured the blue of the Arctic snow. The only time I have been to those parts was at the invitation of a Marquess whose family once owned, it seemed to me, most of the North Pole but who was now on rather hard times, and he was a one legged divorced alcoholic with a three legged dog. Consort says I only befriended him because he was a Marquess. Does she still not know me? My friend Charlie, the Marquess, set up a company to take business people to the Arctic and enjoy huskie driving and other snow centred pursuits, and in so doing, help colleagues bond. He wanted me to go as his guest in the hope that I would subsequently recommend the experience. At the end of an enjoyable time, he awarded

me the overall trophy, which was an embarrassment and clearly undeserved, although I did, albeit inadvertently, take my sleigh over a large hump, landing successfully with the help of the lead huskie, which kept looking round to reassure me, and I was told that it was a skilful manoeuvre. I was completely out of control. The last time I saw Charlie, he was rather focused on the difficulty he had had that morning flying down from his last castle in Scotland – Robert Burns was once a tenant of his family – when he couldn't get through security because his artificial leg was in his overnight case and it set off the alarm. He was the head of the Kennedy clan worldwide but unfortunately fell off a platform in Kentucky and was banned. He once sat on President Eisenhower's knee as a wee lad; Culzean Castle, one of his then many castles, had a grace and favour apartment for the American President. Charlie once asked me whether the RSPB's offer of, I think, £2 million for Ailsa Craig off the west coast of Scotland for the gannet colony was a good deal. I said I was a bit weak on pricing craigs and gannets. He needed the money, so I said, yes, go ahead. I was used to him seeking my advice. If he had a potential Marchioness in tow, he would introduce her to me for my opinion. I think I saved him from a fate worse than death on more than one occasion.

Re-reading *The Spade*, our livery magazine, reflecting on the earliest part of my year, realizing that our magazine is as good as the other livery magazines, if not on occasion better. A remarkable achievement. The editor is Upper Warden and

intends to continue as editor when he is Master. Devotion indeed.

6 December

I once saw a plaque, 'On this site in 1745, nothing happened'. Today, for the first time since becoming Master, there have been no emails about the livery.

One Past Master told me that immediately after he'd finished being Master, emails dried up. He asked the office whether they had lost his email address.

8 December

Decorator in, calls me 'Sir'. When I go to the City, I am called 'Master'. Getting used to this!

9 December
DICKENS FESTIVAL - ZOOM

A bit of a logistical, technical disaster.

The idea of my Steward, who, along with others from the livery, are Dickens fanatics. Known to dress up as their chosen characters, an alter ego, and then doing something to perpetuate the name of Dickens. The evening involved the great times three grandchildren of Dickens, the Senior Curator of Gad's Hill, his former home, and members of the Dickens' Fellowship. But the zoom and the slides somehow didn't quite go according to plan and as we are again in lockdown, it was the only means of having a Dickens'

Christmas. I was told repeatedly that Dickens invented the modern Christmas.

There was a vague horticultural connection. Dickens loved vivid red geraniums, pelargoniums, reflecting the splashes of colour in theatre. The red geranium, being his favourite, is the emblem of the Dickens' fellowship. Also Dickens referenced gardens in his many books; in *Sketches by Boosey*, a matter of constantly being in the garden, I haven't read it, nor most of his books despite once living in Cobham in Kent, and my local being where Dickens would sit and read the latest instalment of *Pickwick Papers*, which he had composed whilst strolling across from his home nearby in Rochester. Dickens' books frighten me. Dark, sinister tones with a rich overlay of social connotations. Great stuff, but not entertainment for me.

According to his family on zoom, Dickens was inspired not only by colour but by shade and architectural structures, a restless, creative soul, his mind always at work. He reflected on what made a good space in the garden, even consulted in 1851 the Gardeners Benevolence Society when creating his own garden at Gad's Hill, sadly now, only a shadow of its former self but nevertheless today enjoying something of a renaissance. He met Joseph Paxton of Crystal Palace fame and sat on the same gardening society committee. He would walk 12 miles seeing what he called, 'The Great Garden', supplementing this with travel on the Continent and to the US, viewing diverse flora. He realised that gardens can influence the emotions of his readers and that

neglected, decaying areas added atmosphere. In *Nicholas Nickleby*, the poignant combination of the grave with grass and fresh flowers resting on the stone had a magical effect. Christmas for Dickens meant redemption, renewal, the joys of nature welcomed into our homes, a grove of berries, perfect transformations. Actually, I am beginning to like him. He especially liked ferns, the trendy 'in' fashion plant of his time. Kept adding to his garden, saying, 'Positively the last improvement.' But cruelly, perversely, he finished the garden just two weeks and two days before he died.

Dickens and white Christmases reflecting his youth, with the vivid portrayal of Christmas Past apparently is bollocks. Snow covered, deep winters were not common in his childhood either. But the memory of the Frost Fair in 1814 when the Thames froze over, might have had an influence – although he was only two years old then. *A Christmas Carol* was written in a mere six weeks. He said there was no point in having a government report to highlight the problems of the poor – a book would be more effective. The book was a great success. He had to partly self publish, paying for four full page hand-coloured steel engravings. Marley's Ghost gives me the creeps; cast a deep shadow over my childhood.

Despite the technical blips, as jolly an evening as one can have with Dickens, rounded off with a virtual toast and certainly a big privilege to be in the virtual company of two people who had Dickens blood in their veins.

11 December

Future Gardeners graduation Bankside Open Spaces

The building has many uses, a real hub in a deprived area near Waterloo. There are no longer Youth Clubs of old – why not? This venue acts as a safe environment where the young can chill out. Many events held here in a typical week/ month: Tropical Salsa, Afrobeat, Brazilian Fantasy Dance, Karate, Hop Hop, band rehearsal, Catalan choir, Swing Control 40s–50s era, Game End's Dance, children's after-school clubs, learning difficulty groups, youth football, Kids dance class, street dance, London Ambulance Service training and dance, Unison trade union branch, Green Party for lock down, venue for kids parties, West African, Bulgarian, Korean and Austrian church services.

No government funding. Indeed Lewisham Council wanted to close it and board it up five years ago, which would have cost them money to have done so. One person's initiative kept it open, and now all these offerings to a diverse and needy community, saving lives and saving money and the Council, undeservingly, even makes money from it. Admittedly, the Council do give a little back, but the centre still pays the rent and utility bills.

Five offices upstairs: Jo Fox Foundation, Free to be Kids (children's charity offering residential trips and counselling), Human Trafficking Foundation, Hong Kong scheme to help those leaving Chinese repression in Hong Kong. A venue for girls in Lambeth to hear talks from the Israeli army, a sort of SAS division, on how to protect

themselves. The centre opens its doors from 8am to 11pm seven days a week and sometimes even earlier if there is a need. One boy, known to many, stabbed to death, gang warfare, his wake was held here in 2018. 300 attended, nowhere else in the vicinity offered a venue for fear of reprisals – there were none. Killed in July but not buried until the following September.

Muscular Dystrophy party held here yesterday and today our Future Gardeners graduation. I gave out the certificates to 14, the maximum we can accommodate on each course. Our gardeners have helped renovate the adjacent park – Millennium Park – which was allowed, soon after being established and having spent public money with no aftercare management scheme in place – to quickly degenerate into an area full of needles and dog waste, a place to sleep rough. Now a splendid oasis with ponds, a green space to enjoy and be proud of. No Anglo Saxon names among the 14 who were graduating, except one who was Chinese.

During their course, we had taken them to gardens in Devon and Cornwall. They loved it. Also helped by the Tree Council which pleased me. City people experiencing country life.

Asked before I became Master about Future Gardeners in order to become more familiar. One course participant had gone to prison. When due out, social services asked who would be welcoming him, 'no one' was the reply. No one even knew he had been in prison, no one apparently cared.

Eventually, it was ascertained he had been on our course. He was able to resume the course, and this was his passport to a new life – he is now a qualified and much respected gardener. A feel good story. Another in my briefing had said after getting his certificate, 'Now I have this and a job to go to on Monday morning, but without it, I would be dead by now.'

Over 70% graduate successfully. Our record improves annually, and all could get jobs if they wanted them. Compare that with Southwark Skills, a government scheme for bricklayers where only 30–40% retention and get jobs. And ours, unlike the government scheme, for the participants, is totally free.

After receiving their certificate, I asked each to say a few words. Painful for some, a struggle for most, a real challenge, but they all got through it – well done them. One said in the future she wants to, 'Grow gardeners.'

A speaker employed at the US embassy, who was previously a gardener at Leeds castle, spoke of the benefits of networking. Early in his career, he had met the then US Ambassador. Later, used that connection to join the staff at the US Embassy at their residence in Regents Park, a lovely stately home with a 12 acre garden in the heart of London. He was instrumental in creating a wonderful garden there and in establishing a new garden around the newly relocated embassy at Nine Elms when it moved from Grosvenor Square, with the theme of grasslands of the American Prairies. He said gardeners never retire, they

merely feed their runner beans. The moral of all this, he emphasised, is use your networks, and I reiterated this to the graduates, encouraging them, pleading that they keep in touch; we might be able to help later in their careers. Over tea, I said to one of them that I wished the embassy had moved sooner, when I worked almost next door. Chanting protesters outside on a regular basis, always wanting something from the American government, and once I went out to the official and said, 'Please give them what they want – independence or whatever, and let us have some peace and quiet.'

15 December
CAROL SERVICE

Today would have been our annual carol service. It is sad that we had to cancel it. Being so near to Christmas, people might catch Covid and disrupt their Christmas plans. I always enjoy it when our Hon Chaplain splits us into three groups when we sing 'We Three Kings.' Each group takes the part of one of the kings: Casper, Melchior and Balthasar. The criteria of testing is unfathomable, the outcome unchallenged.

At least, so far, this is the only event in my year cancelled due to Covid. Last year, the carol service was recorded in September in the church; we came out afterwards into the bright sunshine. It must be similar for those who act in Christmas TV commercials. They would have been recorded earlier in the year, perhaps in summer time?

I needed a visit from the Holy Spirit at the carol service. Yesterday, asked to do a food shop, came back, unloaded the first item. 'Why did you buy that?' 'Because it was on your list.' Second item from the list received the same way. I had found an old list in a pocket and used that.

We hold the carol service each year at St Stephen's Walbrook, the Samaritans church, just behind the Mansion House. The original Samaritans telephone is in this church, in a glass case. Made me reflect on the work of a great friend who volunteers for the Samaritans. Formally number two at London Underground, had experience of suicides on the Tube, badgered Network Rail to advertise the services of the Samaritans at stations, and this has been a hugely beneficial and instant success. The founder of the Samaritans went to my school, fortunately knew his son, who told me when he was a child the telephone rang, his father was on the phone for at least 45 minutes hardly saying a word, the son asked what that was about, the father said 'I was helping somebody in distress.' But you said very little.' 'I was listening and in so doing I was helping.'

23 December

Briefly looked at the pile of Christmas cards from other Masters. Some specific to their livery and all greatly cherished. One was of a snowy Chelsea Hospital, which reminded me of the occasion when I visited and was told, when standing beside a bench with a statue of a Chelsea Pensioner seated, that a member of the public, seeing it

through the railings covered in snow, thought a Chelsea
Pensioner had fallen asleep and needed rescuing.

One card from the Company of Pikemen and Musket-
eers, a photograph of members assembled for their post-
lockdown day at Armoury House. A fine cutthroat lot of a
certain age.

Other cards from the Worshipful Company of Horners,
of Glass Sellers of London, of Blacksmiths, of Wax Chand-
lers – on their card was their Company Grace, composed
by a former Wax Chandlers' chaplain in the 1980s and set
to music by a pupil of the Guildhall School of Music and
Drama:

> *For thy creature the bee*
> *The wax and the honey*
> *We thank thee, O Lord,*
> *By the light of all men*
> *Christ Jesus our King*
> *May this food now be blessed*
> *Amen*

I noticed that most of the Christmas cards had secular
images. We live in strange times. I recently popped into
Waterstones in London, and being near Christmas, I sought
one or two religious books, only to find that religion is
tucked away on the third floor and on the ground floor,
the principal floor, is devoted to indoor games and horror.

Tractor calendar for sale. Takes all types.

4 January

Wanted space, despite a happy Christmas, a sentiment no doubt shared by others. A long brisk walk across the lovely adjacent countryside adorned by village and church, woodland and country lane, unbelievably only seven miles from the nearest Tube station. I was trying to work out whether to incorporate some supposed misprints in my Mansion House speech next month. I had them in my pocket and could say them out loud to the wildlife which had either not migrated or had hibernated. Richard III 'Ponces in the Tower' should have read, of course, 'Princes throw in towel'.

What a contrast between this cold but lovely winter morning and what it's like to stand up in a great livery hall.

I remember a businessman once told me that he had made the main speech at a major conference in Birmingham in front of an audience of over 500. The following week, he met a delegate who asked him if he had attended.

Will anybody remember me the day after my successor's installation?

10 January

Quite frequently, I get emails from members of the livery who have seen an interesting horticultural story. Kind of them, and always welcome. One email today informed me that hedges were planted in 18th and 19th century South Africa and have become in themselves a legacy of

the colonial era of the Dutch and British, that they define a space but also keep out a neighbour or an unwelcome person, and often the latter in practice meant a black person.

A few days ago, I was told about a colony of rare orchids growing on a rooftop in London – a small flowered tongue orchid, the first time seen in the UK since arriving in Cornwall in 1989. It originates from the Mediterranean. Apparently, there are 15 of these growing in Nomura International's 11th floor roof garden, which constitutes the entire known wild UK colony of the species. How did they arrive? Maybe over the Channel on southerly winds which also bring Saharan dust deposits to London. What happens next? Once on that roof, the seeds would have formed a symbiosis with a mycorrhizal fungus enabling them to germinate. Quite extraordinary, and whilst possible, the odds against it happening are astronomical, yet how else did they arrive and flourish? The world of plants is incredible. A friend, who was on the National Trust Council and was visiting North Wales with them, noted a peculiar wildflower and was told that the seed would have got embedded in the tyre of a long distance truck from Eastern Europe, where the flower is native and then deposited here and has germinated.

Another fellow Gardener told me recently in an email that the best English garden tools were made between 1900–1960, that French ones excel in ingenuity and quality and that the Holy Grail is the patent nickel-plated articulated apple picker. However, if you want to collect

garden tools, the golden age is passing as supply has virtually dried up and prices are rocketing.

11 January

Invitation to a curling event. 'As close to snow and ice as you can get in central London', was the wording. All part of the Livery Curling Championships, organised by the younger members of the Ironmongers. An event open to all ages. The venue was the Langham, Portland Place. 'No experience is necessary; in fact, experience would be frowned upon!' Alas, I can't make it.

12 January

A request has come from my old school for news about old girls and boys. Can't wait to tell them about the Mastership. Recently made a mental note about a van parked near Guildhall. British Blinds and Shutters Association. I can see it. News from old boys, 'I have recently become President of the British Blinds and Shutters Association.' I bet he never showed promise at school, a true inspiration to the next generation.

14 January

Company Catch Up on zoom – a clever idea of my predecessor. Again the members' survey – do we offer what they want – choice, duration, cost, location, variety etc? I receive the magazines of other liveries and some have carried out similar surveys and have received similar feedback. On the whole, costs are rising too quickly, there is a reluctance to

travel at night, perhaps because of the age profile especially in the case of our livery, or to travel at all, due to recent lockdowns. We discussed the remaining events scheduled for my year, for example, celebrating the Platinum Jubilee and routine matters, such as when to be face-to-face and when to have a zoom meeting. Decided that the first in a cycle would be the former, in order to get to know each other, and thereafter mostly zoom, but with Court always to be face-to-face. We discussed the website, the changes to the charity board constitution, and informing the Company where and how much charitable giving is allocated.

15 January

Chantilly

I've just raised with the Clerk whether we should consider bringing back our hitherto annual visits to Chantilly – sadly paused because of Covid.

Not solely in my hands, this will need to be discussed. It became a tradition for the Master and Consort plus a few others to attend in early summer, for a couple of days, a flower show and dinner at which the Master would present the prizes, making the address in French. I would like to go, even though I can't speak French, but fortunately the Consort can. She would write the speech and I would mangle it.

Annually we would present the Ostrich Egg Cup and being a silver ornament made in 1809, decorated with the Company crest, we would quickly reclaim it.

The event was held originally at Courson, then, thanks to the Aga Khan and his younger brother who is now a liveryman, was moved to Chantilly in an attempt to give it a boost.

18 January
GUILDHALL GALLERY

Popped into the Guildhall Gallery, a favourite of mine. Looked again at the five stained glass windows, each given by a different livery (one then still a Guild). One is from the Gardeners. I always think ours is a bit wishy washy, but nevertheless a proud moment to stand in front of it as their Master.

Engaged in conversation in the shop. I was asked what was my favourite picture in the gallery. I was caught out there as I like many of them. I chose Millais' my First Sermon, it is one of a pair, and both are equally arresting. Those two portraits are rather like the Pears Soap ones of that era. All those flawless, matchless little innocents – probably some later divorced, others gained criminal records, others conceited extroverts, possibly a splattering of kleptomaniacs. I may have even passed some of them unawares as they dragged their overweight selves along some bland thoroughfare. Or are they ageless examples of the best? And hers, I asked. That of Clytemnestra. Fine, but she had a bit of explaining to do. Clytemnestra was the sister of Helen of Troy. She had killed Agamemnon, her husband, on his return from Troy after a ten year jaunt.

As I was leaving, I said she didn't look as pretty as her sister, Helen. 'How do you know?' the assistant asked. I don't, of course. The assistant said she could have done similar to what Clytemnestra had done. In her case, to the person who had killed her cat and didn't report the incident. How long ago did this happen, I asked, ten years as with Troy? 'No, 20 years ago.' She had harboured a vengeance for twice as long for a cat as Clytemnestra had for Agamemnon.

22 January
METROPOLITAN PUBLIC GARDENS ASSOCIATION

Zoom meeting. It seems I am a member ex officio and often a Vice President of a number of worthy organisations, this one doing good since 1882. These positions seem to appear unexpected and on a regular basis.

While we were waiting for the zoom meeting to begin, I noticed a particularly interesting painting depicting the wild west on the wall behind one of the attendees. The delay before the start of the meeting was long enough to enquire about the painting and to be told that the painting had cost her more than she had planned to spend, so the artist had lent it to her and then she bought it and has been grateful and pleased ever since. I said I had seen a painting in Harrogate 40 plus years ago and still regret not buying it. It's probably more beautiful in my memory than in reality. I mentioned the paintings that a colleague and I had bought from Rolf Harris, the disgraced performer and painter. Their value had gone up and up, but at the time of selling

the company, they had crashed to almost nothing, despite maintaining their technical standard. On a happier note, I mentioned how we had acquired three commissioned paintings. A colleague had seen a painting on a wall in the City, asked who painted it, was given the name, came back to me and said it seemed a familiar one. It turned out to be the deaf son of our office cleaner. He painted scenery for the West End stage. We still have one of these paintings now at home. The others were stolen in the brief moment when our office doors were open and we were moving.

We were bought to order by the chairman.

31 January
GARDENERS' COMPANY GARDEN IN GUILDHALL YARD

Cold morning as we assembled in Guildhall Yard for the official opening of what has been, in recent years, our special contribution to the event, the unveiling of a temporary garden which will remain in place until the spring. Was duly robed at Ironmongers' and walked to Guildhall, hoping nobody who knew me would pass by. No longer feel so inconspicuous thus attired, and that in itself worries me.

Whilst waiting for the dignitaries, I mingled with the many other Masters. The Master Needlemaker said his Master's present at his Mansion House function, which he has kindly invited me to, will be a needle set with their logo, but with last year's date because his year was delayed due to Covid. He said it will be a rare item and worth selling on

eBay. I do the darning at home, even made clothes for my daughter's Cindy dolls, so I will cherish the present.

One Master said she had been a local councillor and proceeded to take me through what seemed like the deliberations of the many committees she had sat on. I mentioned that I had once been a local councillor, and because she was rather keen to talk about herself, I said that I had possibly been the youngest councillor in the country at the time. I was asked by one constituent to look into why a bus stop had been located outside her house and consequently those on the top deck of a double-decker bus could see into her bedroom. Beauty is in the eye of the beholder, but I also had an eye on re-election and investigated the bus stop issue with great focus. The only other event I could recall from all those years ago was that I got an additional railing installed so that the lollypop man could usher the young children safely across the road and that I probably saved half the next generation of little Rugbeians from being squashed. Indirectly, and as a consequence, I might have been responsible for the massive house building currently going on around Rugby in order to accommodate all these children I have saved.

Met the chairman of the Woolwich Garrison Church. Also met the President of CBI. Told him that I had worked there and, surprisingly, had been the youngest director they had appointed by that time. We both agreed that his predecessor was an outstanding businessman, and I said that he was one of only about 20 whom I rated sufficiently

to be a guaranteed success on any troubled board in any situation, business cycle, sector or size of company. Spoke to the Master Musician, this one a former Dean of St Paul's. We reflected on how rapidly the Square Mile was redeveloped and that this was ever the case since the earliest of times. Having been away from London because of lockdowns, both of us noted some changes. We reckoned that the City was largely redeveloped every 50 years or so, sometimes due to bombings but mostly by choice, and that archaeology can show this pattern and story, like peeling an onion revealing its different layers. The Guildhall itself is over the site of the Roman amphitheatre.

Talking to many Masters, it was fascinating to learn the variety of approaches adopted to accommodate the lockdowns and whether a Master who was unfortunate enough to have his/her year largely cancelled should have a second year added on. One next to me had only three months of his Mastership active. He then handed over to another who had been earmarked for some time to be the Master for their 450th anniversary celebrations and then the Master whom I was talking to would resume to complete his full year.

Now the dignitaries arrived, the Rolls-Royce with the Lord Mayor, the Hon Artillery Light Cavalry shuffled into place. They have two troops, mounted and dismounted. Too expensive to bring the mounted here today. I think the real reason was, despite reminding me of Don Quixote, the mounted were at this very moment galloping across

Europe to defend the Ukraine. Any seismic qualities, if they ever existed, were either well disguised today or were long since extinguished.

Our garden looked splendid, designed by the same person who designed our centenary garden in Welwyn Garden City.

Had my picture taken with the Lord Mayor and Lady Mayoress. I commented on her stunning green outfit. She said it was Donegal green tweed.

The gardens were formally opened but not before a long speech by someone who, despite being briefed, mistook our disease resistant elm for a disease resistant ash. Such a plant doesn't exist.

4 February
THE INTERNATIONAL GARDEN PHOTOGRAPHER OF THE YEAR AWARD, KEW

I was one of the first guests to arrive at Kew. Spoke to our team in the Marianne North Gallery. The gallery has an interesting history. The said Marianne, stimulated from childhood to show interest in all things horticultural, visited Kew with her father – the family knew Darwin and Joseph Hooker.

Her father said, 'Come and give me a kiss, Pop (he called her that). I am only going to sleep.' But he never woke up. That was in October 1869. She then became a recluse, went abroad for 15 years in order to paint all things botanical, horticultural and the occasional native. She had both

the money and the means. She painted one thousand pictures visiting Borneo, Australia, Jamaica, Java, America, Singapore, Japan, Seychelles, Tenerife and New Zealand and also painted 'sacred plants of the Hindus'. She travelled 'alone', i.e. with no companion. Her signature was always hidden away in her pictures, for example, on a rotting log. In the gallery, there are over 240 different panels and varieties of wood covered and adorned by her paintings. All this artwork was completed within 20 years. She mixed her pigments herself.

Some of the plants depicted are now extinct, others discovered by her paintings. Five plants are named after her, the latest as recently as last year. Her merchandise in the Kew shop, including her books, are always in the top two of their overall sales. Some plants depicted by her are still not named despite Kew's vast collections. Her book 'Recollections of a Happy Life', in two volumes, is apparently a great read.

She paid for the gallery we were in and saw it completed in her lifetime. The only additional item is her bust given by her sister, as Marianne was possibly too modest to suggest such an idea.

It is necessary to take the paintings off the wall on a rotation basis in order to check for possible damp and condensation behind. If not done before the time the damp appears, then too much damage will have been done already.

Wilfred Blunt dismissed her as second rate and insignificant and this constituted a major setback for her reputation. It didn't help that she was a woman and also

that most of her work is in one place, this gallery, with the remaining 10% at the family home, so there are precious few occasions when the general public can be introduced to her marvellous work.

And now to the photographic ceremony. The Director of Kew had Covid so couldn't do the honours. One of the event's organisers was called Victoria Kew. Another organiser, one of the Gardeners, said that the Duke of Marlborough wants to meet me. I must remember.

Blind judging competition with entries from 20 countries, 20,000 submissions in all and the winner, Magdalena Wasiczek, had claimed the prize twice previously and yet had not entered in three of the last 15 years.

Spoke to one of the judges, a former editor of *Amateur Photographer*. He said it was easy now to get the technical side right with modern mobiles/cameras; it is the presentation that differentiates between the ordinary and the outstanding.

I didn't wear my Master's badge, and one of the judges, therefore, didn't recognise me and when he realised who I was said I was obviously very modest. Actually, nobody had briefed me to wear it.

Today's *Times* showed one of the photos but failed to refer to the exhibition itself.

Was told that the *South China Post* covers all such events from Kew.

How judges could pick an overall winner beats me, but certainly the one which was chosen, 'Stardust', was extra-

ordinary, of a butterfly on a stem that somehow touched all the senses.

7 February

Dinner at Drapers' Hall – motto 'Unto God Only be Honour and Glory'.

Consort didn't attend. She had lunched at the Mansion House with the Lady Mayoress and 17 others. She told me that the Lady Mayoress's labrador greeted the guests and spent the lunch under the dining table, resting its head for a few minutes on the knee of each person in turn.

I spoke to one Master who had slept rough in Guildhall Yard the previous night in support of Whitechapel Mission. I question whether sleeping rough in that way can really give the person a true taste of how ghastly it must be for those who find themselves with no other option, and will not return the next night to a warm bed. The charity offers a day refuge for over 300, doors opening at 6am giving them a hearty breakfast. Some of those seeking the charity's assistance had been successful City types, others were bankrupts.

Drapers' Hall is on the site of Thomas Cromwell's former home. Over 300 present at the dinner, and I was flattered to be next but one to the principal guest. The hall has been recently refurbished. Such a shame I couldn't have my Installation dinner here as planned but it was uncertain when it would reopen. I discovered this evening that the Drapers had decided to close the hall until all work had been

completed, as it was so complicated and, in so-doing, saved over £100,000 on scaffolding. A huge and lovely hall with a garden that complements it, an especially striking painted ceiling which was rolled up in the Second World War and was deposited in Wales for safekeeping. Apparently, used over 70,000 sheets of gold leaf and seven and half miles of scaffolding to complete the refurbishment. Obviously, there is money to be made in converting wool into cloth. I must see if any of them have grandsons of a similar age to my granddaughters.

During the refurbishment, they found a cannabis plant in the basement. I have often wondered how we Gardeners got our supply of herbs we present each year to the Lord Mayor and Lady Mayoress on Lord Mayor's Day. Now I know. I hope they didn't turn our posy, therefore, into soup as suggested. Doesn't bear thinking about.

Master Draper mentioned that he had a friend of sixty years present. I said I was seeing a friend at the Mansion House next Friday whom I have known even longer and we both agreed how special such friendships are when we still have something in common.

Sat between the Mistress Draper and the Master Pewterer – judge at the Old Bailey. The Master Pewterer was worried about being here because of Covid with a husband who is over 80. She spoke of her desire to get dual nationality – a sure sign she was a Remainer. Said the Portuguese were feeling guilty that they had expelled the Jews in the 16th century, sending them off to Constantinople, and were now

offering dual nationality to their descendants if they can somehow prove the legitimacy of their claim.

The Mistress Draper, it turned out, is an enthusiastic CPRE supporter, so we instantly had much in common.

Turned back to my Pewterer, and we chatted about pewter, how one can make practically anything out of it. It's easy to melt down, therefore, much has been destroyed, and so there is little that is old that has survived; over time made into jewellery, tableware, artwork, plenty of uses and adaptations. She told me that pewter is made from a combination of tin from Cornwall and zinc, that it is not wise to have pewter drinking vessels, although once fashionable, it can kill. Not universally regarded as a beautiful material but it has a certain fascination. The Lord Mayor often takes pewter as a visiting present. In her day job, she presides over young offenders' cases, mentioned that the offender often didn't care what their fate would be, but she reflected at a personal level how tragic most cases were. I got the feeling she disapproved of many of the punishments meted out, even some she had to administer. Frequently they are not the solution, just adding to the problem.

For lighter relief, turned back to the Mistress Draper, day job Oxford University Development Officer for donations of £2 million and above; apparently, there are plenty of them, some exceeding £100 million. I asked whether a wider distribution of funds, therefore outside Oxford, might be more beneficial. She said having a few centres of excellence

is an advantage, but they do, on occasion, redirect to other centres of excellence.

I was aware that my Pewterer friend was keen to confide in me. She almost whispered that she had a problem. I was flattered that I had won her intimate confidence. She had bought a house in Kent. All looked great on that day, but it suffers from badgers, and as a Gardener, did I know the solution? She had already been advised that her husband should pee into the sett, and that would do the trick. Apparently, it didn't. I said, of course, I would think about it.

One of the speakers said, 'In life, it is a matter of which bridges to cross and which to burn' – rather a nice phrase. He said the Queen is a Draper, hence her portrait in the hall. I thought I couldn't mention that Prince Edward is a former Master Gardener. I seem to mention that to every other person every other day. I did mention, however, the occasion when I had asked Prince Edward after a committee meeting what it was like to learn the history of England and often, therefore, about his relatives, for example, Edward III. 'Never knew him,' he said. It made me feel rather silly.

After dinner, adjourned for a stirrup cup, went via the Gents. Cartoon there by H.M Bateman 1929; it could easily have been of this evening's event. One Master in the Gents, for no perceived logical reason as far as I could make out, asked me whether it was right or not to pronounce Margot like harlot.

Having escaped this, spoke to the Master Glover over the stirrup cup, who told me that gloves were not quite as well made today as they were in the 17th century, detail better then than now. Said gloves have new purposes in the contemporary world. For example, some need to be tough enough to be knife resistant. Then spoke to Master Glazier, or was he the Master of the Honourable Artillery Company? I was not sure at this stage of the evening whether the former was soon to be Master of the latter if they had one, or was he a Past Master of one or the other. All a bit confusing. He had an interest in guns, that I remember clearly, said that he is a dealer in antique weaponry and if a film such as 'Braveheart' is released – never seen it but I know it's historically inaccurate – he gets a spike in demand for old weapons. He is prepared to drive to Switzerland to buy one piece of stained glass, usually for a client, but often cannot part with the item and his house is adorned with stained glass windows. I asked him why he wished to be involved in more than one livery. Because he gets one free meal a year. Spoke to one Consort; her son was a keen rugby player. He had made a poor speech at a school occasion due to being underprepared and had therefore learned the hard way. Now he speaks well and just in time for his era of best man appearances.

I left late but happy, a little unclear who had said what and when, concluding that I respect many people but that I am in awe of none.

11 February
GARDENERS' ANNUAL MANSION HOUSE DINNER

Consort and I were kindly driven to the Mansion House by the person who has been helping me so much from day one and who lives locally; a great convenience to me, not least because I was giving a copy of my new Housman book to the guests, and I had several large boxes of books to take into London. It is a tradition that the Master gives a present to the ladies. As I was giving a book, having cleared the suggestion with the Clerk, I thought it appropriate to give one copy to each couple and one to those coming alone, whether male or female. The tradition has cost me a cool £1000.

We had debated the costings for the flowers as numbers were down for this event compared to previous years – Covid, no doubt. We had a solution; the Lord Mayor had entertained archbishops and bishops the previous night, and we requisitioned their floral displays. A nifty coup.

I sat beside the Lord Mayor on the long high table. We talked about his distinguished office, how he was its custodian, rather like owning a listed building, the aim being to preserve or even enhance the legacy. He said he would be off to the US and Mexico in the morning, flying the flag. He said the first occupant of the Mansion House insisted on taking up residence even before the building was complete. The Irish Prime Minister visited him the other day, and Ireland was playing England in the Six Nations, and

it was a struggle for them both to keep a balance between watching the rugby and talking about matters of state. He said my choice of menu for this evening was surprising, only in the sense that despite the wide choice, most Masters seem to plump for the same one or two options. Not apparently me on this occasion. He whispered that they were all waiting for me to start the meal. I had no idea about this ritual. I picked up my knife and fork, and, as if by magic, everyone started eating.

Now eating, I said it must be difficult for him to keep fit with so many functions, lunches and dinners, saying it is bad enough for me this year as a mere Master. He agreed and said that he had been looking at the record of the last 20 Lord Mayors, noting that some had already died and that few had reached their three score years and ten. He's married to a nurse, so I think he'll be alright. He said he had met his wife at the races in Ireland. I didn't ask if he was a winner at the horses. He was certainly a winner in other ways. I related that my former club, the Savile, had once sent out a questionnaire on what members might want more or less of, and in response to the suggestion of having a fitness room, a member wrote, 'I did not join the Savile to become fit. In fact, quite the opposite.'

We talked further about his great office. I mentioned the times when the electoral system in the City was abused. I gave one example – there was a candidate for high office, who, on being accused of pulling the plug on the beer barrels, which were used to exhort the undecided voters, said it was the housekeeper who did it.

The dinner was the second time that the Consort had dined at the Mansion House in a week, and we will be dining there again next week.

One of my principal guests has had a sparkling career, her CV being added to on a regular basis. She had been Chief Executive of CPRE, Director General of the National Trust, a governor of the BBC, Master of Emmanuel College, Cambridge, etc. She came from Rugby, my home town, went to the same school as the Consort. Apparently, the National Trust gardens are more popular than the houses. We reflected on the current trend to give a precedence to women over men and state schools over private. She had insisted on face-to-face tutorials as soon as possible after the Covid lockdowns were lifted, unlike some colleges and other universities.

Another of my guests was the editor of *Country Life*. I asked him if he feared running out of buildings to cover as a weekly feature. No, there are 10,000 such buildings to consider, and he could revisit those already covered as each generation will view a building in a different way. We spoke of the artist Eric Gill whom it was revealed recently had an awful sexual history, abusing two of his daughters. My guest said that he hoped and believed that his readership could differentiate between the man and the artist. He said he had, as editor, great editorial freedom. I said that his readership, which is expanding unlike in the case of most other magazines, has great expectations. He agreed. He has added to the legacy of his successful predecessor, who was also present tonight.

I reminded him that he had once invited me to his then office in London, a recreation in a modern building of the original editor's iconic office. Now that *Country Life* was produced without the need for staff to be concentrated in one place, this office furniture was to be sold. I asked what would happen to the table and chairs designed by Lutyens, which were of great historic and aesthetic value. He said they were to be sold by the new owners, an investment house. I mumbled that they were selling the family silver, and it was typical, lamentable, even contemptible. I think he agreed, but he was too diplomatic to comment.

On an earlier occasion, he told me that even his staff look, perhaps enviously, at the property adverts in their magazine: Grade II*, beautiful, elevated setting, outstanding views, rare opportunity, of 17th century origins, recently refurbished to the highest standards, landscaped gardens, outbuildings, private woodland, fishing rights.

Turned back to the Lord Mayor, who told me that part of his regalia almost certainly once belonged to Sir Thomas More in the 16th century and that the chain of office was especially heavy. I said it reminded me of the Queen saying that the crown at her coronation was very heavy. The Lord Mayor said his regalia survived the Great Fire simply because the Lord Mayor was wearing it at the time. I wonder if the then Lord Mayor was also fortunately wearing the regalia in the Blitz.

A further chat with the Master of Emmanuel; her students now prefer online lectures, which they had used

during Covid. They could replay the session if they had missed it or reflect on it further.

In his speech, the Lord Mayor started by saying that the Lord Mayor's Banquet at the Mansion House, a long established annual event, at which the Prime Minister delivers a key note address, had not taken place for the last three years. This was due to a combination of a General Election in 2018 and 2019 and Covid last year. He was much more fortunate than his immediate predecessor who, despite continuing in the role for two years rather than the customary one because of Covid, was still only able to enjoy his first face-to-face event in the August of his second year. Apparently, the only other recorded time a Lord Mayor had extended his tenure in the last two hundred was in 1852 on the death of the Duke of Wellington and in deference to the great man.

He cleverly referred in his speech to a special relationship between the City and the Worshipful Company of Gardeners, saying that we shared a common language – 'seed fund', 'gardening leave', 'hedge fund'.

My speech:

'Lord Mayors are getting younger. Mind you, not as young as Dick Whittington in our recent pantomime. Couldn't have been more than 18. I happen to have a long association with the august office of Lord Mayor. When at prep school, one of the boys became Lord Mayor. He wasn't still a boy there, we leave at 13½ – he wasn't that young. So,

my Lord Mayor, if you need a mentor/confidant, please don't hesitate to ask me, and drop the 'Master', just call me 'Peter'. If you find that too casual, call me 'Master, formally known as Peter'.

Did you know that some plants have a memory span of up to 20 seconds? Flycatchers, for example. If you touch the hair inside their cup once, it is not likely to close thinking it might be a wasted effort, but if you touch it twice within 20 seconds, it snaps shut. I still find it difficult to reject an applicant to the Gardeners' Company, saying, 'Sorry, but you have a memory span of only 18 seconds.' Mind you, some plants seem pretty dim. Take the snowdrop, currently adorning gardens and hedgerows. It must be dim; it appears in mid-winter, dies back, and misses spring.

We could have a snowdrop category of membership of our Company: Liverymen, Freemen, Snowdrops. 'Great news! Daddy/Mummy has become a Snowdrop of the Worshipful Company of Gardeners', in their Christmas Round Robin.

I am sure that the Spectacle Makers, one of the liveries of the current Lord Mayor, has an equally challenging entry level. How many eyes does the average person have? Average is the operative word. A multi-choice question – one, two or three? Those tutored in exam techniques have a clear advantage. Apparently, my Lord Mayor, you answered correctly and first time – and without hesitation. One member of your Court predicted then that one day you would be Lord Mayor.

One of the great things about being a Master is that you meet the other Masters. They are all a great lot – not just your Master Gardener.

Master Girdler was in an agitated state when I last met him, telling me that the invention of trousers with pockets had destroyed his industry. I said, 'No! I'm so sorry to hear that. You will be in my thoughts.' Did he expect me to discard my trousers? Then, on further reflection, I said to myself he should get a life. After all, we Gardeners were chucked out of the Garden of Eden, but we don't go on about it.

A domestic matter for a moment. May I say how disappointed I was that my painting of Adam in the snow came back with blue snow, despite my Steward saying I had captured the essence of its colour in the light of the Arctic Circle. With Valentine's Day a mere three days away, I thought I might design a livery Valentine's card, but having just signed the Diversity Charter for livery Companies, I thought better in case somewhere in the small print...

As spring touches our gardens, I am reminded of Shelley's poetic words, 'It is as a goddess bending from heaven to kiss the forehead of the earth and bade the frozen streams be free.' I always thought Shelley was a bit soft in the head. Finally, as the vicar said to the gardener, 'Isn't it wonderful what God and the gardener can do together?' 'Yes,' replies the gardener. 'But you should have seen the state it was in when He did it on His own.' That is from

Country Life, two editions back, page 45 – check it out!
Their editor is here. I suggest you don't check any other
'facts' in my speech.'

In the Gents, which I visited, before resuming the after-dinner drinking, I spotted a notice on the wall that had been there for many centuries:

'Rules of this Hall
Swear not, lie not
Neither repeat old grievances
Whosoever eats or drinks in this Hall
With his hat on shall forfeit six pence
Or ride the wooden horse
Witness Usher of the Hall'

After dinner, one guest told me of the time when staying away on business, he had inadvertently locked himself out of his hotel room with apparently nothing on and wasn't sure how he got into that frightful situation. I related an occasion told to me by a member of my then London club, of when he was Private Secretary to an Archbishop of Canterbury, he had had a similarly embarrassing moment. He had accommodation at Lambeth Palace, was tidying up in preparation for his wife's arrival, and was caught in his pyjamas with a hoover in the corridor as the Archbishop and a Head of State went passed.

As I was leaving, an old school friend, the guest of another old school friend, came up and gave me an

affectionate hug. I said I wanted to clear my conscience. When we were both seven year olds, we would cycle to school together, but one day I had a new bicycle. He asked if he could ride it, and I said no. This has worried me ever since and I apologised tonight. We laughed. He couldn't remember the occasion, but it was, for me, like entering the confessional – I felt greatly relieved.

15 February

Terrible news. My great friend from school days who gave me the hug at the Mansion Dinner only four days ago has had a stroke, and his prospects are poor.

16 February
NEEDLEMAKERS' DINNER

This evening I was a principal guest at the Mansion House. Third time there in ten days for the Consort, second for me. The Needlemakers' motto could almost apply to my livery, 'They sewed fig leaves together, and made themselves aprons', referring, of course, to Adam and Eve. The original charter given by Cromwell, not recognised by Charles II at the Restoration and so granted a second one. Once had a hall in what is now Threadneedle Street, their arms being three needles, hence the street name.

At the reception before the dinner, met a person awarded a CBE for business in the community in Scotland, who was also chair of the Royal College of Surgeons of Edinburgh, established over 500 years ago and claiming to be the oldest

establishment of its kind in the world. Conversation with another; one of ten siblings, some had a poor gene dying young, others luckier, pure random chance. He will become Master of the Worshipful Company of Tobacco Pipe Makers and Tobacco Blenders. Surprised when he said that sales of both cigars and pipes were increasing. I mentioned that I used to pass the headquarters of the Pipe Association in Euston Road, long since vacated, along with, I thought, the habit of smoking pipes. He advises UK firms on military accuracy for films – someone has to.

Spoke to a couple who lived on the South Downs, had bought an ugly house, replaced it and found in their lovely garden a Roman villa when levelling the lawn. The villa was there because this now quiet spot was once the main pass through the Downs.

One male Consort present introduced himself as Mistress.

At the dinner, spoke to Master Spectacle Maker. He said 80% of the population of Singapore had poor eyesight due to too much time in front of computer screens and predicted it would also be the case here shortly. He wore a hearing aid, said he attended a concert by The Who in 1979 at the Apollo and that such concerts had affected his hearing and others of that generation. He said removal of cataracts is a relatively simple operation costing a mere £5. I mentioned that the Consort had had both eyes done and it cost a few thousand pounds. He said he had never seen a poor ophthalmologist.

To my left Mistress Needlemaker, former nurse, hoping to establish a livery for nurses. I asked why? Was there a need for a nurses' livery and how could nurses afford one? She said there was plenty of money in relatively obscure trusts which are no longer used for their original purposes and could be accessed. When successful, it would be the 112th livery company unless the Entrepreneurs get in before them and if they live up to their name.

To my right was the CEO of the Royal School of Needlework, set up 150 years ago to support women who might otherwise become destitute. She said in the 19th century, the Season was Ascot, the Derby and two sales of needlework from the Royal College, such was its status. They make the coronation robes. Technically, the robes belong to the monarch they are made for and not the nation. She said on one occasion in the lifetime of the College, needlemakers had to complete a robe in 48 hours, necessitating continuous stitching by 45 people and the finished item had to look as if it was done by one hand. I asked about the EIIR logo on the curtain at the Royal Opera House. She said when the time came, it can be replaced with the logo of the new King as only that section needed to be detached, even if it looks, because of the needleworkers' skill, to be part of the whole. Interestingly, she commented on Gertrude Jekyll, saying that Jekyll started her career doing embroidery and painting, but with failing eyesight, became a gardener instead, and she hypothesised that her famous colour drifts for bedding are a giveaway for poor eyesight.

Back to a discussion with the Master Spectacle Maker. He said not everyone has two eyes. I asked if they were cyclops. Apparently, some of us are blind in one eye. I said I once met a young man, captain of the England Men's Blind Football Team, who casually said to me that he was having both eyes removed shortly.

Principal Speaker General James Bashall, head of the Royal British Legion, said that the Armed Forces will not fail the nation, and the nation will not fail the Armed Forces. Stirling stuff. When the Royal British Legion was set up in 1921, he said a third of the unemployed were former soldiers begging – surely an example of the nation letting them down? He added that 1.75 million soldiers returned from that conflict with disabilities.

Left the hall with inspiring words about inspirational people tackling big issues, investing in a better tomorrow, and clutching my needles and thread.

22 February

My dear friend has died.

23 February

Today I received a copy of the City Livery Club magazine with the review for 2020–21. After the usual lament about cancelled programmes due to Covid, there was a piece saying Prince Philip was a member of Fishmongers and of Shipwrights because he had an interest in both because of his connections with the sea. It seems, from all accounts,

that had he not married who he did, he might, by sheer merit, have climbed to the top of the Royal Navy. When he attended his first City Livery Club event, he said, 'I was asked by my wife where I was going, and I said I was going to the City Livery Club, so she said, 'Oh, am I a liveryman?' And I replied, 'No, I am sorry that you are not. You are only a livery woman.' His wife's response was not recorded.

24 February
TACITUS LECTURE

Attended the 35th World Tacitus Lecture at Guildhall, named after Publius Cornelius Tacitus, born about 66 AD, who described 'Londinium' as, 'A town of highest repute and a busy emporium for trade and traders'.

Tacitus Lecture, this time around was all about our historical addiction to slavery. The lecture was well delivered, powerful, but biased. Not a good word for that period of history, for any of the benefits of Empire, no reference to the slavery conducted between black African tribes before the Europeans arrived, even Sir Hans Sloane was tarnished with the same brush, having invested in a commercial entity that in turn was involved in the slave trade. I asked myself how many of us sitting here had pensions indirectly and distantly associated with companies which cause environmental damage. There was no mention of emancipated slaves after the American Civil War wanting to remain with their former slave owners, or of others, when freed during the Civil War, became slave owners briefly themselves, nor of the

fact that England was the first country to abolish it. Plenty of comments about the debauched misery of the plantations, of the children automatically becoming the property of the slave owner, of attempts via basic herbal remedies to abort a birth. The speaker said that the stigma of slavery continues if one is black in contemporary Britain – apparently, 19% of us would think a black person is less intelligent, but there is no scientific evidence for that whacky assumption. The speaker reminded us, with a leap of logic tempered with convenient rhetoric, that therefore one in five must think that way, and so one in five teachers, one in five police officers are racist. He conceded that the bias was less prevalent with the young. He said there were names everywhere in British history tainted by slavery, including George Downing of Downing Street fame. The site of the Guildhall was poignant, he said, as two slave owners in this very hall were given a charter by Queen Elizabeth I to conduct slavery; that the statues adorning the hall today are of slave traders; with the remains of the Roman amphitheatre in the basement below, where gladiators possibly fought. So a wretched place all told, but the right venue for his lecture.

The Master International World Traders, our host, asked what our generation has done which future generations might see as equally pernicious and perplexing. The chair of a corporate sub-committee, who had been asked to look into the association between slavery and the people depicted in statues in the hall and generally in the Square Mile got up. She wanted to remove all the fine statues around us in the Guildhall – she was clearly more a student

of woke than of history. Another asked if there should be reparations, such as Germany to France after the First World War, Germany to Israel after the Second World War and now possibly between corporations and institutions over slavery.

A great stirring in the hall when one speaker said there was no point waiting for official initiatives in and gestures from politicians, rather we should all take action and now. All power to the people!

When the clapping ended, another said the wording on the statues in the hall never referred to the owning of slaves, only to the good character of the man and of his works – that statues are mute, whereas documents speak. Another chipped in – black youth unemployment was higher now than before the lockdowns, that blacks had suffered even more than had whites and, therefore, the message is clear, the legacy of slavery lives on. The speaker, possibly frothing at the mouth, but I was too far back to see, said the City has more associations with slavery than has anywhere else on earth – its street names, its wealth etc. I noted that a former business school of which I was once a visiting professor had changed its name from Cass – no doubt a wicked, degenerate slave trader with one or three eyes – to that of Bayes. No idea who he is. No doubt a saint, not a sinner.

Sat beside the wife of a trader. She was asked by the Worshipful Company of International World Traders if she was a soprano. They were short of them at the time; she is now included in their annual carol service.

There was a very glamorous woman sitting in front, late middle aged, well-groomed, possibly South American. Noticed her as I walked into the Great Hall. She stood out. All the seats in front were reserved, but fortunately, behind her was an unreserved seat, and I sat in it. She turned and spoke to me. She said she knew me. Complimented me on how I had readily taken to the role of Master – obviously a natural fit, like owning a pair of new shoes. I said I didn't know who she was – hazarded a few suggestions. I got nowhere. We agreed to meet afterwards at the Reception. We met. After a few moments, she pointed across the room and said she must meet someone but would return shortly. I stayed for half an hour talking to others but seeing she was engrossed in conversation elsewhere, I slipped out and never reached the bottom of the conundrum of how she knows me, but I don't know her. She probably plays that little game on others.

I had been speaking to someone who had a friend who was a Vintner and then joined the Plumbers. I asked which tap was for red and which for white? I chatted to more guests. One I recognised from the dinner at Drapers a few weeks ago. He didn't recognise me. I mentioned the cannabis discovered in the basement of Drapers Hall during its recent refurbishment. He said it was in his ward and showed entrepreneurialism.

As I got into the taxi to return home, I remembered that the building which housed my Prep School was largely paid for out of slavery, as was the Grade I Catholic church in the same town, which was endowed by the same benefactor.

28 February

Consort invited by the Mistress Feltmaker to a function, was given a medallion – a magnificent gold thing with the words, 'Incorporated by Letters Patent granted by James I in 1604 and by an extended Royal Charter in 1667'.

2 March
LONDON CHILDREN'S FLOWER SOCIETY

A member ex officio.

At Alderman's Court, Guildhall. List of Lord Mayors since 1957 behind the great chair of office. 1957 happens to be when Sir Denis Truscott was Lord Mayor, the former boy of my prep school. I remember well when he was elevated and the school choir, not me, performed at the Mansion House. So many years ago. So many Lord Mayors since.

Given a copy of the 2021 annual report of the Society. At the last annual prize giving ceremony at Guildhall, which I attended, the official photographer forgot to attend, unlike him, and apparently still acutely embarrassed. Mobile phones were used instead. The pictures on the back of this report from that ceremony and via that means were of sufficient standard, but the one of Alan Titchmarsh, who gave out the prizes along with myself, was of excellent quality. I asked how. Apparently, he wore the same tie and a white shirt in 2019–20, so they used the picture again, and hopefully no one would be any the wiser – except perhaps

the proud mothers of the children who knew that their children were not in attendance in 2021.

I am mentioned on page three – and by name! The Queen Mother doesn't feature until page five. It probably won't bother her because she is long dead. Alan mentioned on page one, I don't mind, he was so brilliant with the children. Alan is president. HRH the Countess of Wessex, GVCO – Sophie, is Patron.

We started the committee meeting; chairman no longer to be called such, now 'chair', it won't be long before another name change to comply with the gender fluid approach of the moment. Sat beside new representative from the Royal Parks. I said I thought they had recently changed their funding. Yes, no longer via government, they were given a lump sum and sent forth. Rather like the Zoological Society of London, I said, enabling the organisation to keep unspent funds beyond the end of the financial year and thereby accumulate and deliver larger, more expensive projects hitherto precluded. Yes, she said. This arrangement, for example, has enabled the current major refurbishment at Greenwich by the Royal Parks. Asked what was their main source of money now they were independent of government. She told me funds came from a combination of Winter Wonderland and the Household Cavalry, Royal Artillery, when they use the parks for ceremonies, for example, firing royal salutes and, although a voluntary arrangement, such worthy organisations always contribute financially. Also proceeds from cafés and loos,

'You would be surprised how much from that last source!' she whispered. The pandemic has hit funds so hard they had to dig into reserves; there was no Winter Wonderland etc, during lockdowns.

Schools leave everything until the last minute to enter the award schemes, sometimes due to changing teachers, a lack of briefing for their successors, poor publicity within the school but, in fairness, often the school has other priorities. Hoping to get 30 plus schools entering next time.

Discussion on what to offer each successful school in addition to the £500 offered for seeds and for seed trays and thanks to generous discounts offered by suppliers. Debate on plastic containers, the benefit being that they will last longer versus wood which if not treated won't last, but if wood, which wood to consider? All so complicated. Asked about follow up, surely no good one year of excitement then a broken empty tray the next, and do schools discard the equipment after one year? A rather sophisticated new scheme to monitor all this going forward. In theory, each school agrees to participate for a minimum of three years. Picture of preferred veggie pod passed round. All the schools are either secondary or special needs.

Next discussion about timing of judging. If February / March then some bulbs won't be out or be at their best. Then a discussion concerning the best bulbs for that time of year, the star bulb being hyacinths, but even they can have a timetable and mood of their own. One committee member

added that if you follow the label and feed a hyacinth, they can become an unwelcome giant!

The principal guest this year to give the prizes will not be Alan but some chap from Kent who enjoys dressing up as a Victorian plant hunter. He is very good and well known. Just hope the professional photographer turns up. A blue tie on a Victorian plant hunter would not look convincing. The inevitable discussion on possibly encouraging pollinating plants.

AOB: Annual Health and Safety Review. And if that was not exciting enough, next a Risk Assessment – eight pages – surely there should be a ninth in case someone foolhardily feeds a hyacinth. They have been doing risk assessments for the last ten years: activities, risks, who is at risk, how we manage risk, putting controls in place, rating whether it is all at an acceptable level.

If I come back, I think I will join the Worshipful Company of Fan Makers.

Then our attention was on a Complaints Procedure – we don't have one – yet we were founded in 1945 and have survived, indeed flourished. Interestingly, nobody seems to die who is associated with us. The Queen Mother was patron until her 'demise' in 2002, the original chair, Alice Street, 'passed away' in 1966.

We have about 60 judges, which is good but not spread widely and evenly enough. For instance, short for East London. Couldn't do much about that today, so we adjourned.

3 March

Managed to get a glimpse of the demographics of other liveries; interesting read. Both Apothecaries and Carmen have 80% plus aged over 60 and Cutlers and Cooks only 43% and 32% respectively.

An invitation arrived today from the chair of the City of London Guide Lecturers' Association to attend the 19th annual Derek Melluish Memorial Lecture at the Dutch Church, Austin Friars on 'Then and now: Migration, Race and Empire in the City of London'. Alas, had to decline, but a bit suspicious – a touch of the Tacitus there.

4 March
INTERNATIONAL BOOK DAY

First time we have celebrated this designated day, the idea of my Steward. We met at the Natural History Museum (NHM) to enjoy a programme she had organised, which included a peep at the incomparable collections at the museum and a zoom link to the Royal Collection at Windsor and a talk by the Friends of Milton's Cottage.

On arrival, told that the NHM had 80 million specimens; by the end of the day that figure had risen to 95 million – 15 million new specimens acquired in only six hours! Coincidence? We were told that when the Herbarium was established only dried specimens could be included; it was not possible to keep plants alive during long sea voyages and expeditions. That early collection is in 265 volumes, constituting an invaluable medical resource and means of

re-establishing biodiversity. I mentioned my talk with the chair of Kew who had said that dried coffee specimens in their collection would help to re-establish the coffee crop in civil war-torn Ethiopia. London is the clear capital of Herbarium with collections at Kew, NHM and at the Linnean Society.

On display are only a fraction of the 2.5 million specimens in the Herbarium. It seems to be a collection of collections. The oldest collection in NHM is that of Hans Sloane's, dating back to 1603, the largest surviving collection from that era, his collections constituting also the basis for the British Museum and the British Library.

Behind the scenes, a jungle of metal containers in a temperature controlled environment. We saw collections also from Sir Joseph Banks and heard that Botany Bay was so named because the number and variety of hitherto unknown species overwhelmed those on the voyage. Some specimens had a red band attached to denoting priority specimens to be saved in the case of fire. The descriptions were useful, the specimens themselves even more so; some well mounted, others less so; many still unpacked from Captain Cook's voyages and therefore even today not analysed! When unpacked, some of the specimens are predicted to be new, and others, sadly, will now be extinct.

Unmounted specimens are better as one can see the entire item, but alas, less likely, in that state, to have survived. Botanists keep changing the plant groupings.

The temperature needs to be constant. Beetles lay eggs

at 17 degrees centigrade. Light damages specimens, so all lights go out automatically when not required. Most plant exchanges today take place between collections.

I asked if we might one day bring back species from extinction as a result of these collections. Not yet, but the knowledge is progressing rapidly and especially over the last 25 years, so who knows?

Saw one of only two of Fairchild's Mule (the other being at Oxford). Was one of the most motley looking specimens despite its huge importance.

Told that few vegetables in the wild are edible for humans, that the original potato plant was toxic, and presumably only through trial and error and after many deaths was a safe potato cultivated. Extraordinary.

Originally, plants were pressed between waste newspaper as paper was so expensive, even an early edition of *Paradise Lost* was used. Still today, collectors linger on the plane, gathering up discarded newspapers. Coronation Poem to Charles II on the back of one piece of newspaper, only copy of the poem extant – a very bad poem.

One plant, a tea specimen, improves in flavour with age. This one was from 1690.

At lunch, a fellow Gardener read an extract from John Evelyn's diary, of how he let his home in Deptford to the future Czar Peter the Great and his cronies, who proceeded to destroy his holly hedge with their wheelbarrow races. Evelyn's friend who recorded this was a Freeman of our livery but never made it to the Mastership.

Afternoon zoom link to the Royal Library at Windsor. Castle there since 1080. Not there to be convenient to Heathrow as one American thought.

George II gave his old library to the British Museum, George III, a proper book collector, established the King's Library of 65,000 volumes, George IV needed space for a kitchen to serve his ever-expanding waistline and glutenous preferences so gave the King's Library to the British Museum. William IV refounded the library in 1830. Prince Albert had it catalogued and was a book collector himself. It is all protected – by law no volume can be dispersed.

Next, Poetry Paradise, 'Milton: 'The Great Florist' and the Poetry of Paradise'.

Milton helped define the English gardening style and in so doing rejected French formalism. His description of Eden stirred the emotions and influenced future garden design in England. He inspired Kent, Blake, Turner. Wonderful talk on changing styles of garden illustrations, including one example from Paradise Lost of Adam cleaning paths in Eden and waking Eve in the morning. 'A wilderness of sweets', – a wonderful line from Book V.

The last treat of the day, the 'Gilded Canopy', – the roof of the Great Hall of NHM. Often overlooked, it is a glorious ceiling of tiles decorated with depictions of plants and flowers, painted in situ in the same way as the Sistine Chapel. All done in three colours only, but clever variation of shading. Long established mystery of where the depiction of the plants originally came from and then one day, our

speaker, an NHM botanist, was staying in a house in Ireland, explored their private library and found a book on plant illustrations which corresponded almost exactly with the tiles. A fortuitous happening.

The themes were plants for medicine, those known in the Bible, of the British Empire, depictions of the kingdoms of the UK, but no leak, Wales not being a kingdom but a Principality. On 10 September 1940 NHM was bombed, but miraculously not a single tile fell.

5 March

Noted some of the latest non recurring grant applications. These, and others under a certain amount, can now be administered between formal board meetings. It gives me a lot of personal satisfaction to know that we can touch and improve many lives.

The Church Homeless Trust operates therapeutic gardening projects, in so doing, helps the vulnerable gain confidence, skills and ultimately even a home. I am torn. Recently, got a request from my school to help fund bursaries so that others can gain what I undoubtedly did, but then we have this other sort of request where a few pounds will go far in a basic way for the less fortunate. Do I help both or a preference for my school in the hope that former pupils will pay more tax, thereby offering more to society, and my initial meagre offering may actually go further? I have no idea.

Another request for training and employment oppor-

tunities for young ones with learning disabilities. Another request from a charity to create a sensory garden in the grounds of a hospital. When on the board of a local NHS trust, about my only contribution apart from arguing that nurses should not automatically be given counselling in a profession they have chosen and been trained for – a stance appreciated by the matron – was to make sure the gardens patients could look out on were fit for purpose. One request is to fund four wheelchair friendly tugs for those with limited mobility; I would give thousands for hundreds of them. Another request was to help break the cycle of crime by training prisoners to gain their City and Guilds and have something meaningful when they come out. We have also been asked to give in order to establish a lavender bank at a hospice. We can help some of these heartfelt requests. A few with relatively large amounts, many with a gesture. But even the latter can be truly transformational. I successively championed a charity in Islington for money for bird boxes which have proved very successful. Locals sit and enjoy the experience, and they would name a street after me if they could.

As I am writing these notes, the cat has just been sick.

6 March

Consort invited by the Mistress Broderer for an afternoon of calligraphy and champagne at Vintners' Hall. The pre-briefing said, 'Your level of skill doesn't matter, it's the fun of ink on paper. 3.30pm tea and cakes with champagne.

4pm tour of Vintners Hall'. Dress code, 'Ink can get spilt, so please don't wear your finest, lightest clothing'.

To take place in the Swan Room. An easy beginner's calligraphy tutorial for writing italics, all equipment provided; welcome to take home the nibs, pen holder and ink in order to further their calligraphy skills at home. I was hoping in future to be reprimanded in Arabic calligraphy, to be armed with a shopping list done in Western calligraphy and on occasion, for variety, be communicated to in Eastern calligraphy. Alas, the Consort was unable to attend.

9 March
CHARITY BOARD

First meeting of the revamped charity board. Chairman opened by complimenting me on my livery Christmas card, which pleased me very much. The board already has a new profile, a modern feel and is even more fit for business. Recurring grants are streamlined, clear outcomes to check on how grants are used, a split between small and large grants, adopting a policy that the former can be administered between board meetings, with larger ones only being reserved for discussion at a board meeting. The charity currently in a healthy financial position. It was agreed to abandon the arbitrary target of a figure that seems rounded but plucked out of the air. Our role is to allocate grants in a sensible way and capital will probably increase to that target anyway via compound interest. As Master, they are deferential to me and allow me to make any

point, however daft and let me regard my contributions as perceptive and helpful.

Trying to change signatory names on our bank account – a nightmare. The investment portfolio administered by the same company but by new managers and we will go from medium low to medium high on the risk scale, which equals about 1 ¼ % with not much additional risk.

Ethical policy means we will not invest in tobacco or porn, but generally, ethical policies don't perform quite so well as many others. You pay a price for being moral.

Discussion on how we should communicate to the livery on our charitable giving and make sure that those applying to the livery will commit to that additional request although giving money to a charity cannot be a condition for joining the Gardeners. However, liveries are in existence, stay in existence, sometimes for many centuries, because they give to charities. We need a more robust conflict of interest policy. I suggested we should have one trustee who is an ex-investment banker rather than rely on laymen familiar with charities. The idea rather ignored. Then near the end of the meeting was told that the firm employed at the time to advise on our investments had taken their fee out of the investment return and as we had not been invoiced separately by them, the charity couldn't reclaim VAT. Apparently, this went on for years, then noticed. The Inland Revenue gave rebate retrospectively for a few years, but our charity still lost out, and the trustees seem to accept this with good grace and little comment. All water under a bridge.

At present, our personal liability risk is too great, which I knew, and has prevented one or two from joining the board. This will now be rectified.

Discussion on our second Nuffield Scholar. Potential sponsorship will take up a large percentage of the total we give to training across the board. But that is regarded as justifiable, we need a potential star who might change the face of horticulture. Unfortunately, the livery committed to the second scholar, but no money had been allocated. The charity board agreed to pay this time but insists on a formal policy being adopted going forward. At the end of today's meeting, one trustee said he felt it was time he retired. His Mastership had been 17 years ago, and in those days, the Master chaired all committees and charity was a committee not a separate entity. Agreed that trustees would entertain the previous chair and the secretary, both of whom had now retired or are retiring and that current trustees would meet the cost privately.

Adjourned for lunch. The conversation was not my comfort zone:

> 'income asset of choice is equity-based rather than bond-based', 'Bottom of medium high by being medium-low in our case'!!

In the afternoon, via zoom, discussed the current performance and future role of the Clerk. Working party set up nine months ago, some progress but all rather slow. Clerk said when he started 11 years ago, on average, about 5 emails

a day; now, over 100 with more than 170 after a weekend. They all take time to filter. Some are rubbish, others marked urgent when they are not. One or two pages of bank statements ten years ago, now seven to ten. His retirement is on the horizon, but when he gives notice will depend on health and his ageing mother-in-law. Fortunately, Clerk will remain to see my year out at least. I was on the original interview panel that appointed him and soon after was staying in a Bed & Breakfast cottage in deepest Sussex once owned by Enid Blyton and in the conversation over breakfast found that the new Clerk was a friend of my hostess.

It is all too easy to criticise the Office. But as my year progresses I become increasingly aware of the demands on both the Clerk and the Assistant Clerk. I like to think we make a good team.

10 March

Such a shame, cannot make the annual True and Fair Lecture of the Worshipful Company of Chartered Accountants to be given by the CEO of London Chamber of Commerce – lecture plus canapés. This time the theme is 'London's role as a Global City' and why it is regarded by many as 'first amongst equals', as it continues to pioneer ESG and ADR (no idea what they mean) whilst building stronger bridges with other cities around the world. Our Flowers in the City awards also surely contribute to that reputation, a sense of sophistication, colour and renewal. Would have mentioned that between canapés.

Had lunch with a friend who couldn't join me at one of my dinners. I arrived first and went to the Gents. Waited outside a long time. Queue building up behind me. I was getting ready to brace myself to assist the occupant who must be in distress. I pushed open the door. The cubicle was empty.

While dining, my friend said he had knowingly trespassed onto an ancestral estate near his home, a 4×4 came up; the driver asked, 'Is your dog a gay dog?' My friend said he didn't know. The driver had a broad Scottish accent and was actually asking, 'Is your dog a guide dog.' He told me that when he was headmaster of his public school if he wanted to raise money, he would always start by asking those who had been expelled. They have the fondest memories of their schooldays and have usually done the best. He told me about the power of forgiveness. One of his former chaplains was a prisoner of war in Japan. He later met his brutal camp master, whom he forgave, and who converted to Christianity. Another chaplain at the time the school was commissioning a portrait of Christ for the school chapel somehow managed to have his face as the model for Christ.

11 March
MEETING OF FUTURE GARDENERS

Recently established ourselves as a separate charity from the livery, a sign of growth and, therefore, success. The charity not fully fledged, still mainly a cash handling vehicle,

but keen to move on and with our new status, will be able to attract other skills and seek those outside the corridors of the livery. We discussed how best to do this. I expressed concern that we might, by so doing, weaken the link with the Gardeners. Was told that wouldn't be the case. Gosh, I hope they are right, because we all so want this project to succeed.

One central theme of our charity is to introduce those who might find it especially difficult to get started on a formal horticultural career because of learning difficulties or poor school record and to be given a constructive helping hand.

One main reason for the delay in becoming an independent charity has been the inordinate difficulty in getting a bank to set up our account. At each meeting I have attended so far this year, the chair has updated us and expressed his frustrations. The chair said the last time he tried to resolve the matter, he was on hold for 30 minutes, got nowhere, and the problem seems to be a general one – banks are not interested in charities as clients for no obvious logical or fathomable reason.

14 March
THE LIVERY COMPANIES' SKILLS COUNCIL AND THE CITY AND GUILDS OF LONDON INSTITUTION MASTER CERTIFICATION SCHEME AND LIVERY COMPANY PRIZES!

Having got over all that, I was determined and willing to attend.

Outside Mansion House, waiting to enter, spoke to a Court Assistant of the Spectacle Makers. They give £1000 bursaries. One candidate said she was getting married and would spend the bursary if successful on make-up and on her wedding. Apparently, she was not awarded the money.

In the Mansion House, I went to the Gents. Inside, a female cleaner. Shuffled around to a more circumspect place next to another Master. In such ways are the bonds between our livery companies established. Noted later, that the Master of the Worshipful Company of Environmental Cleaners was there. Was the said cleaner their Master, and I missed the chance of a bonding between two liveries?

On the way to the reception, I met the mother of our livery's winner. She was going for a cigarette. I mentioned how my father had bribed my brother and me not to smoke before 21 – it worked – and how I adopted the same approach with our daughter, who merely lectured me on the evils of bribery.

Met our Clerk. He adjusted my gown, pointing out that the pocket at the back at the end of its own long tassel, was twisted. I was unaware of such a thing existing. Apparently a throwback from the long distant past; it offered a means of others to petition their Master by depositing their request incognito. Surely quite an achievement to enact this without a sober Master being aware. From now on, I will check my tassel pocket regularly.

Whilst in the queue to enter the Egyptian Hall, spoke to the Master Needlemaker; his badge also has Adam incorporated plus Eve! We don't have her on mine, and I asked why he had either on his. His answer was not convincing. It's lucky this is not the 17th century – in such ways can two great livery companies fall out.

Then spoke to the Master Wheelwrights, who claimed to have spent last weekend making wheels and the Master Furniture Maker chipped in to say he was also involved in his trade last weekend, and then my good friend the Master Needlemaker said likewise. As Master Gardener, I reckon I was the only honest one amongst the lot of them – I was gardening last weekend.

Spoke to another Master – we had to wait quite a long time to go into the Egyptian Hall – who said he had taken his winner of a previous year to the United Guilds Service at St Paul's – a service established in 1945 to unite a fractured world after global conflict – at which the Bishop of Chelmsford had given the sermon. The Bishop said he was enjoying the occasion because usually the clergy are laughed at in their robes, but looking around at all the Masters in their robes, he could laugh at how silly they looked in theirs. It didn't go down well.

Spoke to another Master. Rather cornered and ambushed. She regaled me about her clever grandchildren due to take exams, but clearly worried about the outcome (possibly because of Covid?) I tried to reassure her. Told her

that at a fairly recent supper with friends we were speaking about exams which we took many years ago. I said that when I sat my Ancient History A level, two questions were in Greek, so I had no idea what they were about, my choice of questions, therefore, was reduced to four questions out of six, rather than four out of eight. Completely bonkers and very unfair, and probably, on reflection, had, in all probability, closed many career options for the rest of my life. I was urged to redress this injustice, and despite it being 54 years later, that is what I attempted to do. My examination Board had been taken over many times since and I was told that no examination board keeps records after 30 years. So I told this anxious Master not to worry. In 30 years' time, her precious ones can state any grade and not be challenged or caught out.

Presented to the Lord Mayor as 'Master Gardener.' 'Hello Peter,' said the Lord Mayor. Made my day! All those people he meets on a daily / hourly basis, and he remembered me. I thought I must have made a rather good impression when sitting beside him at the Mansion House with distinguished guests, my guests, those I could attract. 'Oh, Vincent is good with names,' said the Lady Mayoress later. Oh, dear.

At the presentation, some winners and their Masters got their routine wrong, yet it was the same process repeated, over and over – don't leave the platform before photo with your Master and the Lord Mayor etc. When it was

the turn of the Master Plumber, he paused, took a gulp of water which was for the Master of Ceremonies and said he was just checking its quality. My winner was called Junk, otherwise a fine young man from Northern Ireland, who had got up at 3.45 am this morning and will fly back later today. His employer made him take a day's holiday. I said, 'Your boss does not understand. You will have the last laugh. Please keep in touch.'

Noted there were very few female winners even in this day and age – saw one each for the Spectacle Makers', Clockmakers', and Horners' – and maybe I missed a few, but I doubt it.

Chatted to a few other Masters whom I knew. The Master Tin Plate Workers said she was their first female Master but it took a mere 340 years, and the Master Ironmonger was hopeful that they would have their first female one within the next ten years; they got their charter in 1463 and had been an effective organisation since 1300. Some things take time. I said we Gardeners have had many female Masters and I am a living symbol and an example that it is possible for a man to become a Master Gardener, even though I don't have a double barrelled name unlike recent female Master Gardeners.

As I was leaving, chatted briefly to the Master Spectacle Maker. He said his magazine has no pictures of social events as they don't want others to think they give priority to such matters.

15 March
FLOWERS IN THE CITY

Arranged to meet for lunch with another Master. I was keen to impress. After a time over lunch, I served my guest the wine, taking the bottle from the adjacent wine bucket. A minute later, our waiter appeared and poured out some wine from another bucket. Inadvertently I'd helped ourselves to the wine of the neighbouring table. Apologized. Grovelled. Said they could have ours. No thanks, yours isn't of the same quality. Luckily for me, there are 108 other Masters to befriend.

Later, at our meeting, discussed the inevitable changing nature of the awards as they adapt to reflect green-walls, sky gardens, enclosed areas, atriums, streets, big/small venues and encourage bee friendly planting regimes. Originally, the scheme was conceived to bring hope after the Blitz. We need more plants for bees, plus more trophies to reflect these changing array of awards. Some of the now defunct trophies are engraved and can't be used for another purpose. Learned today that a sky garden is not an outdoor garden. No idea why not.

We had 16 areas designated now down to 12 and will move judges around to different spots so that they will see things with a fresh eye.

Clock in the room, neither a grandfather nor a grand-mother and the painting on the wall, 'Russian River Scene', donated by the Soviet leader Khrushchev when visiting

these offices. A rather heavy, lugubrious Russian depiction, but it looked technically very sound. Just been reading an excellent biography of Macmillan and was reminded of the time Khrushchev banged his shoe on the table at the UN, and Macmillan asked for a translation! Never quite sure whether Macmillan was very clever, or just clever at appearing so.

Walked back to Moorgate with a fellow member of the committee via Finsbury Circus. He said one of the other committee members managed to save the mature iconic trees in the Circus, which were going to be chopped down when Crossrail was being built. This other member had said it was unnecessary, was vandalism, and the trees must be protected. He was right. Crossrail is now built and will open later this summer, renamed the Elizabeth Line.

The trees are as glorious as ever and are in rude health.

16 March

Email from the Lord Mayor reference Ukraine, which is causing a touch of angst amongst livery companies. Lord Mayor wants each livery company, and this is the bone of contention, to disclose in confidence the donations each has made or plans to make so that he is well briefed, whilst acknowledging that some livery companies will be giving in kind but he would like that information as well. The Corporation has already given £250,000 and a further £25,000 to UNESCO. Some of us feel that our giving should be more private whilst understanding the sentiment behind this email.

Also today, an email in respect of Jubilee garden parties; one Gardener unable to host a party on the designated day, is proposing to propagate two of the plants in his garden, those much admired by others, and offer them with a personalised vade mecum to those who give a donation. The idea was warmly endorsed. Vade mecum will be strictly limited, a unique and personalised souvenir. On offer are Crinodendron hookerianum (the Chilean Lantern Tree), an exciting and flamboyant shrub when in full bloom. Also Hydrangea Quercilfolio, which is an oak leaf hydrangea with a wonderful oak shaped leaf and autumnal colours and with engaging white conical paniculate flowers.

A little later, I was given a draft of the first newsletter for Pollinating London Together, all about an interaction art exhibition featuring work by the artist Alex Hirtzel and music composed by Lilly Huntergreen (why do those involved in plants/horticulture have such appropriate names? Yet another example.) Bumble Bee Conservation Trust on board, three workshops via Superbloom, six livery companies and other city gardens plus courtyards now signed up.

17 March
LORD IMBERT SECURITY LECTURE

To Barber-Surgeons' Hall, courtesy of the Worshipful Company of Security Professionals to attend the Lord Imbert Security Lecture, an annual event apparently. Hogarth painting adorns the hall, depicting Henry VIII and some of his buddies.

Lecture given by the Deputy Assistant Commissioner, who is Senior National Co-ordinator for the UK's Counter Terrorism Policing network.

Had to remind Master Security Professional a new one – charter 2010 – we go back to Adam in the Garden of Eden, albeit not continuously, with breaks and lost records of Masters. They are number 108. In the cloakroom, in a cabinet, a book entitled *The Art of Growing a Beard* and another *The Barber's Book of Recipes* and yet another in another cabinet *A Snip! The Life of a Barber.* I don't think I have copies of any of them at home. Might recommend them to my book club.

Sat beside my new pal, the Master Needleworker, who had the previous night attended the Trelos charity dinner – I wasn't invited, but we donated a raffle prize to raise money for a school for those aged 2–25 with acute needs. 180 pupils, 100 of who are residents. There were about 150 in the Mansion House last night, and together they raised an incredible £72,000 from the auction.

Also spoke to Master Firefighter. They got their charter in 2001. Met him earlier in the Gents when putting on my badge. He was doing likewise, and he told me his badge was 20 carat gold, I had to confess mine was only 18 carat. Not the way to make friends.

Next I met his wife. He then familiarised me with some of the shocking incidents he had had to endure in his long career, such as of the autistic young man who said to a gang, 'I know what you do.' Next the gang put a bomb through

his letter box killing him and two others in the house. Then Mistress Firefighter added her take, as a former midwife, of the time when a pregnant 15 year old kept saying she was in that condition due to a certain young man. Former midwife didn't believe her. Turns out the girl's father was the culprit. Then spoke to the Master of the Air Pilots; I asked him what damage, if any, to planes when parked for so long on runways during the lockdowns. He hinted that it didn't do them much good and that it was fortunate that none crashed later.

Speaker said his job description covered homicide, major crime command, sexual offences, exploitation and child abuse, was head of Trident Gang Crime Command and of the Anti-Corruption Command, which is responsible for coordinating emergency responses in the event of major disaster or mass fatalities. Recently added to his portfolio the lead in the UK response for body recovery in Ukraine, for the MH17 air crash. Despite all, he seemed quite a happy sort of chap. At last good news soon followed. He opened the lecture by saying there are less terrorist incidents in recent years compared to 1970–1990, but largely due to that era being when the IRA was at its most active. Said terrorism adversely affects the economy and our global image and then slipped in that he was lucky to be here at all. He once stood on the flyover at Staples Corner when a bomb went off rocking the whole, huge structure.

Covid had increased the sense of isolation amongst many, depriving some of normal family support, dimin-

ishing their social networks, affording plenty of time, as a
result, to learn about terrorism, how to make a bomb, to be
brainwashed, to conduct activities online, mental health
problems galore and a tiny minority, but a significant
one, wanting to commit heinous crimes. There were four
terrorist plots during lockdowns, fortunately, all nipped in
the bud.

Volatile situations include changing crowd dynamics
at football matches, anti-vax, anti-government etc,
all mingling and becoming increasingly aware of trends
elsewhere in the world through technology which gives
ideas and assistance, creating new challenges for those
trying to protect us. There are five levels of threat. Currently
UK in the middle due to Ukraine. A distant conflict to
us, deceptively benign, but it means that behind the
scenes there is a need for increased blood supplies, that
the military are on standby – the unknown ripple effects
of such events on a global scale. 80–90% of terrorists are
homegrown. Contrary to what we might believe, many are
lone attackers, kitchen knife in hand, and modern terrorists,
unlike their IRA predecessors who wished to live to cause
further trouble, they don't today care if they are killed in
the incident they are planning, in fact, they often welcome
that outcome. An immediate issue for the lecturer was to
coordinate the evidence on war crimes in Ukraine against
the Kremlin and to monitor a potential threat from militant
Ukrainian refugees seeking asylum here.

A contemporary event such as the war in Ukraine

galvanises right wing groups in this country, adding to his in-tray. Last five terrorist attacks were all different in nature. Nor were they connected – 32 plots have been stopped in the last few years alone. Terrorism is split into groups/ types: sites, for example, The Shard; groups, for example, faith; zones, for example, Trafalgar Square; sectors, for example, business. The lecturer tries to keep all these groups prepared in order to respond effectively.

All fascinating stuff. There were further reasons to be optimistic, including new technology such as drones, but then IT can be another weapon for the terrorist too, for cyber attacks, for attacks such as 9/11. Artificial Intelligence is helping authorities keep five minutes ahead of most of the challenges. But social media and telephone companies have huge resources, are often unintentionally in the mix, and could work harder and liaise closer with the authorities than they do currently. There can be hints, signs, to follow up on Amazon: an order for the three ingredients which make a bomb, plus an order for a few thousand nuts and bolts and an order for a rucksack appears – surely someone should be suspicious? We were shown a short film of a terrorist, unknown at the beginning of the day but successfully tracked down by the end of the day and arrested as he attempted to leave the country by ferry – a successful outcome. The three big threats to our security from countries are from Russia, China and Iran. Strangely North Korea not mentioned.

Policing, media and politics equals a toxic mix, the

trend towards elected mayors rather than long standing councillors means more meddling and making matters sometimes worse.

Afterwards, and after a couple of drinks, spoke to a person with no hair. He said he was bald because he had kept bees, had been stung and was obviously allergic to them. Understandably, he got rid of them.

Stopped to make a note of one or two points covered this evening, leaning on the 'Metropolitan Drinking Fountain and Cattle Trough Association' on London Wall.

18 March
COMPANY CATCHUP

Discussion on best way for individuals to pay for events, BACS less good than DD, even cheques are better although old fashioned, possible outsourcing, too much time taken by the Clerk to track down, marry up a payment to a particular event where the payee fails to detail which event the payment is for. Chat about the garden parties hosted by members to celebrate the Platinum Jubilee and an update on our new Journeymen scheme to encourage younger members into the Company, on terms that are tailored for their needs and stage of life. Discussed award winners, what happens to them subsequently, how closely do we monitor their careers, how do we keep in touch and do we really cultivate this early link to the benefit of all involved? Brief discussion on whether plant heritage should be a new award category. Further update on website – almost

there. Reminder of forthcoming art exhibition and talk on Pollinating London Together – how insects see the whole matter of pollinating, of making honey, and the challenges they face. We are taking pupils from our adopted schools to the exhibition. Mention of Tower of London Superbloom event on 27 June – my birthday, so I cannot attend, but will go to a preview, but not the big dinner. An update on Big Curry Lunch on 7 April. Sold out. Our garden in Guildhall yard will be one of the stars of a star studded day. Our magnolia Black Tulip looking great. Let's hope that is the case on the day. I doubt it, being a magnolia.

19 March

Consort received an invitation to attend the Worshipful Company of Basketmakers event at the Dutch Church, but it clashes with the Rome trip.

28 March

Call from a Past Master, says he is looking for two grand-children. I thought he might have lost them and I couldn't think why he thought they might have turned up at my place. He was looking for two grandchildren to present posies to the Princesses Beatrice and Eugenie at the Big Curry Lunch, and later, to the Lady Mayoress. I said we had two granddaughters who fitted the bill. He said he knew that hence the call. When I mentioned the prospect to the granddaughters, met with screams of delight.

March 30
SPRING COURT

As I entered Butchers' Hall, realised that I hadn't got any cash for the Poor Box. 'Don't worry,' said a fellow Gardener, 'I have some.' He checked, didn't have any, and I rushed out to find a hole in the wall in the City, an increasingly difficult undertaking despite being in the City, to get some for both of us. Already dressed for the subsequent formal dinner, therefore overdressed to venture forth now. One woman commented favourably.

The Hon. Almoner gave the customary Grace in the absence of the Hon. Chaplain. I delight in these important occasions, between them, these two worthy Past Masters, offer clever adaptations or unique compositions,

It was a lover and his lass,
With a hey, and ho and a hey nonino,
That 'ere the green corn-field did pass
In the Spring time, the only ring time,
When birds do sing, hey ding a ding, ding;
Sweet lovers love the spring.

And so it is The Gardeners' Court
Where comes the work and Gardeners' thoughts
May we be bought to serious decisions
With You O Lord in mind.
We ask You now for Your provisions
That we and all mankind

May persevere to do Your will
In a tone and proper frame of mind.

Amen'

Later, when welcoming a new member to Court, I made him aware that the Gardeners are a joy but be wary that you might have to pay the Poor Box contribution of another.

Another faux pas – a Past Master, the same one who had hauled me over the coals at Autumn Court, my first Court as Master, on that occasion for not remembering the words to welcome new members to the Freedom and to the Livery when I relied instead on a printed script, now she asked, 'Don't we insist on those who speak to stand when speaking?' Oh dear, I forgot. She hadn't.

As if that wasn't enough, she then said that there is not sufficient time to debate items at Court. I was ready for that! Issues are already discussed, and in appropriate detail, in the relevant committee, and if to be discussed further at Court, the Master needs prior notice. To which another Past Master rose to endorse my stance, followed by a general warm, supportive murmuring of consent. I was drawing on many years on various boards, often as chairman, with the transferable skills that such experience offers.

Covered the all important new matter of new Journey-men.

Three Court members whispered later that it was the best Court they had ever attended.

SILVER LECTURE

After the Court meeting we had planned to hold a lecture on our livery silver. Whilst undertaking the annual assessment of the company's silver, we discovered that our collection was of greater value and substance than previously thought. Unwisely, we made the location for the lecture at Ironmongers, after Spring Court, when the dinner was at Butchers'. This was all rather illogical – for those attending the dinner this would necessitate going in all their finery to-and-fro between two different locations. The lecture was to focus on particular items and be given by an expert who specialises in Far Eastern silver, on which he has written several books and has a stall in the Portobello Road, and who is also on the Court of the Worshipful Company of Art Scholars. In the meantime, we discovered a large silver tray with the names of all the Masters up to the Second World War. We intend to add the subsequent office holders and to use the tray at receptions.

SPRING COURT DINNER

This evening's Spring Court dinner was a very special occasion. We were at Butchers' Hall, livery motto, 'Thou hast put all things under his feet, all Sheep and Oxen'. 14 had dropped out for the dinner this morning, unavoidable in the present Covid era, but fortunately, being Butchers' Hall, a relatively small venue, we filled it sufficiently.

Was going to ask Paul Myners, an old pal, one of the best businessmen of his generation. I rated him particularly highly, he ended up in the Lords as City Minister at the time of the 2008 crash (he said the banks failed not as banks but because they were badly run businesses.) Chair of FTSE 100 companies, and of Tate Britain etc. Sadly, he has just died, and suddenly. Quite a personal story, orphanage, adopted by a fisherman turned butcher and by a hairdresser – his obituary was the main one in the *Daily Telegraph*, above that of the nominal head of the Romanoff (they spelt it that way, the old spelling, of the former Russian Royal Family.) Not bad – from an orphanage to pipping a dynasty. He wanted me in the Lords to spar against him, but it came to nothing.

Over dinner, the Bishop of St Albans said Trinity College Cambridge had more Nobel Prizes than all of France, and this was partly due to German refugees escaping Nazi Germany and that Germany would surely have been even more dominant in post war Europe if such talent had remained.

In my speech, I thanked the Master Butcher for allowing us to be in her newly refurbished hall, justifiably popular, with all except those with cloven hooves, best abattoir in the Square Mile. It was mentioned in the Welcome Speech given by one of my fellow Gardeners, that a rose was named after one of our principal guests, Lady Salisbury. I said Princess Michael of Kent joined the livery on the same day as I did. She had a rose named after her as well and she

quoted from the catalogue, 'Princess Michael is not good in a bed, but is excellent against a wall'.

She is not the only member of a royal household who joined the livery in my time. We had His Highness Prince Amyn Muhammad Aga Khan and His Imperial and Royal Highness Franz Joseph Otto Robert Maria Anton Carl Heinrich Sixtus Zavier Felix Renatus Ludvic Gaetan Pious Ignacious von Hapsburg Lothringen, Crown Prince of Austria-Hungary. I remember the Archduke saying that his visit on that day was only the second time his family had visited London since the defeat of Napoleon. Another guest, the former First Sea Lord, said it is better than being First Land Lord, adding that the cost to the Exchequer of maintaining the slave trade was greater than its supposed financial gain. We also have the King of Sweden and the Queen of the Belgians in the livery, also Prince Charles and, of course, Prince Edward.

I thanked the bishop for saying the Grace. The Church of England has the right words for all occasions. Recently, the Suffragan Bishop of Hertford came to our little country church to bless our new loo, installed outside in its own shed, so that the church could be used for other purposes. He had a prayer for that. I said people enter the loo and are only allowed out if they convert. We will invite the Suffragan Bishop to return to bless the church extension and a multistorey car park in the field next door, to meet this mushrooming congregation.

We were to have Stanley Johnson as a principal guest, but Stanley has been invited to add an Australian leg to his Far Eastern itinerary now that Covid restrictions are easing and it was uncertain whether he would get back in time. So we thought it better not to attempt to.

I said:

'Had he been here, I would have looked at him almost as an equal. After all, he has only one member of his family as Prime Minister – only one more than mine, so I am not far behind, and my Lord Salisbury, you have only two more than my family – well four more, if you include the Tudor and Stuart Secretaries of State.

You will have noticed the floral displays, they are in the colours of Ukraine, a gesture of solidarity. Recently, I read a diary written in 1945 by a young girl who walked a mile through the East End and noted that not a single building was standing, yet out of this came renewal. Plants rewilding empty spaces, not least London Pride, immortalised by Noel Coward's song and we set up one of our charities, Flowers in the City, to plant, offer hope, renewal and colour. The charity is still very active with many new categories, green walls, roof gardens, window boxes, best street, best square etc. We gardeners know that however dark the winter, spring always follows, or as country folk say, spring never skips a season. So Ukraine will rise again.

Last month at the Mansion House, the Lord

Mayor sitting beside me cleverly referred to the special relationship between the Gardeners and the Corporation due to the language we share – seed funds, gardening leave, hedge funds. I can play that game. Imagine we are at Fishmongers' Hall and the theme is entertainment: Prawn Free, Tiddler on the Roof, Kiss Me Skate, Whale Meet Again and Stickleback Rider.

We Gardeners are also a sociable lot: 'Hiya Cynth', 'Allo Vera'.

Last night, I tried to telephone the Upper Warden – he was at the opera. We are a cultured lot as well. Some might wear straw in their hair, if we have hair, but don't be deceived. We know our peonies from our Puccinis. I have just planted my Puccinis – Tosca is my favourite type – most resistant to greenfly. [I missed this, although it was in my notes: at this stage at Autumn Court when I was speaking someone fainted. I thought she had swooned. I was going to suggest that if any of the ladies want to swoon, may I suggest that this is the best time to do so in my speech.]

There are fashions in gardening – the formal Victorian approach, the more naturalistic look, herbaceous borders with perennials, shrubs and other plants of the late 20th century, and now a trend towards new, natural gardens with wildflowers.

It is easy to keep abreast of these trends these days with so many TV programmes on gardening. Not the case when I was a young man, even younger than I am now. There

was only 'Bill and Ben the Flowerpot Men', with Weed. It is sad to relate that the voiceover for Weed died recently. This is a double whammy for me; I didn't know Weed had a voiceover, and as soon as I did, she dies.

Ladies and Gentlemen, there is a weed killer out there. Now you might think that is a good thing, but weeds today, what tomorrow, I ask?

One of the privileges of being a Master are the invitations to other liveries. I bring you hope. A few weeks ago, I attended a lecture at the kind invitation of the Worshipful Company of Security Professionals. They received their Charter in 2010. Upstarts! But here, in Butchers' Hall, I should be deferential as you go back to the tenth century, although gardening, being the oldest profession, we can claim Adam as our first Master. The said lecture was on counter-terrorism. I now know how to blow up a potting shed. So if you think there is something suspicious in your shed, contact me.

In this room tonight, some of you will have temples doubling as potting sheds – my potting shed doubles as a temple. I don't want you blowing up your temples and for Laurie here, as chairman of Historic England, writing to me to say, 'Peter, because of your irresponsible speech last night, more listed temples to Venus, to The Four Winds and to Easy Virtue have been destroyed today than in the last 200 years due to weather and changing fashions.'

I just can't take that.

Under this assured façade, of a man with the chain

of office, proud and with gravitas, is a mere mortal, vulnerable, especially because of the recent performance of the English cricket team and of my beloved Bath Rugby.

At our last dinner, I invited the editor of Country Life as a principal guest. It is one of my favourite magazines. I have not invited the editor of another favourite, The Oldie. I am upset by their adverts:

> *'Life saving wristband'*
> *'Does sitting make your back ache?'*
> *'Why have a stairlift?'*
> *'Joints? Bayleaf formula.'*
> *'The world's lightest mobility scooter.'*
> *'Don't wait because you don't need to...' (I didn't read further, was it for assisted dying?)*

As I enter the last quarter of my Mastership, some of you might want the words to remember me by, before my name is added to the many stretching back over time. I can help. Recently, I revisited the lovely Abbey Gardens on Tresco in the Scillies. There was a diary entry by Lady Sophia Tower in 1870 describing Augustus Smith, the garden's 19th century founder, who, by the way, came from Hertfordshire, your diocese, my Lord Bishop, so we come full circle. In the entry, she wrote, 'A man of good presence, above the middle height, lithe in figure, firm in step, upright in carriage with well-cut handsome features, a face closely shaven and an eye observant; he looked as if he had been accustomed to command, or was born to be a ruler,

whilst his gentlemanly address was prepossessing, conversation with him quickly added to the good impression he had first made; nature had well-moulded him, education and refinement aided him to please and to inform others.

Please join me for a stirrup cup, and then as one of my 17th century predecessors might perhaps have said, 'Return to your gardens pleasant and groves delicious.''

Relieved and happy with audience reaction. Former Chief Whip in the Lords said it should have been recorded, bishop enthusiastic, brother likewise. I was pleased I had asked the bishop to give the Grace. It was perfectly succinct, appropriately composed and engagingly delivered – but I can't remember what he said.

I am pleased I chose Butchers', recently refurbished, so it had not been available for hire in recent years. Many, therefore, were not familiar with the location. Not the most regal or spectacular hall and the occasional picture of an abattoir or still life of hanging meat, but there is something very special about the place. It is also their seventh hall! The usual reasons, the Great Fire, the Blitz, another a Compulsory Purchase to make way for the Metropolitan and District Line, the second underground railway in the world, the first being between Paddington and Farringdon Street.

When I sat down after speaking, I said to those beside me that Princess Michael had once told me that her mother, in turn, had told her that English women of a certain age either turn to gardening or to God, but that God is present in the garden.

On the way down to having a stirrup cup, Lord Salisbury said that the Welwyn Garden Centenary went well despite Covid and I should be very pleased (he had been Patron). I could have added that we didn't get a thank you or any acknowledgment from the local council for seven years of work to achieve that result. I mentioned the next challenge – to get the two Garden Cities designated as a Joint World Heritage Site. Applications are being sought in particular for the planned environment rather than for specific buildings such as the Taj Mahal. I said we had a Taj Mahal in Welwyn Garden, but it was an Indian Takeaway. Letchworth, as the first Garden City, and Welwyn, as the most complete, together would almost certainly qualify, but neither independently. However, plenty of problems, mainly but not exclusively from Letchworth: self-interest, fear that the status would restrict their freedom to build despite Letchworth being given plenty of reassurances. We have been over these fears frequently with the UK representative of the scheme. Lord S, as Patron of one of the Letchworth organisations involved, said he would be happy to bring those involved together in a room and sort things out.

Principal Speaker, chair of Historic England, known from business days, said he had to endure the disruption of having ten Secretaries of State in ten years and that the relevant Department doesn't even have heritage in its title. Yet heritage could be an invaluable and treasured tool for levelling up, a key government policy, with so much history

and culture in the North. He said government doesn't really get it. He was a relative of John Masefield, former Poet Laureate. He said plenty more gems beyond the few often quoted and urged me to buy the Complete Works. Will do.

The highlight of the evening for me was my sister-in-law wearing my mother's necklace, saying that she thought it would add a personal touch of her almost being present.

31 March
EARLY EVENING – POLLINATING LONDON TOGETHER (PLT)

Private viewing of the exhibition and talk at St Vedast-alias-Foster near St Paul's prior to a Mansion House dinner. PLT is a collaboration between a group of livery companies, professionals and business leaders who share an interest in sustainability and promoting action to increase pollinator-friendly planting and habitats in the City. That's the blurb. I have a dream that one day there will be more bees than bankers in the Square Mile.

This is a crucial initiative; if a type of bee becomes extinct, the plants it pollinates will do also. Fascinatingly, if a musical note, in the absence of a bee, makes the right sound, the plant will respond as if there were a real bee present. Equally, a virus which can attack and destroy a hive so quickly can also be stopped in the same way via the mimicry of music. Bees socially distance in their hive if there is a virus. How they communicate is equally fascinating, floral scent guides the bees from a distance of up to one mile. There are

visual clues, including iridescent petal and nectar guides on petal surfaces. Bees see in UV spectrum. Some pointy shaped flowers carry a floral electrostatic charge between the petal tips and the bees themselves. Gripping the cellular structure helps the bee grip the petal surface. A small difference of floral temperature within the flower head can be seen by the bee through the thermocomic camera, as depicted in the flowers informing the bee whether a flower has already been pollinated. So you see, I was listening!

There are 376 open spaces in the City, private and public, a combined area of 32 hectares, plus the addition of a number of rooftops. Extraordinary for a square mile. The intention is to extend the bee friendly environment of a pollinator friendly city with links to similar projects in adjacent boroughs. The initiative being discussed will use an app to audit quarter metre spaces.

Challenges for bees are legion – climate change, habitat loss, chemicals, seasons are shifting, bees and plants they specifically pollinate are not in synchronisation.

Arrived at the church in white tie ready for the dinner, fortunately it was cold, so I could cover the formal attire with a scarf and avoid being attacked on public transport. Next to me in the pew someone who had attended my Autumn Court dinner. I said to him that the musical rendering of the noise bees make, which was recorded and we heard, when busy in their hive, sounded to me rather like a Gregorian chant. The person beside him, clearly

more educated in musical matters, gave it a more specific diagnosis and ignored me for the rest of the lecture.

MANSION HOUSE DINNER FOR MASTERS AND THEIR CONSORTS

Consort opted out as our Spring Court dinner was only last night.

When I arrived, my name was not on the list even though the Clerk had confirmed my attendance. Huge table plan, over 360 attending, the staff could not have been more cooperative. One of the registrars confirmed that a place would be found for me and that the whole seating plan would be reprinted, not in time for this evening, but as a future souvenir for me. I said that was unnecessary, but she insisted.

Not many homes can welcome 360 close neighbours for dinner. Our hostess, the Lady Mayoress, had slept rough outside Guildhall the previous night with the homeless, had crept back in the early hours, she on a high, the Lord Mayor at that time, less so. Master Grocer, whose livery is number two in the hierarchy, asked us to guess how long each speech would be and thought the Mercers', number one, would be the longest, adding it's a heavy price being a number two, that it's emotional coming second, but those who are third are more positive and look down on those below them. Something to reflect on.

Last two years no equivalent function at Mansion House due to Covid and lockdowns, so this was especially looked forward to by one and all.

Spoke to one Master who related the occasion, how, when Sheriff, needed a pair of tights and went out to buy a pair, very embarrassed, had to admit they were for him, panicked and decided at the last minute to get stockings which subsequently kept slipping down. The event was at Buckingham Palace and he had to keep dropping back to yank them up. I recalled how the current Lord Mayor had difficulty putting on his tights on the morning of the Lord Mayor's Show. I recounted to this Master the occasion of a birthday dinner at an Oxford college when my wife laddered a pair of tights and sent me out to buy a pair. I had been out earlier to buy a pair of black shoes. I had forgotten to pack mine. Only recently, we had been away and again I had forgotten to pack black shoes. It was at a hotel where there was dancing each night. I borrowed a pair from the manager whose feet were at least one size smaller. My dancing improved; each time I touched the ground I leapt in agony.

Spoke to the same Master's Consort. They have a lovely garden in Hampshire, designed by Jekyll, and she was seriously considering joining my livery. I have two others also requesting: Master International Banker and Master Apothecaries.

In the speeches, we were told that liveries gave in total £78 million to charity during Covid. Indeed liveries

combined are in the top 5 charitable givers in the UK in most years, that 43% of those working in London today were not born in London, that governments, regulation and professional control, combined with enlightened self-interest, was the DNA and the ingredient of the livery companies' longevity and continued success, and Master Mercer said that was the hallmark of Dick Whittington and then duly reminded us that Whittington was a former Master Mercer. Every time I hear the word 'Mercer', I hear the name 'Whittington'.

Ukrainian Ambassador present as a special guest. Given Freedom of the City.

Sat beside the Master Farmer. She comes from Staffordshire via a grandfather who was a tenant farmer who bought and sold land, moving up the social scales as a consequence. As a young woman, she had met two young men 45 years ago, she was keen on one of them, she met the other 45 years later at a Highland Games and learned that the one she liked had since died.

Having rather monopolised the Master Farmer, I chatted to the Master opposite, who had been in on some of our conversation. He said his brother was a sheep farmer in the Lake District. I mentioned a walk in the Lakes where three friends and I had met a sheep farmer. We asked him how many sheep he had. '15,000 to 20,000, depending on how many survive the winter,' was his answer. One of my friends told him that my wife and I also kept sheep. 'How many?'

asked the farmer. 'Two,' I replied. 'Colette and Gigi.' He was somewhat taken aback.

Standing beside the bust of Major General Sir Henry Havelock (1795–1857) – I confess I am not that familiar with him – jotted down a few notes on a full evening.

1 April
BREAKFAST AT GOLDSMITHS' HALL

Invited to Goldsmiths' to be introduced to the delights and merits of sustainable eating. Food offered, an acquired taste, but pretty good. Speaker said we can all help save the planet, in particular, in respect of eating habits as we tend to eat three times a day, hence three chances and 1/3 of all global emissions are related to food. We had chickpea scramble, and this was compared with a full English fried breakfast. The difference was the equivalent of recharging a mobile 491 times.

Next to me, Master Frameworker Knitters, whose livery was granted its charter by Oliver Cromwell. Charles II gave them a new one, not recognising the first when he ascended the throne. I did my party trick quoting the dates of a king instantly. Went down well. He told me that as a Church Warden, he had once found a pewter jug at the back of a church safe. Took it in for valuation. There was plenty of fine artwork and symbolic depictions on it. Not valued at much, but the verdict was overheard by someone else who knew better. It was valued again and turned out to be one of the oldest and greatest pieces of pewter in existence.

It celebrated the wedding of Charles II to Catherine of Braganza. I said most pewter is melted down and reused. I knew that having sat beside the Master Pewterer at the dinner at Drapers' Hall. He was impressed.

My new best friend does clever things with embroidery for medical purposes. For example, for shattered bones, embroiders sew them together, leaving the embroidery in the body for life, proving less intrusive and no need for screws. One item – he took it out of his pocket- had become internationally iconic, front page of *Time* magazine, worldwide recognition, but he confessed that it had only been used twice for its original purpose. It had become a star in its own right, and he makes copies for museums. Mentioned that on a previous occasion, he had got a call from a Formula One team to embroider a helmet to add strength and safety. Worked overnight. Meanwhile, a driver drove across Europe, collected the newly made item and got it to the race just in time.

He said once he took someone to Gregg's the bakers in Newark to the upstairs room because that was where Charles I had fallen out with Prince Rupert, which largely resulted in the former losing the Civil War. Said his godson lives in Germany in an area heavily bombed in the Second World War. Said his godson likes old buildings and misses them. My new friend invited him to a Haberdashers' Hall for a livery dinner, but alas, their present hall is a new one, replacing one bombed by Germany.

SERVICE AT ST PAUL'S

Whilst waiting to enter, and close to the Chapter House, spoke to one Master who said as a young lawyer, he once took an envelope from his office to the Chapter House – he was to ask no questions. It was, in fact, money from foreign governments to support lawyers defending those campaigning against apartheid in South Africa. His firm had acquired this clientele and following as a result of some South African lawyers coming to the UK to work for his firm after the Sharpeville Massacre.

Took my seat. Looked more closely at the back of my Master's badge. It said, 'Masters Badge 1892'. No apostrophe. It was just as bad back then as it is now. One Master said that the acoustics in St Paul's are some of the worst of any church in the country because of its dome with a 12 second echo. I thought this incredible considering the genius of the architect. When I visited the New Library at St John's College Oxford, also by Wren, I was told that there was no need for air conditioning for their priceless collection of books because it was so cleverly designed.

The dignitaries started to process. Their official titles could be out of any medieval era: Virger, Crucifer and Acolytes, Choir, the College of Minor Canons, the Clergy of the City Deanery, the Select Preacher, the Bishop of Southwark, the College of Cannons, the Lord Mayor's Chaplain, the Sergeant-at-Arms, the Sword Bearer, the Right Honourable Lord Mayor and the Lord Mayor's Ward

Beadle. The whole occasion was grand, although I hope I never hear another anthem. Just when you think it's about to end, a couple of lines are repeated.

LUNCH AT BUTCHERS' HALL

After the Service at St Paul's, a choice of a number of livery halls to have lunch. For some silly reason, I chose Butchers' – silly because I'd been there only 24 hours ago.

Spoke to one Master who claimed to be in her 5th Mastership. I was a bit overwhelmed and asked what was the point, but on further interrogation, although impressive, in one or two instances, they were not full liveries, including Parish Clerks and Watermen (both chose not to be upgraded).

The grace:

'Good food, good company, good God!'

Sat beside the Master Air Pilot. He said Prince Philip was a great chap who had said to him and to others when passing out at Cranwell, 'One or two of you will one day become Air Chief Marshal, but not as fortuitously and as quickly as I did.' The Master said Prince Andrew was of a different mould, reminding his colleagues in the Services of his status, did so even as a helicopter pilot in the Falklands when his reputation had been enhanced by being in the front line. He would mess with the lads then suddenly remind people who he was. HRH, on one occasion, went down late at night to the kitchens, the staff were having a well earned rest at

the conclusion of the dinner. He entered, nobody took any notice. He reminded them of who he was and said that he'd better go out and come in again. Said when the Queen and Prince Philip visited Trump Tower in New York before Trump was running for the Presidency, Trump showed off all the bling – the gold taps etc, – the Queen turned to Prince Philip, 'Too luxurious for us.'

I asked the Master if there were still naughty goings on in hotels between pilots and crew. He said not so much now – flight times are much reduced, fewer stop-overs.

He said in his village in the Second World War there was a young woman with a rather flighty disposition nicknamed 'Dolly Drop-Drawers'. Years later, he visited Australia, his English accent was noted by a woman who asked where did he come from. He told her, and the enquirer was none other than Dolly Drop-Drawers. He said he knew despite the fact she had lived half a life since and had travelled half way around the world to start anew.

He said he had a friend who, for no apparent reason, would keep his friends in separate boxes so they would never meet. But they did once, at a friend's wedding, and my new friend met his future wife, who had hitherto been in a different box.

I asked about computers flying planes. He said they still cannot take off and land so they need pilot input for that. I also took the opportunity to ask whether some airlines, regardless of the make of plane, were less safe than others. Off the top of my head, I mentioned Nigerian Airlines.

He recommended choosing the better known flagships wherever possible! He said he flew Margaret Thatcher around during a General Election. I asked whether it had come out of party expenses. He said he didn't know.

He had once flown Queen Noor of Jordan, who complained that the air stewardess didn't wear gloves.

I told him I had once asked a flight attendant to get a fellow passenger to sit down as he had spent ages standing adjacent to my seat in the corridor talking to a friend and not being prepared to sit down when I asked him. The flight attendant said to the person, 'Either sit down or get out.' As we were 35,000 feet over Europe, he wisely chose to sit down.

I then spoke to his colleague from the same livery who had once worked for Roddy Llewellyn. Indeed, she features in one of his novels. She said that when a certain telephone number appeared, it was to be put through straight away to Roddy. It would be Princess Margaret.

Looked up at the various portraits of Masters at Butchers' Hall. I commented on the one of Princess Anne, their first female Master. I sat beside the current Master Butcher last night at my Spring Court dinner. The current one is also a woman.

Back to the Master Air Pilot. He said Princess Anne and husband Tim sail off the Scottish Coast. I asked about security. He said there were two identical boats, all the security officers were in one, acting as a detour, leaving HRH and her husband to sail the seas.

4 April

I have received a typically kind letter of thanks from Lord Salisbury:

> 'It was a great kindness to ask Hannah and me to that great Gardeners' Company dinner... I do also want to congratulate you on your work for the Welwyn Garden City Centenary, it must have seemed that the Gods [sic] were conspiring against you at times, what with the pandemic and other things. In spite of everything, it was a great success, largely because of your leadership and drive. Many Congratulations.'

How kind!

5 April

HIGHGATE CEMETERY

Arrive five minutes late due to trains. The guide a true performer. First grave pointed out was number 28,198, of a coachman, who betted he could go from London to Brighton and back in under eight hours. Bet £1000. Won with ten minutes to spare. 16 changes of horses. Most of the winnings spent on his grave.

One 19th century tomb had a pyramid design adorning it. Last week the guide had asked a group where they thought the inspiration for that design had come from. One had replied, 'The Shard.' I despair.

Very few crosses. In the 19th century, the cross symbol-

ised Catholicism, and at the time Anglicanism versus Catholicism was still a live issue. Richer tombs at the top of the hill, so all could see them, with wording usually to convey how successful the family was. The families would picnic by their family tomb overlooking London – there were fewer trees then. Stopped at the grave to Alexander Litvonenko, a prominent critic of Putin and killed by him. Sufficient toxins in him for his father to say seeing his son die was like watching a nuclear explosion. Special cremation for safety reasons. A recent film on his life used this actual location. They had a rain machine, thought that seemed authentic, but at the actual funeral it had been a sunny day.

To buy a grave in advance, the person needed to be over 80, ill, or dead. Some plots remain empty, bought by a family who then moved away. Can never be transferred to another.

Plenty of Greek, Roman and Egyptian designs, the vogue of Victorian England. Many died of the 'grave-yard cough' (TB); 53,000 graves, 170,000 bodies piled up on top of each other in family graves, evocations of mortality. Before Highgate and the other six cemeteries were established, bodies would be dug up, dentists would buy the teeth, wigmakers the hair and a family would have no idea if a body was still there. One who visited saw his mother's arm sticking out, recognised it by the ring.

Egyptian Passage used for films, now the abode of a rare spider which prefers dark places. Our guide had never seen one.

One grave to Marguerite Radclyffe, the lesbian author and poet – who went by the name of John, dying in 1943. Was termed as 'sexual, congenital, invert', and had on her tomb the words, 'kissed on our lips and that might not divided'.

Victorians viewed cremations in a hostile way. Thought the soul left the body awaiting to be reunited on Judgment Day, and so, if cremated, that would not be possible. With so many dying in the First World War with shattered remains, a rethink was necessary, as it was no longer possible to bury the complete body.

The cemetery filled with characters and anecdotes. One tomb, lion edifice, shoemaker and bag maker by trade, would buy snakeskins from the Isle of Dogs. On one occasion bought live snakes, turned them into a circus act – there were no zoos then – went on to acquire lions, an elephant, kangaroos, etc. On the way to one show, the train crashed, a lion escaped, killed four people, the judge let him off, and the self-same entrepreneur made money by saying, 'Come and see the lion that killed the people.' Another tomb, that of Tom Sayers, the bare-knuckle boxer, 10,000 attended his funeral – only 12 attended that of Karl Marx nearby. Similar music and ceremony as that for the Duke of Wellington. Now Sayers' faithful pet is portrayed as protecting his mortal remains. Michael Faraday's tomb tucked away – he chose that location, was offered Westminster Abbey, wanted no title, not even a reference to him, saying, God knew him, that's what mattered. His widow had other ideas. Einstein called him, 'The Father of the 20th century.'

Nearby, and typical of Highgate, an unmarked spot for ten prostitutes, all young girls, pathetic lives, only one reaching 14, they were often helped in houses of retreat, but many were so ill by then that they soon died.

On the way to lunch, popped into a bookshop hoping it might stock my book on Housman, seemed interested. I bought two books from him. He then seemed even more interested.

Over lunch, interesting point raised. When a livery member dies their surviving spouse, who is not a member, is excluded from future events. This is a great deprivation at a particularly poignant moment in their lives. Will look into it.

Email today – invitation from the liverymen in the north to their annual Brigantes Breakfast, the northern lunch for liverymen and guests, this year to be held in the Tower Ballroom, Blackpool; musical interlude, performances from professional dancers from Strictly. It would mean trying to attempt the journey there and back in a day, with a start time of 10.15 – hardly possible. Have to decline.

7 April
BIG CURRY LUNCH

This charity raises money to support those who have served in the Armed Forces, most recently in Iraq and Afghanistan, and are now in need.

The day has arrived for the granddaughters to present the posies to the Princesses Beatrice and Eugenie and to the Lady Mayoress. Great excitement – new dresses.

Before the event commenced, family assembled in the vaults, could see the marks made by Cromwell when he tethered his horses.

Another, having coffee, said these vaults were the set for a Harry Potter film. Whilst waiting for coffee, I mentioned to another that our two granddaughters would be giving the posies. She said that when she was six (she must be in her 70s now) at Manchester Free Hall, she had presented a posy to the then guest of honour, the author of the Orlando the Cat books, Kathleen Hale, never forgot the occasion and still remembers how to curtsy.

In a room in Guildhall before the official commencement, the Masters and a select few others presented to the Princesses. Before their arrival, spoke to Master Turner, said how much I admired her recent exhibition. Some looked like porcelain or marble, not expensive considering the time involved. She asked if I might ping my eulogy to her. Can hardly remember what I said. Later met up again at her stall. She said my words made her almost weep. Also spoke to another guest, CEO of a major finance house, the firm was a former client of mine, so enquired about the chairman I had known. No longer with us. Dead I assume? Committed suicide. On the surface successful but underneath a different story, as is so often the case. So sad.

Interesting conversation with a former Sheriff who was also a former Master Weaver. Said the Weavers were older than the Mercers, who were number one, but latter got the number one slot even though the Weavers got their first charter in 1155. It was not signed by anyone, not even by the

King or by Thomas Becket. Possibly most couldn't write then. Asked him why this clear example of injustice was allowed to be perpetuated. He said up to 1515, any new livery was listed chronologically but that somehow Weavers had no number given and when Henry VIII raided the City for funds – expensive chopping off heads of wives and having foreign adventures – asked each livery how much money they would contribute. Mercers trumped, so Weavers tumbled to number 42. Quaintly, they now have an annual ritual where the Master Mercer and the Master Weaver invite each other to dinner to resolve this long standing, ongoing dispute, but the dinner never takes place.

At that time, the Weavers had gone over the hill. Happy ending though, they have one of the largest endowments resulting from selling various previous halls, they had six of them, the last being in Basinghall Street, which got a direct hit in the Blitz. They ended up owning a crater with all their treasures gone except a few which were in the Guildhall at the time. After years of debate, concluded that after losing six halls they should get the message, and sold the hole. Money now used largely for education.

I was reminded of the toast I have made frequently but never appreciated its meaning. The Weavers technically have an Upper Bailiff, not a Master, hence the toast – 'Masters, Prime Wardens and the Upper Bailiff' (only one of the latter, the Weavers, my new best friend). One of his charities is the International Student House, ex-chair of their trust, when young had stayed there, aims to give

accommodation to those who can't afford such and might otherwise not be able to take up courses in London. Patronised 20% UK and 80% overseas. Now other centres in the network. So many benefit from that hole in the ground. Finally, my new best friend is due to be Master two more times, of the Joiners and of the recently chartered Investment Bankers. Surprisingly, there are some Masters who pick up more than one Mastership. Are they addicted? Asked him why it was necessary for yet another livery covering similar ground – financial services. He replied there are 50,000 employed in investment management. I said that is more than the number of bees in the Square Mile. He thought they would become a livery just ahead of the Entrepreneurs and the Nurses, and there are others in the pipeline – HR Practitioners and Communicators. Exciting as the Boat Race.

Turned and spoke to Master Baker, third year in that role, two due to Covid and now replacing the Master who sadly died last month. He will, where possible, honour the planned year of his late predecessor. His sister will shortly be Master Baker and the first female one, yet baking has origins going back to Genesis – the Pharoah 'hanged the chief baker'.

Another Master told me she had set up a business offering hot and cold treatment packs for breastfeeding mothers instead of relying on frozen peas. I think that's what she said.

The Princesses arrived. Long chat with Princess Beatrice.

Enjoyed my moment. In fact, a long moment, we talked about the easily available and cheap therapeutic benefits of gardens and fresh air. I think my reverential approach worked. She is patron of Horatio Gardens, a charity for those with spinal problems – had just been talking to their Executive Director, so I could speak to her with a little knowledge. Later outside, granddaughters walked past the official pikemen and through a company of characters from a Gilbert and Sullivan opera to a place in Guildhall yard in the sunshine but cold, beside our garden and which the Princesses would be viewing shortly.

At lunch, big curry in the Great Hall, let my livery tie drag in the curry. Next to me, two from Rugby, my home town, small world, had friends in common. Where can I misbehave? One said she was here to honour the memory of her father, who participated in the failed Norway Campaign, walked to Sweden, saw action in North Africa and in Israel, was left for dead on the battlefield, ended up in a barn which was bombed, but he survived. Only spoke of these wartime exploits towards the end of his life. Died aged 93. All this only came out when her grandson was doing a school project on soldiers. She said there was no counselling for her father, his wife did that.

Back at our Gardeners' stall, one horticulturist said people are often dishonest, make excuses to switch suppliers not because of poor service but for personal reasons and giving made up excuses such as, 'The plants you have supplied last week have become smaller.' Our

granddaughters, attired in our Gardeners' aprons, approached all comers and generated business.

One of the helpers on our stall has been involved in Flowers in the City since the 1960s when there were bomb sites galore. Corporation adopted a laid back attitude then allowing us to establish gardens amongst the rubble, often digging up a skull or two in the process.

Same person mentioned mid 1980s HRH wanted a large plane tree for Highgrove. My fellow Gardener said it would be necessary to take the vehicle over the wet lawn and said that would damage the surface. Was told to go ahead, got stuck, eventually extricated the vehicle. Diana, William and Harry, not Prince Charles (luckily not there to see the damage), and the three helped plant it, throwing in a symbolic clod of earth.

8 April
GLASGOW GARDENERS' GUILD

My book of John Masefield's poems has arrived.

A very pleasant established reciprocal visit is the Master visiting Glasgow as guest to the Gardeners' Guild and their equivalent attending our Mansion House dinner.

Train late into Glasgow, no first class accommodation despite the host kindly booking it. Clerk was due to accompany me but was ill with Covid, so I went alone. No hot meals on the train. The hotel was a former British Rail one, huge, slightly faded glory, but fun. Noted on the wall that Britain's first long distance TV pictures were

transmitted to a room in this hotel by John Logie Baird on 25 May 1927. Spoke to a porter, he said that today Glasgow had experienced all four seasons in one day. I couldn't understand what the receptionist was saying, a very strong Scottish accent, not helped by her wearing a mask. Asked where the Trades' Hall was, the venue for this evening's event and regarded as one of the finest examples of the work of the incomparable Robert Adam, and the oldest building in Glasgow still in use for its original purpose after St Enoch's Cathedral. It turned out to be only a ten minute walk from the hotel, but she had never heard of it. The Trades' Hall had a new additional role in its long and distinguished life, that of a film venue – recently 'Bat Girl' was filmed there with artificial snow cascading from the roof onto Cadillacs below.

At the reception, I spoke to one former Deacon (Master), who had lived on the Bedfordshire / Cambridge-shire border but was now in Scotland. 'Why the move?' I asked. 'The Queen sent me here,' he replied. He had been an officer on a Polaris submarine. I knew a previous Polaris officer and I knew that they would be underwater for many months at a time, prowling and patrolling the oceans with their nuclear deterrent. My new friend said they had supplies for 90 days at a time with a 30-day additional emergency supply, but that was only beetroot and biscuits. Another Deacon said he was part of the Lord Mayor's Show in 2016. He and his Guild had hired a cheap bus which

broke down, it poured with rain and they had to walk, got soaked adorned in their gold and silver chains of office.

A very good article in the *Times* today which I read on the train coming up, on how truly patchy Nicola Sturgeon and the SNP record in government actually is. Knowing that the Scottish edition of the *Times* would not include the article, as Scotland has its own version, sympathetic to a one party state, I vowed to leave the article in a prominent place in the hotel. I mentioned the article to the various Deacons and their Consorts and the accompanying entourage. One pointed to the carpet where embroidered was the motto, 'Union is Strength'. He smiled and said, 'That is what we think.'

On entering the hall for dinner, I was piped in with much ceremony, accompanied by all 14 Crafts. Two down from my seat was the Deacon of the Crafts, an overall position representing all 14 and, as such, he was the 3rd most important dignitary in Glasgow. To my left was my new friend, the Deacon of the Gardeners. He told me his father and father-in-law had all been Deacons of the Gardeners before him and that this was a record. In conversation, I learned a lot about Glasgow: the city corporation is broke, Glasgow is one of the four financial centres in the UK – London, Edinburgh, Glasgow and – Bournemouth! At this stage of the evening, I thought I'd only had one or two drinks.

Was told that 52% of the population of Glasgow have degrees and that 13,000 families are in abject poverty.

The Gardeners' Guild composed the current strapline for the city 'Let Glasgow Flourish'.

Plenty of speeches, including my own, and was forewarned that they would be long – and they were – but it was a superb evening. Engulfed by true hospitality. The Deacon Gardener gave the other speaker a bottle of whisky and I was noting how I would enjoy my bottle when instead he gave me a History of the Trades' Hall, actually better for me long term.

Outside, after the function, urgent email concerning our forthcoming Rome trip, still no final details for those attending, not my responsibility, accept ultimately, but it seems to land in my inbox.

9 April

Went for a long, very early walk before breakfast to see Glasgow and to get some fresh air following last night. Felt Glasgow looked more tired than on my last visit a few years ago, pavements in a sorry state, many shops boarded up (in fairness, they are also elsewhere in the UK), but some lovely buildings, even if devalued by inappropriate modern intrusions of little design, no merit and could be anywhere.

Train to Carlisle cancelled, but a bus replacement service. I took the wrong blue case off the bus at Carlisle, about to disappear into the crowded station, a woman ran after me, explained the mistake I made. How silly of me, embarrassing and inconvenient all round if this had not

been resolved there and then. On train, I chose a healthy option for lunch to set a good example to two young lads opposite. To no avail. Predictable perhaps when I saw that their father was reading the *Guardian* and everything made worse by interminable announcements over the speaker, on safety, reasons for the late running, which stations we were approaching, the policy on first class seats, the position of first class carriages. None of it of any value, merely intrusive. Are we all morons? At Wigan, one passenger asked if she could get an upgrade but was told that it would cost a further £75. She didn't bother. I don't blame her – for the sake of a sandwich, a coffee, a drink and the same grade of seating. All the announcements started up again, identical and repeated throughout the journey to London with the occasional additional notice that there would be a ticket check shortly, please have them ready, some carriages were busier than others, and there was the option to upgrade. The lady who didn't want to upgrade initially repeated the same intrusive conversation I had had to endure somewhere up north. Found I had brought yesterday's copy of the *Times* with me and hadn't left it at the hotel. Drat.

12 April

Looked at the *Complete Works* of John Masefield. Couldn't find plenty that will become new favourites out of the many hundreds. At least Housman, with fewer stanzas, had more memorable hits.

SCRIVENERS' DINNER

To the Armourers' Hall for the livery dinner of Scriveners (motto scribite sciences – Write, Ye Learned Ones). Said to Consort, on leaving for the function, that this was the first formal dinner attended for some time when not expected to host, make a speech, or perform. No comment.

I was invited by their Master, whom I met when robing before attending a service at St Paul's Cathedral when both of us were Upper Wardens. We clicked instantly, an engaging person, cousin of Tommy Steele, had the same modest personality of that megastar. Arrived early, sat outside, felt inauspicious, then went into the hall – wrong hall, I had been sitting outside Girdlers' which I had pointed out the previous week to my two grandchildren when on the way to giving the posies to the Princesses Beatrice, Eugenie and the Lady Mayoress. I expect they, at their respective ages of 9 and 10, were not interested anyway. A silly mistake, considering I once dined at Armourers' when a previous Master Gardener held his Tradescant lunch there.

At the pre-drinks, met Master Art Scholars', a new livery, himself a former Master Upholders (meaning Upholsterers). He said his new livery has a policy of sourcing liverymen and women from all categories in the art world. They have cleverly developed a formula for all company members to be involved in the livery, regardless of their income. Two strangers asked if I knew one colleague, a former Master Gardener. I said yes but why him? He was

until recently one of the Ceremonial Staff of the Order of St John.

I was sure that one person here was the actress who played the black Queen Charlotte in Bridgerton. Probably not.

A former Lady Mayoress requested a glass of water. I volunteered to get it, duly did. Later, at table, sat beside her. 691st Lady Mayoress. At the table, her water glass was empty, the only one. She commented that her maiden name was Waters. Seated next to me on the other side was somebody whose name was Gardiner. She said her husband was a notary and, during recent lockdowns, participated in over 80 meetings with the International Olympic Committee on voting procedures and rights, including possible new sports for future Games, to select a new President etc, and could conduct all these activities via his home in Surrey whilst the committee was based officially in Japan. Said her husband had to be careful with his diet; too much wheat and his body produced the effects of beer and makes him tiddly. Her father was once a carpenter, became fed up not being paid on time, took advantage of a government scheme, switched to teaching, loved it, channelling the enthusiasm of his pupils whose ambitions soon had no bounds. I glanced at the former Lord Mayor three seats along. He had the look of a Roman Emperor. I thought you could put him in any costume and he would still have that distinct gravitas.

The Master Scrivener, sitting two from my right, adorned with medals. He explained them as the Order of St John, Order of the League of Mercy, Restoration of Poland etc. As Master, he could adapt the livery badge for his year, in his case a blue background to symbolise the sea, green the land, which together equalled Dover, two Tudor roses of England, Cinque Foils for Leicestershire. It constituted a fine metallic statement. He said 2023 would be the 650th anniversary of his livery and that there would be a hand-writing competition as part of the celebrations, and they were expecting well over 500 entries.

Afterwards, over the stirrup cup, met the Master of the comparable Guild to the Scriveners' in York, one of eight such Guilds. They seem to be popping up everywhere – Glasgow, Edinburgh, and now Chester was mentioned this evening as another location. Also spoke to one of the chaplains of the Chelsea Hospital, who was also of the Chapel Royal. Big man in all ways, personality, presence. I liked him, blunt but perceptive. Said Prince Philip once told him that a certain sermon of his was bullshit. He reflected with me on the recent memorial service for Prince Philip, saying that whilst popular, it was really a mishmash, and when he officiates, he insists on a strong, clear Christian message within the tradition of the Church of England, adding they can adjourn later and have Sinatra – and Tommy Steele?

Met two Americans, husband and wife, who thanked me

for not mentioning 9/11 as they now realised from having travelled so much that Britain had suffered much more during the Blitz than America had on that awful day.

I have had a long held ambition to kiss the wife of a former Lord Mayor, along with meeting Doris Day and climbing Everest. Achieved one of the three tonight.

14 April

The chair of the Metropolitan Public Gardens Association circulated today a piece from their minutes of 1895 of an amateur dramatic group in Bayswater, which had put on a play for the benefit of the MPGA in May 1894. Col. Basevi, whose daughter performed in the production, gave the proceeds to MPGA. The play, *Two heads are better than One.* 'In Honour Bound these Ladies and Gentlemen have given their services (included Miss Basevi.)' Thankfully, I don't know that play.

Also just received an email from a liveryman informing me that he is leaving us after many years, felt we don't have a sufficient variety of members any longer; there is too much talk about gardening. He will transfer to another Company. Found this odd. Our original purpose that of horticulture is still both popular and relevant. Surely it is a good thing that the balance of our Company is around half in horticulture as a profession, and the rest admittedly all love gardening, but their backgrounds are varied, and eclectic. But sad to lose such a nice member.

20 April
DINNER AT WAX CHANDLERS'

Not my best start. At the welcoming, their Master apologised again for not being able to attend my dinner at the Mansion House due to Covid. I mumbled something to the effect that there were a lot of people around, and it didn't help on that occasion not having the traditional stirrup cup, which would have enabled me to speak to him – but he wasn't there! I will include a suitable apology for my 'senior moment' in my note of thanks.

Spoke to the Master Farmer. I said I had read on the train coming in that Lord Plumb, former President of NFU and President of the European Parliament, had died aged 93. She said she was his hon. goddaughter. Beaten my little story, that I had once met him at a memorial service for a character in the Archers – and that he was also active in the Tree Council when I was at the helm. There were aspects of that memorial service which I will include in my own funeral.

At the dinner, the Master opposite was due to make a speech next week but hadn't started reflecting or composing it.

Another Master, one of the Great 12, said that to be part of that supposedly august group was a convenient title, somewhat hollow, and in her case, her livery was not wealthy. She said Vintners always had fine wines. I should think so. She said a year as Master makes one rather selective, demanding, even fussy about wines. Only invited tonight,

she said, because of the proximity of her hall to that of Wax Chandlers. I was invited because of our close association, affiliation with Wax Chandlers, we are currently partners in Pollinating London Together. Two Clerks sitting nearby, both ex-military. One, a brigadier, outlined how he saw the Ukrainian conflict ending, saying the West would have to give Putin something to save face, then have a neutral corridor defended by the UN. Asked me what I thought. Puffed up but drawing heavily on three years as a Lance Corporal in my school Combined Cadet Force, gave an answer which fortunately I cannot now recall.

I said I had once placed a non executive director onto the board of the largest Ukrainian chicken complex. I detected a moment's silence all round. After this person's last board meeting, he was driving with the CEO and noticed a 4×4 following menacingly, manoeuvring between vehicles in order to keep within gunshot of their car. CEO said it was his personal security officer.

Despite the light hearted mood of the evening overall, I felt it inappropriate to tell them of my other association with Ukraine. I had eaten a chicken Kiev before giving a speech, the contents spurted over my trousers, I had to remain seated while giving my speech, the organisers were duly perplexed and the audience no doubt likewise.

Master Apothecaries sat next to me. I reminded her that my livery had awarded her a Flowers in the City award. She said she remembered. She was in reflective mood, rather pessimistic about the long term future, suggesting that the

world will not be saved by bees, nor by her livery. At least Armageddon not mentioned.

Master Salter said her father had also been Master Salter and had once been their Clerk. Another Master said that he was advised to accept every possible invitation for his year. Advice I was also given, and whilst not good for the liver, it was good for the livery and for my dotage. He said that those who haven't been a Master don't really understand what it is like. I agreed, as it is unique, intense, demanding, constant, full on, enjoyable, privileged and unreal. We then talked generally about the criteria of membership to various liveries, some are closed and exclusive to their original purpose such as the Air Pilots, but those of an older foundation cannot rely on such a base. Yet another group of livery companies aim for a proportion specific to their original purpose. A further category offers a new interpretation of their remit, for instance the Fanmakers are now involved in propellor and wind tunnels.

When the Master Wax Chandler rose to speak, a motor-bike revved up in Gresham Street below, momentarily drowning his opening words. From my seat, I could see the building opposite, which replaced the hideous one I once worked in when employed unhappily with Coopers and Lybrand, and the scene reminded me of my then boss, who in turn would remind me repeatedly of what a privilege it was to work with these intelligent people. I needed constant reminding.

The Master said in his speech that there was a birthday

being celebrated here – turned out to be the Clerk sitting next to me. Piano played by the Clerk to the Plumbers' Company. Once shared a house with one of his predecessors, then it could be done as a part time job, his daytime job being a solicitor, when we both lived in the cathedral precinct at Peterborough. At that time in the precinct, lived an elderly lady with her pet chicken which roamed freely in the hallowed domain. She wanted me to meet and marry the daughter of the bishop, who at the time was the longest serving bishop in the Church of England. Came to nothing. Never even met the girl, however, I did meet the chicken on a number of occasions. But who wants to marry a chicken?

Wax Chandlers' has a special place in my heart. It was where I was inducted into the Gardeners' Company. That little ceremony conducted by the Master which includes being introduced to the Assistants on Court. I believe Wax Chandlers' Hall holds the record of being the longest continuous site for any livery hall.

Our Principal Speaker at dinner spoke of sustainable food, saying the young are willing to pay a little more to save the planet, adding that there are plants and menu choices for all tastes. Said his firm recruited former prisoners, not sure if he joined via that worthy scheme.

The same speaker said the biggest contribution to the carbon footprint is producing food which goes to waste.

Met up again with the Master Salter, said I once left her hall following a Court meeting still robed, approached by some schoolchildren who asked what this was all about,

I explained, and one never knows, that chance encounter might have steered a young soul into a future career in gardening. Such is life. Master Salter said their main reason for existing was taken from them when refrigeration was invented and replaced salt as a preservative.

Spoke to a Clerk of another livery who chatted about the cost of living. I said when I stood for Parliament, I was surprised how many genuine cases of poverty there were which fell between a myriad of schemes, one of which surely should have been of help and yet none were. He said we are all getting wealthier if you look at the picture long term. I agree. I said when I was at CBI, we had a representation on what was then the Retail Price Index on which the inflation rate was calculated based on various items or services. That definition constantly changes, as it should. Being deprived of an overseas holiday or the latest gadgetry shouldn't constitute poverty just because the majority of fellow citizens beg, steal or borrow to enjoy them, yet that was almost what was happening, then at least.

Met someone I hadn't seen for over 30 years. Said we must meet up again, exchanged cards. I doubt we will.

A full evening but a great one. First outing for my two teeth implants, a procedure completed earlier today. Smiled at everyone, saying that before the procedure, they x-rayed the whole of my skull, and where the brain should be, it was totally empty. I said, therefore, you can overcome any disability.

21 April
THENFORD

The much anticipated visit to Thenford. Still chuffed to have received a handwritten letter from Lord Heseltine last July, early in my Mastership, inviting us to make this visit.

In my opening remarks to the assembled fellow Gardeners, on this perfect late spring day, I reflected that most people would be content to be successful in one walk of life but that our host had been successful in three. There are many businessmen and women but few so successful; there are many politicians but few statesmen; there are many gardeners, but few whose creation has been summed up by *Country Life* as being one of the very best of the 20th century. Stowe is the horticultural manifestation of the Whig Supremacy. Thenford is the horticultural manifestation of a statesman who had vision but also, even rarer, the focus and attention to detail, and the ability to take advice and the money and resources to see it all happen.

I quoted a poem dear to me that was depicted on a garden wall in my childhood home, that poem by Dorothy Gurney:

> *The kiss of the sun for pardon*
> *The song of the birds for mirth*
> *One is nearer God's heart in the garden*
> *Than anywhere else on earth.*

I know where the Garden of Eden is. It is a mile off the A422.

70 acres, the creation of the Heseltines. When they arrived almost 50 years ago, there was nothing here but sheep grazing fields with silted up lakes. Now a rich mix of all things bright and beautiful. A stunning location, a patchwork of beauty touched by man. Being spring, the magnolias in bloom, a proliferation of blossoms, and beyond the fold of the gentle hills, the simple symmetry and perfection of the Queen Anne house. The medieval lakes, the newly constructed barns, all in mellow local stone, the unspoilt church, silent and timeless, approached down a path lined with wildflowers of spring and passing the eternal resting place of local folk.

The rill is as good – better said one – than any in Italy. The Lenin bust acquired after the fall of communism in Latvia, now dominating a hedge-lined sculpture park, somehow seems to be at home. A gardener in the walled garden told me that garden designers don't always consider the practical side of maintaining their evolving, maturing creations. The Head Gardener's cottage incorporated in the walls of the walled garden, as tradition dictates, looking lovely, but apparently, a fudge, bits added to windows, a porch added, a touch here, a touch there, to transform a basic building with this makeover. But look at the back – still basic and a bit of a mess. And why not, because it is not on view.

Over a delicious tea, one Gardener asked me about

my work on the board of the Gardens Trust. I told her the board is responsible for ascertaining whether a proposed development would adversely affect a listed man made landscape. The Gardens Trust publishes probably the most weighty and respected journal on garden history. I mentioned an interesting article by a garden historian who had conducted an insightful study of iconic Rousham, a garden nearby. This writer, who was by training a linguist, had worked during the war as a decoder at Bletchley Park (not just mathematicians were recruited). One day, she had noted an Italian signaller's punctuation that alerted her to an Italian battle plan off Greece, which resulted in the Allied victory off Cape Matapan. She said little did Mussolini know that a humble full stop would be responsible for the defeat of his navy in the Mediterranean. We ended by both wondering if we should have a closer link with the Gardens Trust? They too have interesting visits to gardens such as Thenford. Could both memberships enjoy each other's programmes?

Lord Heseltine a consummate host. Slightly subdued. Little of the 'Tarzan', but thoughtful and generous throughout, as was his wife and son. He drove his buggy and provided a unique bus service for those Gardeners in need of assistance. Driven by a former Deputy Prime Minister, by the Prime Minster we never had. I told a Gardener that I once met a former adviser to Michael Heseltine, who said he never knew the man despite working closely with him for five years.

4 May
ROME TRIP

Due to early start for our long anticipated Rome trip, the Consort and I have spent the night at the Premier Inn at Heathrow. Arrived and found Heathrow has two, and that this was not the one we had booked into. They allowed us to stay.

Woke early and watched 'Hardtalk' on the TV at 4am. A banker said Putin possibly the wealthiest person on earth, fortune acquired dishonestly, squirrelled away by various means, for instance, by paying a violinist who happens to be the goddaughter of one of his cronies two billion somethings a year. I thought one of our Rome party was even wealthier, will be less sycophantic towards him.

At the terminal, spoke to one of our group who, as a sideline, advises film directors on all matters pertaining to the RAF for films. Seemed to be a few such around. I once had a colleague whose husband also advised on military uniforms of certain periods, she would complain that he would invariably point out historical inaccuracies – Charles I mounting the scaffold wearing the wrong buttons etc. Once watched a film on the lovely Heriot vet books, a friend with me, himself a farmer, said the gate in the film was a modern design, not contemporary with the period depicted.

Just read in the *Times* that there are about 20,000 wild boar currently plaguing the environs of Rome. Think

it is my duty to inform the group and offer reassurance, reminding them of their good fortune to have a macho Master following two women.

During our stay the weather is forecast to be cooler than it will be in England.

Guide said on coach, England has a longstanding friendship with Italy and hasn't been to war with them since the Reformation. Surely not so? We fought against them before they changed sides in the Second World War. How very Italian to switch sides and then to expect to take part in the victory negotiations.

Arrive at Torrecchia Vecchia, deep in the Castelli Romani hills south of Rome. Negotiate a long private drive, at least a mile. Manor house surrounded by ruins, once owned by the Papacy and the ruins once a village of some substance. Current owners bought it without seeing it. They visit it only once a year for 15 days, the rest of the time just maintained. The natural planting amongst the ruins now matured with deep ravine and wooded hillside beyond. Spectacular and truly memorable multicourse lunch al fresco, beneath a large, fragrant, white wisteria adorned pergola, eating buffalo meat, fortunately without knowing.

A challenging planting regime – how not to damage the ruins. We constituted their biggest guest group ever and were discouraged from wandering off, not sure why, as, like many, indeed most Italian gardens, there is a marked absence of formal flowerbeds.

One Gardener, as we strolled, told me her garden is

stocked with the bounty of 19th and early 20th century plant hunters. Lucky her.

Coach just managed to squeeze through to reach this location. On returning to the coach, one of the party stumbled, bringing down our guide, both almost ending up at the bottom of the deep ravine.

Second garden visited same day, first day of visit, Ninfa – one of the most celebrated gardens in Italy, indeed anywhere, but received a slightly lukewarm, mixed response. Ruins again, including one church where Pope Alexander III was crowned – I wonder why here, must find out. It is styled as an English 20th century romantic garden, with roses, jasmine, wisteria over the ruins, tender plants sheltering within the walls of the churches and houses. The work of three women over a period of 90 years – Anglo-American, Anglo-Italian nobility. Water from the mountains so pure it enables a type of trout which can only survive in the purest water to be present here. *New York Times* regards the gardens as one of the four most romantic in the world. Don't agree. One of their gardeners had been there for 50 years, then moved to the garden we had just visited. Our guide, when arranging the two visits, detected a touch of animosity between the two gardens, and a degree of lack of cooperation was the outcome. Why was the visit to this garden not 'wow'? Perhaps because the wild areas felt abandoned rather than managed in a subtle way, and the formal areas did not compete with what we have on offer in the UK.

On the coach to the hotel in Rome, one Gardener said her sister had worked in the British Embassy in Washington in the Blair/Clinton era when Meyer was our man there. Exciting times, plenty of networking, naked ambition, not for my friend but perhaps all right for her sister. Same person had a reference book on gardens of the world – which ones to see before you die. It was grouped by countries. Far and away the most were in England with over 1300 named, the next nearest was the USA with 500 or so, with most fewer than a dozen. Not an English publication. Coach driver the least cooperative of his breed, said English people always make coach drivers go where no coach drivers have been before. He also announced to the tour leader that he wanted a tip at the end of our visit!

Went out for dinner with a few Gardeners plus the guide. Began to rain, umbrella vendors appeared immediately. I respect their entrepreneurialism but not their product which was virtually useless. Dinner with eight. One said at dinner her father had left school at 16 and ended up as Chief Air Marshall, and who had once said a man should hold a woman around a waist and a bottle of wine around the neck. Another, a spritely 86-year-old, said she had once rolled down the longest mountain in Europe, survived almost unscathed because she had been taught how to relax and curl up like a ball. She was once a professional actress and opera singer, met her second husband, now sadly dead, when performing as Yum Yum in the Mikado and a member of the audience gave her red

roses, pursuing her until she accepted his proposal. Later, between them, they established the largest container grown trees business in Europe and now runs a livery for 22 horses. Sadly, last week two of the horses were ill, one a foal which subsequently died, incurring a £6000 bill – no insurance! Her son was performing tonight at the Barbican as the lead violinist. A brilliant achievement but poorly paid. Once stayed in a Travelodge in Leeds the night before a concert but kept awake by rowdy behaviour. Another at dinner, related a time when his credit cards were stolen but cleverly and surprisingly not the wallet. He didn't realise until later when his cards had already been used.

Caught up with another couple to see what they had done this evening; visiting Italian friends, had passed a park with long grass which the local Bangladeshis had cut themselves in order to play cricket and where annually in the valley, deer are herded and shot. We are in Italy.

5 May

Whilst waiting for the others to come down, read in the hotel lounge in a coffee table book, 'All truly great thoughts are conceived while walking', a comment by Friedrich Nietzsche. Pretty true. Then a few pages later, another quote, this time by Balzac, 'A man becomes rich: he is born elegant.' I suppose so, a bit like style and gravitas, hard to define, easy to recognise, almost impossible to copy.

On the coach to Villa Farnesina to view its stunning ceilings and wall frescos of vegetables and fruit, the guide

said a garden we were visiting today is on one of Rome's Seven Hills, but that there are actually ten. Most places seem to have seven hills, even Luton does. On the way, the guide said Rome suffers greatly from badly developed outskirts – telling me! – and that the previous two capitals of the then newly united Italy, Florence and Turin, fortunately for them, held the mantle only briefly, not long enough to suffer from developments of this nature. Past red light area of Ancient Rome.

Arrive at the headquarters of the Order of Malta in Rome, variously known as the Knights of St John of Jerusalem, the Knights Hospitaller. Peep through a gate, enabling us to see a long avenue to the dome of St Peter's, thereby seeing three countries – Malta, Italy, and Vatican City. Only got access due to a friend who knew a former Grand Knight. Knights of Malta issue their own stamps, have their own legal tender, their own car registration numbers and passports, have ambassadors to several countries, are not masonic, are very wealthy due to legacies, rents, and have spent and invested, wisely. Last election, two women candidates for the first time, both unsuccessful, but at least a start. One of our group told me her husband is a Knight – a Protestant rather than a Catholic one – that the Americans are trying to impose a corporate culture on an aristocratic structure, and it won't work. Outside the gate two original Fiats parked side by side, apparently nicknamed 'Belly buttons', as everyone has one in Italy.

Grand Master, although sovereign, feels obliged to gain

the blessing of the Pope. Not too long ago, the previous one, a Scotsman, dismissed by the Pope. The victim of friction between the conservative and liberal wings. Being sovereign, he didn't need to obey the Pope, but nevertheless did.

Church spectacular. A Piranesi masterpiece. I found myself sitting beside his tomb, most of the interior is white, light, elegant, spectacular. His tomb full of symbolism: a skull for the vanity of life and snakes – often depicted as a negative force, but here he made them a positive one – a definition of eternity, and a play on the name of the hill we were on, 'The Hill of the Snake'.

13,500 Knights worldwide, 80,000 volunteers. On wall leading to other rooms in the palace, a large portrait of Pope Leo XIII with a Mrs Murphy.

For lunch, rabbit. Fortunately not aware I was eating it.

The person beside me told me when visiting Venice with a wealthy friend, her friend had fiddled with her ring, it fell into the canal. Being wealthy, she hired divers who retrieved it. I said my father's hat once sailed off at the entrance of the Grand Canal, but educating two sons, he couldn't afford divers. It's probably still down there with a hat or two of a Doge.

On the coach again, guide said only two metro lines in Rome because of all the archaeological remains below the surface. Also learnt that cypress trees are planted in graveyards as their roots go straight down and don't disturb the dead.

Afternoon visit to British Residency garden at the Villa Wolkonsky. Not much cooperation in arranging the visit, they knew our day, had agreed to it, then said later no visits permitted on that day. I said no way would we revamp our itinerary – we got in. Previous ambassador, a woman, recently left after a relatively short time, married an Italian and her replacement was one of Cameron's contemporaries from his Oxford days. Surprise, surprise. At the beginning of the visit viewed the museum of items retrieved from the garden, some very splendid; a major Roman aqueduct weaves its magic through the gardens, even through one of the buildings. Excellent guide, as was the one this morning. Asked her who owned the archaeological items and should the UK vacate the premises, who would take possession of them? 'You English are good people,' she replied – meaning, presumably, we would do the honourable thing and return the items to the Romans.

Much of the contemporary garden, the work of the wife of the previous but one ambassador, she has done a splendid job. Needed much work, especially after the last war, as a result of Germany requisitioning it. A fine building, once the palace of a 19th century Russian Princess, who conducted her famous soirées here. The Nazis tortured in the basement. A lovely statue, beheaded during their occupation – the ambassador's wife is still hoping the head will reappear at some auction somewhere someday and will be happily reunited with its torso.

6 May

Email this morning from a Nigerian asking permission to set up a Housman Society in Africa – I am chairman of the Housman Society. Apparently, Housman is popular there, even in the shadow of Mont Kilimanjaro, and even if none there will ever visit those 'Blue remembered hills', or see Bredon Hill or the Clee Hills for themselves. Also email invitation from Lord Salisbury, to celebrate the 500th anniversary of the birth of his ancestor, the great Lord Burghley. Alas, can't make it.

Logistical challenge to get into the Vatican. Our group too large to be a single entity, something we knew in advance. Our group guide took one half off with him, gave me his laptop with our tickets on as evidence so the rest of us could get in. Last words, 'It won't cut out.' It did. All calls in attempt to reach him were redirected to his office, despite his best endeavours to avoid this. Tight schedule. Time ticking. Anxious Gardeners. Eventually persuaded the authorities we were bona fide visitors.

Another great guide for the gardens. Strolling in the gardens, our guide said, as a small tourist bus passed, 'Lazy people!' 'I heard that!' said one on the bus. We walked on, saw where retired Pope Benedict XVI lives. I said a bit of friction between the two Popes. Apparently, all tabloid gossip. English garden a mess. No flowers, just weeds. Did they consult an English gardener? Apparently not,

must offer our services to create a plan to do our national horticultural prowess the credit it deserves.

Past a flower, one Gardener said it came from his native South Africa, another said he grew it all over his property at home, the former said it was incorporated into their national flag. I dropped further back, another conversation, this time about south facing walls, often a real benefit. I suggested fine for a few years, but if a plant is growing at its margins, it will succumb sooner or later from a severe frost. Felt pleased at that contribution, but no take up. A motorbike weaved past. I said it might be the Pope incognito, checking on his flock. Another, who had once worked for the Sultan of Oman, said the Sultan would disappear into his fiefdom from time to time in disguise to check on things.

We reached a lovely statue with a pond where the Pope has his favourite 100 turtles, all sunbathing except one, which was having a swim under the watchful eye of a voluptuous female statue. A Gardener said he had a friend who once saw a fish jump out of a pond, gave it the kiss of life, and put it back. It swam away contentedly. The same person said he had swum naked in the Trevi Fountain. Thankfully when only 6 ¾. The group leader told me the Spanish Steps aren't really Spanish at all and that he knew the person who had recreated the gardens adjacent to them. This friend invariably disliked the nationality of the country he was working for at any one time, with the one exception of apparently never saying a bad word about the English. Some like us. The Spanish Steps were designed so that

horses could go up them, rather like at Fontainebleau. One in our party said she had similarly designed steps on a less grand scale at her childhood home in Jersey and when her mother was ill, her favourite horse was taken up the steps to cheer her up.

On returning to the coach, having seen briefly the Sistine Chapel, so crowded, and a few other rooms of great wealth and beauty – hardly true to Christ's words to find him not in the palaces of princes but in the desert. Our driver said not allowed to drive after 6pm. We had a lunch booked, then a 50-minute drive to the Pope's summer residence. Further delay and pressure on time. Two of the party missing – one being the Consort. The guide says he would find them, and take the missing two by taxi to the restaurant. He then disappeared. The driver spotted the missing two. Then the guide reappeared. Cheers all round, we moved on.

Over lunch, one said best health policy for a country is to keep the nation healthy to age 65 and then kill them all off. Also said, in the US – she was English but living there – the poor whites keep the blacks down, needing them to step on. Told by our South African friend, poor blacks in his country are more mobile and often more successful but are doing the same increasingly to the poor whites there. How can the Pope put up with such human nature?

At the Castel Gandolfo, the summer residence of the Pope, need Covid passes. Some had them, others didn't. Some waved on, others less fortunate. Knowing that all had the required vaccinations I told some to slip past while I engaged the official in conversation, assisted by another

who had made it through – she passed back her phone with the NHS app to the person behind. Divine intervention.

The garden's terrace overlooking a lake, spectacular, formal, no colour. Saw all the Popemobiles in the courtyard.

I asked the husband of one of our Gardeners, who has been Master of another livery, what trips had been on his programme. He said one highlight was visiting the battlefields of the Western Front. There was a delay in leaving the site – illegal immigrant, found clinging precariously to the undercarriage of their coach.

7 May

We stopped briefly to stroll through Rome's Botanical Gardens and visit the gardens on the Aventine and those at the Porta Maggiore. Statues of literary giants from many countries. All had gulls or pigeons sitting on their heads. Christened by birds who didn't differentiate between Nobel Prize winners, national poets, or whatever.

At lunch, one Gardener asked if the meat was veal as she doesn't eat veal. We said no. She ate it. It was – and she never knew. Join the club; previous day rabbit, two days ago buffalo. Getting more adventurous and may soon do what the Fijians did – despite their Methodist leanings – eat the occasional person. The flesh at the base of the thumb of the female hand is apparently the tastiest of all. My father-in-law knew a Cambridge don in the 1960s who had eaten human flesh. I once said in a welcoming speech at a livery that my father-in-law had taken a cricket team to New Zealand

in 1948 by boat. One member of the team said there was nothing on the menu that took his fancy, but could he see the passenger list. That went down well.

So much to see – Villa Giulia, 16th century gardens of Pope Julius III, then to Villa Borghese before going on later to Villa Medici. At Villa Medici, one of our group knocked over a particularly sophisticated Italian engineered Covid sanitiser stand which hurt another fellow Gardener. This was the third time this particular Gardener had been injured on this trip. An official appeared saying we would have to pay for the damage. Our leader said it shouldn't have been so easy to knock it over and told me in English that they would probably forget. They didn't. When I collected my umbrella at the end, they wanted my full contact details. I said that we might have to sue them for damage to my fellow Gardener and that I also had their details.

Before leaving, went to the cloakroom; next door was a 6th century version which reminded me of the French loos of the 1960s and 70s.

Held a semi-formal dinner on the hotel terrace. Gave my Latin school grace in sight of the Dome of St Peter's; I can still remember it as my school days are not so distant as those of some here tonight. Later, in my speech, I said that Rome was defined by seven different types / regimes of tree planting: Ancient Rome, native species e.g. Holm Oak; Medieval Rome, trees that grow spontaneously and were used for timber and for their fruit; Renaissance Rome, trees that could be linked to the Roman type villas; Papal

Rome, Elms and Mulberries; French Occupation, those now found in public parks; Pied-Montese Rome, hybrids; Post-war Rome, with streets and buildings in mind.

I said that Rome was home to more monuments than any city in the world, yet 92% of Rome is modern and contemporary. We will have been here for 4.5 days. The average time spent in the city, however, is a mere 2.3 days (London 6.2 days.) Goethe said, 'I have been in Rome two years and I still haven't seen it all.' 68.3% of Rome is green spaces. In 1950 Rome reached the same population as it had in the time of the Caesars for the first time. The Vatican is less than one acre, but the Catholic Church owns 1/3 of all real estate in Italy. It is said that the best Roman songs capture the cynical, tragic, romantic, disenchanted, ironic, and bitter soul of the city. Having overheard our group leader call me 'Il Presidente' on the phone a little earlier in the day, I now requested in my speech that in future, I would like to be addressed with that title. May be the first for a Master of a livery – Master, Prime Warden, Upper Bailiff, Il Presidente.

I then asked our tour leader to reflect on some of the inner soul of Rome by introducing him thus:

> 'If, as is often said, the Trevi Fountain takes the bronze, the Vatican the silver and the Colosseum the gold, we can add one more to that podium, that of Robert who has guided us through this fascinating and unique city and especially its horticultural delights.'

Robert, in his little speech, said on one occasion, due to the disruption by the volcanic ash in Iceland, the plane back to the UK had been cancelled, so he hired a coach, and when the two drivers arrived in London, they commented on what an exceptionally beautiful city London was.

Given two super pictures of Rome by the group with some generous compliments.

Over dinner, sat beside a designer of jewellery of such quality and reputation that she qualifies to exhibit at Goldsmiths but she chooses not to. Also, along with her husband, seems to be a world expert on laying cobbles. I will test her on this little holiday.

To my left, the Gardener said he once worked in Somaliland, and only Toyota 4×4s could traverse their unlaid roads where Defenders once reigned supreme but do so no longer, partly because it has ceased production but also because the vehicle became over sophisticated and it was impossible to find spare parts locally. The person to my right, the wife of the person to my left, met her future husband at a funeral of a young musician who had inherited a legacy despite not being the obvious recipient, felt guilty and had killed herself.

8 May

On the coach to our last garden. Mutterings overheard from the seat in front. Fellow Gardener saying there were not enough seats in the Pope's Summer Gardens, another that there was not enough time to sit and stare. Most did not

agree and all had been informed of the pace and intensity of the trip. One wanted to return early to Rome in order to shop.

Chatted to a Gardener. Has CCTV at her home, could see her house sitter going in and out, and told me that her sister, on a previous occasion, had seen an intruder on the screen, had secured a good picture of his face, but the police were still not interested, feebly arguing that there was a momentary break in the sequence of the film so it might conceivably not be the thief. Pretty daft, door open, uninvited person leaving. At least that community now has a Miss Marple, self-appointed, who solves crimes and rectifies misdemeanours.

Another on the coach leant over to tell me that today is Liberation Day in Jersey and also Naked Gardeners' day in Germany. Don't fancy one or two fellow gardeners adopting a similar day in England. Another said always stay outside a coach to see that your luggage is safely loaded; wise traveller's advice.

The garden, La Landriana, designed by Russell Page is a gem – various rooms, the brilliance of Page, the willingness of the Italian owner to accept his advice, and the result of years of maturity. Initially, the sight of the garden was barren at the end of the Second World War, with bombs and troops on the way to liberating the rest of Italy. Italian record in that war lamentable, reminding me of a phrase applied in a previous era 'the situation is hopeless, not serious'.

Enter Russell Page, who showed the owner the difference between a garden and a collection of plants. Consequently, we walked through an English idyll with trees free to grow yet chosen for their special effect, with always a secret to discover just beyond what can be seen at any one time. Russell Page once wisely said about garden design, 'Know what it is you want to say and then try and express it as simply as you can.' His gardens are understated, unfussy and invariably inspiring. I also rather like what another gardening idol of mine, Christopher Lloyd, once said, 'Never be ashamed of a disaster as long as it is not repeated.' He could have said, as somebody else once did, 'Gardening is a matter of hope over experience.'

Kept trying as we progressed to avoid squashing hundreds of tiny frogs hopping around the paths. Managed to save one after great effort.

Approached the lake, the ultimate destiny of the frogs. One Gardener said her husband had acquired frogspawn for her pond from a biology teacher at her local school, they became buddies and thereafter were invited to all school functions. Another Gardener told me he got rid of his pond weed by introducing a certain fish. The fish were being eaten by a heron. He bought a decoy heron which worked briefly until a heron befriended it and started eating the fish again. A few fish survived, became large, didn't then breed, but at least they ate some of the pond weed.

I dropped back to speak to another; she said her grandson wanted a dog, was told 'no,' he could have a cat and

that it should be a disabled one to teach that all creatures, as all people, are equal.

We passed a magnolia, our knowledgeable guide said it was a very rare one and getting even rarer as the insect that propagates it is now extinct. At the conclusion of our visit, I thanked our guide, gave her one of our Company shields. Later, one member said the balance of compliments was just right; two plus two equals four or even five, and appears honest, but to say that two plus two equals 30 is a lie.

At the garden, the toilet sign was of a dog. One asked me, as Master, do we have to lift a leg? On leaving the said place with another Gardener, we noticed a large abandoned area formerly of greenhouses. He said he was in that business and the margin between success and failure was very thin, that materials deteriorate and fashions change. Need to secure the structures against abnormal weather, but also have to decide to what degree; too much equals too expensive and could even affect their effectiveness. He knew a civil engineer who described the scenario as, 'Not fail safe, but rather safety fail.' My companion added that nothing manages its affairs on earth as well as a tree does, getting the balance right in order to survive the extremes and look at the tree in front of us he said, all made out of sugar, starches and water, created above ground so why doesn't a hole appear below ground? No idea, but both agree, all a miracle. Will tell the Pope if I bump into his Holiness. He told me Prince Charles once said, 'We can go to the moon but we can't create a blade of grass,' that photosynthesis is one of the most incredible processes of all.

Spoke to another, pointed out a lovely bulb. He had some at home, had picked the original one up which was loose on the floor of his local garden centre, knew what it was, was given it free and he now gifts some to friends and neighbours. Another picked up a four leafed clover. I told her of the time I was with my then six-year-old granddaughter explaining that there are such things but, alas, I had never seen one. At that precise moment, she said there was one at her feet. There was. It is now pressed for posterity.

On the return journey to Rome, our leader warned us of the narrow streets often unsuitable for cars but, being Italy, likely to encounter them nevertheless with scant consideration for pedestrians. Reminded me of a spoof advert for a car, 'Designed by Italians, built by Italians, driven by Italians.' The car crashes into a wall. My theory is that without the car, their population would be double. Very little decent countryside all the way back to Rome, a fact I had noted previously. Ribbon development, dilapidated dwellings, etc. Even Rome was looking tired; near the Colosseum in a back street only yards away, long discarded rubbish, weeds, empty buildings, the permanent air of abandonment and gloom – evidence of unpaid taxes!

We passed a number of livery yards, a grand title for a hotchpotch of temporary buildings and a few horses. The person beside me on the coach said riding accounts for more accidents in the UK than boxing but that the bond between rider and horse is amazing. Passed a shop called 'Sexy Shop.'

I moved to be sociable with another Gardener on the

bus. He got out his laptop, showed me a recording by the daughter of another member of our group concerning Ukraine, which was pretty telling and insightful, and the mother then said that her grandson, aged four, voluntarily decided to sell his toys for the war effort – a future Secretary General of the UN. Heard it here first.

On return to Rome, Consort expressed a wish to visit the cat sanctuary at the Piazza Argentina. The taxi driver didn't understand what we were seeking, 'Miaow, miaow,' said I. We came out having adopted a half-blind cat called Jefferson for our two granddaughters for a year. I thought I had got off lightly. Then she said, 'Of course, we will renew the adoption.' Later, I gathered others had bought Gucci etc.

Ten of us joined up for dinner. Beside me, a former Lord Mayor. She said that she had been only the second woman to hold that office. The City were looking forward to a female Lord Mayor, the first one being some time ago, and the only previous one in almost 800 years. They were even undecided on what to call the Consort, despite a realistic precedent by the long established Lord Mayor of Westminster where there had been female officeholders.

As Lord Mayor, she had a budget from the City Corporation for all her costs and had to live on it or pay the extra herself. Much of the red wine for the banquets had been purchased but she had to taste over 30 white wines in an hour. Her palate eventually protested and, after a while, she was unable to choose! Further reflections by the former

Lord Mayor: all experiences cherished; it was less satisfying sitting between a married couple because, when you turned to one you often got the same or similar stories from the other. On visiting the Indian Stock Exchange on her travels, her host assumed she was the Consort being female and gave her the bouquet. She is a former Master Plumber. Said in UK no legal requirement needed to be qualified to be a plumber, unlike the scenario to be an electrician, nuclear scientist or brain surgeon.

I wasn't going to tell her about the time my toolbox was confiscated by my wife – twice in fact. The first time, and when newly married, I put a picture up above the bed and told her to go and look at it. She did and said she couldn't see it. It had already fallen down. The second time it was confiscated was when, in order to rectify a springy floorboard on the landing in preparation for a new carpet, I put a nail through a hot water pipe. Still have moments when I can see the water dripping through the ceilings and light fittings below. My wife was eight months pregnant and nearly gave birth on the spot.

On my other side, she had adopted two Chinese orphans when only weeks old, not sisters. They are now young adults and both girls are flourishing. The victims of the Chinese one child policy and cultural preference for boys. The babies had been left at public places with labels giving their dates of birth and nothing more. Most other girls in a similar situation were less fortunate, regarded as disabled when they were not, and left to die or to become institutionalised

for the rest of their lives. Quite horrible and it upset me deeply, yet for their new family, their girls are truly a gift.

One of the fellow Gardeners presented me with a thank you card featuring Pope Francis with the caption 'Why I chose Francis? Because he embodied poverty. I want a poor Church for poor people.' Has he visited the Vatican?

9 May

Scheduled to attend as a non player Blackheath Livery Golf Day. Unfortunately, due to the flight back from Rome being cancelled and rearranged for the next day, the day of the Golf Day, I couldn't give the prize at the dinner. A wretched nuisance. Feel I have let them down but actually beyond my control. Two of the golfers were with me in Rome.

10 May
CHARITY REQUESTS

Various requests for smaller specific amounts, which included paying for a social impact coordinator one day a week for four months, reaching an additional 100 plus volunteers and training them in basic horticultural techniques at a farm. Another, to improve alleyways in the historic centre of Ormskirk. A further request for dementia support to create a memory garden for customers, carers and for activity attendees. Apart from the rather strange terminology seems an excellent idea to me. Failed to secure monies for the young plant collector at the Oxford

Botanical Gardens. It was felt that the gardens have access to plenty of funds already. Frustrated and disappointed.

12 May
UN INTERNATIONAL DAY OF PLANT HEALTH DINNER

Met at Guildhall. Given wine from oak leaf, very strong, almost had the effect on me as oak wilt. I asked for more. Met a PR person. She was rather over the top. Had dismissed her staff during lockdown, reemployed most later, business now booming, apparently. Her friend said she was the best PR woman in London. Turned out friend was the godmother of the declared PR star. Husband of the former produced a book on favourite trees chosen by celebrities. Told him we did a similar one at CPRE, *Icons of England*, proved successful, people rather like that sort of thing. Another from up North, said his friends up North couldn't grasp how he had managed to become a liveryman, I thought not that difficult, there being over 80,000 – he was of the Painter-Stainers' Company.

My table was interesting – Table One. Dame Judi Dench, M to James Bond, only made Table Two!

To my left, Associate Editor of The *Times*, whom I knew and had previously put on a CPRE committee. Said I enjoyed the biography of her grandmother, high up in the WVS, wife of a Nobel Prize Winner and daughter-in-law of another winner (I recalled her grandfather being notified as a young man in the trenches of that award). She added

that her grandfather and great-grandfather on the other side had also both won Nobel Prizes. I said surely that must be a record. Apparently not – a French family have five. Family owns one of the two most significant oak arboretums in the country. Invited down and hope to take up the invitation.

Also on the table, Chief Plant Health Officer for DEFRA, gave an address which on the whole was encouraging about the likely state of tree health going forward. Plenty of work in hand, indeed only today she had opened a new research facility. Another on the table was Under Secretary of State at DEFRA, now in the Lords. I had met him when he held a similar role as an MP and when I was Chair of CPRE, addressing the local county branch at their AGM. Said to the President of the branch who collected me from the station and was the Lord Lieutenant that I knew the host well. Turned out I knew his father! I am getting old. Wonderful stately home, ramp at front door, installed for a visit by Queen Elizabeth I. To my right, an interesting person, who once worked for Alex Salmond when First Minister, at the time of the Scottish referendum. I couldn't resist telling her what I thought of the current First Minister. She agreed wholeheartedly and said that Salmond had told her to find the supposed evidence to make the case for independence. When she couldn't and told him so, he – after some bluster – accepted her point. Another speaker, this time on zoom, was the President of Zambia and spoke on tree health generally.

Between the first and second courses, one eminent

person at my table said that trees in the UK have a value even beyond their aesthetic and health attributes of around £175 billion. A fact that should help the case to appreciate and protect them. Another speaker, responsible for trees at Kew, good speaker, been on TV, indeed I had seen the programme he did with Judi Dench – reflected on the time when he was blackboard monitor at school, ritual of going down a long playing area to beat the dust against a horse chestnut tree. That tree inspired him to become what he is today. Returned many years later. The large playing field, in reality, was a very small patch. The mighty tree a modest specimen. The teacher, who was inspirational and had predicted how the buds would open over a weekend, was now long since dead.

One person on the table had gained horticultural experience in America. She said that someone she met there had told her that when blacks were interviewed for a job in certain government departments, they would be asked, at random, to name, for instance, the 24th President, whilst the whites were merely asked to name the current one. We then got on to lighter matters. She asked about my year as Master. I said that I regretted few things, not the things I did but the things I didn't do, was so grateful for the privilege etc, but would have liked to have had one formal event at Vintners Hall. It had been on my mental list ever since I dined there and I noticed the reference in their hall from a different era. It referred to the Amicable Society, which met at the Bull Inn in Bishopsgate and that

Mr van Horn, a member, consumed on average four and half bottles of wine each and every day throughout his 22 years as a member – he missed only two; for the burial of his wife and the marriage of his daughter. He died aged 90.

Another speaker said that the Corporation of London, owning 11 000 acres, including six SSSIs, can play a big part in mitigating the adverse effects of climate change. Reminding us also that London is prone to moth blight which is attacking oak so no new oaks can be included in the planting regime for the Queen's Canopy in London, that a large oak tree is a little acorn that refused to give up. He said we all have a small bottle of whisky in our goody bags and that if all the bottles of whisky produced in a year were put end to end they would reach within 98% of the distance to the moon so let's drink a further 2% and get there. A bit like a comment I once heard from a Harry Ramsden director that all his chips produced in one year if laid end to end, would reach the moon – I've got a feeling he also said, 'And back again.'

Met current CEO of the Tree Council. She recognised my name! Made me feel good.

Left generally feeling optimistic. Plenty of useful research on disease resistant varieties. Even for ash; we will certainly suffer meanwhile greatly from ash die-back, but it was predicted that somehow ash would survive in our landscape.

13 May
TRADESCANT LUNCH

Normally held at the end of the calendar year but postponed because of Covid. We celebrate father and son, both called John, latter a member of our livery, and both among our most important plant collectors and travellers of the 17th century. Held at Founders' Hall for the first time, now acknowledged as one of the first post war buildings which will add, in due course, to our historical architectural heritage. Most of us couldn't find the entrance, but once inside a modern gem with a small hall and lovely gardens adjacent and were able to observe the lush foliage through peephole windows. Brief charity board meeting to discuss motion for the long overdue revamping of the charity board. One committee member showed me an article in today's *Daily Telegraph* about a garden we are helping to save with grants and another with a beady eye noticed cucumbers being grown in a greenhouse, commenting that most horticulturalists and fruit growers have abandoned the idea of growing cucumbers due to rising energy costs. This garden apparently could afford to grow them. Not much passes us gardeners. Grace admirably given by the Hon Chaplain.

> *'Two Johns lie in Lambeth churchyard,*
> *Both gave gardening a boost in plant collecting,*
> *And gave us magnolia, tulip, phlox and asters,*
> *We are told angels shall with trumpets waken men,*

And fire shall purge the world ere resurrection come.
The garden tomb will change then to Paradise
Bless their memory and our food Good Lord.
Amen'

Another gem from that source. How does he do it? And his contributions to the deliberations of committees are amongst the very best. Reasoned, reasonable, perceptive and deeply appreciated.

One of the best lunches enjoyed anywhere. Noted that the Founders' Company had two 17th century charters. One from the 16th century, one of the few bodies charged with the 'sizing and sealing' of weights, with weights coming in different forms and designs, depending upon the commodity being weighed. A pair of Queen Anne weights were on display on loan from the Worshipful Company of Woolmen. Noted the fare for a Court dinner of the Founders' in 1934 – clear turtle/ cold salmon/ quail pie/ cold saddle of lamb / cold smoked tongue/ iced souffle petits fours/ dessert/ coffee with wines to match. Punch (Birch's)/ Sherry (Domecq's) / Hoq (Liebfraumilch 1929)/ champagne (Geo. Goulet 1921) / Port (Martinez 1908) / Brandy (Rouyer Guillet 40 years old)/ Benedictine Dom. O. M. Eve. No wonder they are now all dead.

Instead of the traditional deliberation on the Tradescant elder and younger, one a liveryman of ours – naturalists, one a liveryman of ours, plant collectors, gardeners to royalty, and founders of the first museum to be open to the public, introducing many plants (I felt we had exhausted

all there was to know about these two worthy souls) –
I approached a member of Court to speak on a different
topic. He obliged and spoke eloquently about the plants of
his native South Africa – home to 9000 plant species found
nowhere else, with such concentration of variety per unit
area. Kirstenbosch, the truly wonderful botanical gardens at
the base of Table Mountain, whose gardens at Chelsea won
the gold in 1929 and 1933, is regarded as possibly one of the
seven wonders of the horticultural world.

Beside me, Renter Warden and so next Master but one,
off to Canada next week – had only just returned with me
from Rome – to have a sort of closure for brother-in-law
who died in Canada, wanted no funeral but have his ashes
scattered near North Berwick in Scotland. He talked about
Sam McLaughlin, who founded the automobile company
that eventually became General Motors in Canada. He had
built up a successful motor business and on the proceeds
had built a famous art deco mansion in Canada, left it to
the local next door hospital which wanted to pull it down.
Renter Warden's wife's family saved it. Now it is a charitable
trust and let out regularly as a film set, e.g. *Chicago*.

On the other side, my successor as Master. When started
as a journalist at local newspaper, the editor told him in no
uncertain terms that journalists are not important people
and to remember that you are representing the newspaper
and always wear clean shoes. On leaving, spoke to a Past
Master, who had been briefed by another Past Master about
my box caterpillar infestation, destroying, rampaging,

especially depressing as the hedge is a pivotal, defining element to the overall layout. With such wonderful input, will turn a challenge into an opportunity.

Despite drawing to the close of my year, there are still surprises and discoveries, often about fellow Gardeners. One said – I think he was referring to himself rather than to another – that he was once introduced as a backgammon player recently returned from a two week tour of Egypt representing England.

16 May

The Renter has raised an interesting idea. He told me he had looked closely at his badge of office and was intrigued by the small 3cm crowned badge on top of the basic badge. Careful scrutiny of the words indicated that it said 'Coronation 1911'. On researching further, he found that the livery archive states, 'Those members of the Court who were members of the Coronation committee should have a further emblem above the badge'. This resulted in a lovely Edwardian emblem of a Lady Hermione carnation surrounded by the text.

Noting that the Prince of Wales is a current royal liveryman, we should therefore think of repeating this gesture when he ascends the throne. I said we could involve one member of Court who is a jeweller and the wife of another liveryman whom I met in Rome who is a jewellery designer.

Today is committee day.

Craft: Highlighted again the frustration resulting from colleges of education whose administration made it very difficult for the Gardeners to encourage and process applications for various awards – usually because there is a turnover of staff responsible with little debriefing. Yet the concept of these Awards is sound, popular with the students and can even be career changing. Again the issue of rising costs of flowers for our official functions. We pride ourselves with the displays, we have a reputation, and they are commented on and there is always the expectation of a bold floral statement. Fuel costs, Brexit etc. all putting pressure on margins. Possible alternatives include sponsorship, the reusing of flowers from an event held the previous night by another livery.

Also discussed was our Guildhall yard garden for the Big Curry Lunch. Again a success. Pollinating London Together also going from strength to strength and a further discussion on the proposed Camden Highline. Other items included an apprentice discovery day at RHS and our involvement in the Livery Climate Action Group.

Communications: Reviewed the updating of the website, much more fit for purpose even if still work in progress. It includes a new facility for our successful livery schools link to enable easier access by and to schools careers advisers and to pupils to learn about careers in horticulture. The members' section on the website will have the appropriate statement on equality, diversity and inclusion.

Further discussion on our newsletter e-Trowel.

Education: Reported on its continued work with Future Gardeners, schools outreach including discussion on further funding to accompany this initiative, Royal Park's Discovery Day, and our next Nuffield Scholar.

Finance: Discussed, amongst many items, the lower attendance post Covid, especially at formal events and the financial pressure this puts on the livery. Should smaller, cheaper halls be used more often? Delete one formal dinner from the year?

18 May

The Consort and I have just tested positive for Covid – that's the reason I've not felt very well these last few days. First time. Thought foolishly that I might avoid this wretched virus – means missing a book event as a guest of a member of Court, plus two dinners this week, both at the Mansion House.

Need to inform those who have kindly invited me to their events this week. For some odd reason, I seem not to have specific details for one of them – the first time ever and entirely my fault – I had no clue who this mystery invitation is from. I have written down, 'Mansion House – white tie', in my diary. So I called the Mansion House and was told the event was for the Furriers. I telephoned the Furriers to explain that I was sick and couldn't come. They told me that I hadn't been invited. I thanked them for not inviting me. I had written another engagement – the one later this week

– down incorrectly in the diary. The other event to cancel was the Actuaries dinner – a particular disappointment.

19 May

Just got an email with the draft minutes of the finance committee. Rumoured that we will incur a debt in my year as Master exceeding £17,000 and maybe, when all the bills are in, considerably more. Unfortunately, I couldn't make the meeting.

Apparently, in the discussion, it was felt the Clerk should play the main role in organising all future events. I discussed this point with both the Clerk and the Assistant Clerk over a pint prior to my Mastership, agreeing at the time that if the event was not organised largely by the office, then the office at least should be kept fully informed of events, plans, deliberations and potential commitments. With the office being overworked and wishing to use where appropriate experts I thought this was the way forward. I had been told by the office that recent Masters, on occasion, had done their own thing and had expected the office to pick up the strands at the eleventh hour. I then read in the minutes that the Master is responsible for making up any deficit and that historically at least one Master did just that. I smell the roses and reflect.

20 May

Now informed that the deficit may only be £3000 and I am being praised for arranging a programme in the shadow

of Covid with all its uncertainties. One moment heading for the Debtors' Prison, the next on a pedestal with a halo. To cap it all, if one can cap a halo, the general conclusion of the committee is that the Master should not have to meet the deficit in a year as unique as mine, and if Masters in future had that heavy commitment hanging over them, some might not wish to have their name put forward for the Mastership. Of course, a year as a Master can easily cost a Master personally between £10,000–£15,000.

23 May
CHELSEA FLOWER SHOW

And thus to Chelsea for the Flower Show, as Pepys would have said, had the Flower Show been around in his day, which it wasn't. Never been before, quite a confession, not from lack of trying, but now successful, and what a way to arrive, for the private viewing and as a guest of the President of the RHS with a lunch thrown in. Many recognisable faces in the crowd, a few I even knew personally, one or two rather well.

Read an interesting article in today's *Times* on the train coming in. Recognised the author in the Gents, caught up with him just before lunch. We discussed Thenford, which is a favourite of mine. He knew its creator, was a near neighbour and was in frequent touch, said he didn't rate the Chinese pavilions in the walled garden. I said that others on the day of our visit felt likewise. Owner said that he was aware of that opinion, but at his age, he didn't really

mind either way. When my contact asked him why on one occasion the rill wasn't working, he said he couldn't afford the electricity!

Security check as I entered the lunch marquee. Those in front made Table 6. Not bad. I thought I would be doing better, often on top tables. Mine – table 42!

On one side of me at lunch, another Peter, next to him a woman who had a female friend called Peta and I said I once knew a secretary called Peta. We were all jolly and close friends before the first course. RHS President called Keith Weed – how do we attract those with appropriate names? Reminded of those who were or are on the panel of Gardeners' Question Time – felicitously named: Pippa Greenwood, Bob Flowerdew and Clay Jones! My Immediate Past Master is called Heather. I also know of a Penguin book long out of date called 'Soft Fruit Growing' by Raymond Bush. Told a member of the Gardeners later, he knew someone called Cedric Scroggs. I said I had heard of a man called Norman Conquest.

President said he has cancelled, postponed, delayed and now presided at Chelsea for the first time, at the right time, since becoming President. He thanked all sponsors, especially those with a horticultural bent. Referred to the need to attract the next generation of gardeners, that the young have other priorities but are missing out big time. That he last spoke to one great gardening pioneer who was advocating gardening as a career. It turned out to be the day

prior to his sudden death. He was giving acorns to school children to germinate for the next generation.

To my right, guest said Perennial had acquired the iconic garden designed by Roy Strong which the National Trust had rejected despite there being a suitable endowment. The new owners feel confident that they will be able to perpetuate his memory long after he would otherwise have slipped into oblivion. This is despite his stellar career – director of the National Portrait Gallery at 32, followed by the same role at the V & A, and writing the definitive guide for such important roles. Perennial are always seeking new gardens which must meet their criteria, namely having an endowment and in the right geographical location. They have two more potential acquisitions in the pipeline.

At lunch, I was told that I am Vice President of Perennial as part of my year as Master. First I'd heard of that.

To my left, the chair of a long established family firm and of a conservation group. He had been a guest at one of my formal dinners. Said he wanted to borrow the odd joke from my speech. In his free time he is a Gentleman-at-Arms, has worked with Royalty, on one occasion was told that Prince Philip wouldn't choose beer at their reception. He did. My friend rushed out of the Palace of Westminster, where the reception was held, pushed to the front of the queue at the local pub 'A pint for HRH, please, a priority.' Turned heads. Got back quickly, sufficiently quickly for the Prince not to have known what had gone on. HRH said, 'Perhaps you weren't expecting me to ask for beer.'

Another at our table said there were too many working in horticulture earning only the minimum wage, despite the multiplicity of skills required and this was unacceptable in every way.

President on his feet again, reminded us Chelsea is also a major charity, needing funds to sponsor schools, apprenticeships and to maintain their own gardens for the future. Next up, Monty Don. Introduced with words, this person needs no introduction – for once entirely true. Monty has the ability to enthuse, to engage warmly on all matters horticultural. His a life in gardening, filming, visiting great gardens globally – not a bad remit he said. Reminded us of his own mental health challenges and how horticulture had been a major remedy. Yet as a child, he hated gardening. When family asked him to do some, to him it meant preventing him playing. Expelled twice by 17 – sex, drugs, rock n' roll, then discovered gardening. Reflected on the special smell of the chalk in Hampshire after rain. It helped inspire and convince him to be a gardener, said life is tough, but a bit of weeding, staking, seeding and all is so much better. Said gardening creates a work of art changed by the seasons as days lengthen, shorten, the seeds grow, the dark days return, a rich link with nature. Every school should have a garden, every new housing development likewise, there should be allotments nearby (similar to my wish when chair of Brogdale to have locally sourced apple trees lining new streets and let the children scrump). In reality, gardening largely drops out

of the psyche between age 18 to 35. Monty said we must welcome the next generation and don't be frightened to learn from them. Then given Victoria Medal by the President. A huge accolade He was noticeably moved, suitably grateful.

Popped along to the stand of the Great British Garden Festival, I am an ambassador. Given a truly lovely medallion, pinned on to me, will wear it with pride, not sure when or where. The badge has the word 'Ambassador' embossed in gold with an eight petalled enamelled emblem in blue, black, red and gold. Picture taken to record the event for posterity.

24 May

Spoke to the Master Tin Plate Workers alias Wire Workers of the City of London to give them their official title. She was the one who fainted when my guest at the Autumn Court dinner and I thought was swooning. She said she had seated me beside her for the evening I missed due to Covid. What a pity. The dinner was at the Apothecaries Hall. Not concentrating, I said that at least her livery can cure me. Quite daft, when does anyone consult Tin Workers for a medical cure? I was thinking of the Apothecaries.

Whilst lamenting the misfortune of missed opportunities, call from the Clerk telling me of an invitation from Prince Edward to attend the outdoor Platinum Party at Buckingham Palace on 4th June to celebrate the Queen's jubilee. The Clerk noted, 'A late invitation' – jealousy on his

part? I am aware that I am part of the 15% of the population who lived before her reign began. Something I have in common with Diana Ross, who will be performing.

25 May

Now that I know I am a Vice President of Perennial (I have just looked it up), full name 'The Gardeners' Benevolent Institution' established in 1839 'For the permanent relief... of Aged and Indignant Gardeners and their widows'. My twilight years are sorted!

28 May
JUBILEE GARDEN VISITS

Designated today as a day of livery garden parties to celebrate the Platinum Jubilee and to raise money for our Future Gardeners charity. Better to celebrate in an appropriate manner. Eight livery members are hosting garden parties today, inviting livery members as well as friends, family and neighbours with one tomorrow. The numbers may be few, but the variety of choice and geographical locations are widespread.

First visit a local coffee morning. Spoke to host's teenage son, just played piano at Number 11 Downing Street. Said the half grand there was out of tune and they had a better piano at home.

One attending told me his team had arranged the Queen Mother's 100th birthday at Guildhall. I referred to the fact she was a local lass, that the obelisk in the churchyard

adjacent to her home depicted the various titles by which she was known during her long life – Princess, Queen, Queen Mother etc but not Empress of India. Asked one of the original initiators of the project why this was so. He was told by the Foreign Office that it was politically incorrect. 'Rubbish,' said her first cousin, whom I know. On matters royal, I said I knew former press secretary to the Queen – had been on my board at Brogdale and we have kept in touch; he said the Queen told him after a unique lifetime of travels and meeting people, that she thought the best times weren't necessarily as good as they appear nor the bad ones as bad.

Another told me at this garden party, that he had built over a long period a gauge railway in his garden – I have visited it – and has since added to it. He said he met his wife when he went up to Imperial College. Went there because it was about the only university then – 50 plus years ago – that didn't require French O Level. Did engineering as a result. Was introduced to a lifetime's love of Gilbert and Sullivan, wanted a pianist to play at one university performance. A flatmate introduced her friend who was at the Royal College of Music next door, there were few female students then at Imperial, they subsequently married.

On the way to the next garden, a regional winner of gardens open under the National Gardens Scheme, negotiated a bridge which had permanent bollards to limit the range of vehicles, scraped my car, damaging three panels. The passage through was too small for a car of my

size. Another saw the incident, commiserated, said many locals had complained and others had suffered as could be seen from the state of the bollards. Wretched nuisance. Third time similar degree of damage via different causes and, in all honesty not my fault; the car being too large for country lanes. Not in best of spirits. Had to arrive as Master all smiles. Not easy.

Garden lovely in its variety and setting. On a barn wall, a stone disc, newly placed this year – 'The Nation's Favourite Gardens East'. Informal down to the lakes, stream, meadow, garden rooms, etc. Used milk to deter muntjacs. Has nightingales in the woods. Plants and lifts annually 10,000 tulips, sudden keenness on snowdrops from 3 varieties to 223 in three years. Making use of the natural near drought conditions of these parts, even making use of what is defined as a hill in this flat county, a hardly perceptible incline, where she has placed a sculpture of a bird of prey's wing at the top. Entirely self-taught, trial and error, no overall plan, and confessed if moved to a different part of the country would have to relearn many of her horticultural skills. Home and barns from various periods, all listed. Met the person who will become the first woman Master Grocer in 2027, yet their charter granted in 1426. Host's husband, former Master Distiller. Said the Apothecaries came out of the Grocers and the Distillers out of the Apothecaries. The connection between the latter two is that the Distillers could produce a product of good cheer if also damaging in excess.

One rose, a favourite of Vita Sackville-West, 'Souvenir du Docteur Jamain' a deep colour, a fantastic smell, and loves a north facing wall and still grown at Sissinghurst. Must make a note to seek it out when we visit in June.

Hostess said part of the garden was originally a farmyard and she would never attempt to establish a garden in such a location again, farmers in the past, at least, dumped a lot of noxious waste in the ground, including fuel spillage.

Finally, visited the wildflower meadow. Spoke of the benefit of yellow rattle taking out nutrients which grasses would otherwise thrive on, saying that wildflowers each have their best years and then rest. Nearby a plantation of willows used for making cricket bats.

A splendid tea. A nice touch that the Past Master Distiller was liberally engaged in serving champagne.

26 May
FLOWERS IN THE CITY

Meeting of the Flowers in the City committee, discussion on the new judging boundaries, some judges wanting to keep their existing areas. Also, suggesting greater emphasis on pollinators, others feeling that being volunteers and not horticulturists might be one step too far in their current knowledge. When reviewing the judging format there may be criteria which are not clear and so different criteria could be inadvertently judged, for instance, what actually is environmental sustainability – even the committee weren't sure! Nor do we want to encourage sustainability if it means

replacing plants as the seasons change with cheaper, rather dull evergreens. At least green walls are sustainable. But they do take up a lot of water, as do window boxes. Some judges, with an eye to their booked summer holidays, wanted to judge too early, before the winter/spring planting had been replaced by the summer one. Even finding a date suitable to train the judges proving difficult due to holiday commitments. And so the deliberations behind the scenes continue. As does the next topic, the continued incompetence of the bank to make financial transfers and to amend the signatures for the charity.

It always depresses me to see dead plants and dried out window boxes when a company moves and the plants are left abandoned. Perhaps too much to expect bankers to be able to manage something as complicated as managing a window box.

29 May
A LONDON GARDEN VISIT

Today a visit to another garden for our jubilee weekend. This one, unlike yesterday's, exclusively for livery members. On the way, we entered a Tube full of boisterous football supporters. The Consort felt uncomfortable. Not a good start. Tried to reassure her, saying it was harmless banter and that most of them probably held responsible positions and were conscientious parents, perhaps even kept guinea pigs, as she does. Looking at their club logo and hearing that they were destined for some playoff at Wembley, I was

surprised that club had got so far. On another Tube near our destination, we bumped into a fellow Gardener who had been with us in Rome, also on route to today's event. She said she would not normally have taken this Tube, she was making a circuitous route in order to avoid the football supporters. She said she had tried to book a parking place online for today, that her eleven year old granddaughter realised the site, similar to the official one, was a scam. So unfair.

Arrived at the garden, triangular in shape, hidden away and offering a degree of exclusivity to the adjacent neighbourhood. The Consort said the Bloomsbury Group lived in squares and loved in triangles. I was quite impressed. Bunting adorning the location, one of the fellow Gardeners wore jubilee earrings and a generous summer fare was offered to all. Spoke to one about the proposed redevelopment of Holloway Prison where there were gardens cultivated by prisoners which would be retained and incorporated in the new design when redeveloped for housing. She had also visited East London beyond the main area of docklands between lockdowns, said much had been going on, over 40 new blocks rising in that short period. She said that Thamesmead, a 1960s eyesore, despite its canals and lakes, was about to experience the Midas Touch via the much respected and long established Peabody Trust.

Spoke to the mother of the organiser of the day, aged 92, from South Africa, a very elegant lady. Her father was Russian. She lamented the missed opportunities of South

Africa due to apartheid and corruption. Her husband had been a neurosurgeon and when seconded to Canada with his boss, the latter operated on Khrushchev. Her husband had a conscience and, on his return, transferred to a hospital in a Black township. She was an Anglophile, lived overlooking this triangular oasis, liked our British inherent decency, said Macron was devious and very anti-British, as were, she added, most who negotiated the Brexit negotiations in Brussels, their arrogance had converted her from being a natural Remainer. She mentioned Boris, said he once addressed a residential home pre his Mayoral days, that many residents were reluctant to invite him, he was booked to speak on age and related matters but ripped up his brief, engaged with them all and won them over. Such is the great Boris!

A fellow Gardener mentioned a type of rose she had bought for £4.99 only a few years ago, but now the same rose would cost her £20.

My Steward informed me that two of her teddies were off to the teddy bear hospital. I must make a note to enquire about them.

Spoke to another Gardener who has the 'loveliest garden in Lymington'. Said her garden walls were of various periods, many listed, together offering seclusion and a barrier to vermin. Hers was the first residence outside the original seaport. She is the proud custodian of a garden dating back to 1760. Recently acquired blue and yellow iris, I said the colours of Ukraine. Her husband once dug up some of their

snowdrops to sell at a local stall, all readily snapped up, apparently being especially rare – a fact he didn't know.

Then spoke to another who lived in Paddington, she said the delights of the basin were great but very different from where we were today. Rats had been appearing this week since the Elizabeth Line opened. She gives her fuel allowance money to a local donkey sanctuary with their numerous needs. I mentioned the donkey we sponsored and the pig-footed bandicoot of Western Australia – and Cindy in Dorset, a chimpanzee, not forgetting the whale in the Southern Atlantic and our most recent sponsorship – the half-blind cat, Jefferson, in Rome. Once visited Cindy. Keeper went up to the enclosure passing many people, called out, 'Come and see your mummy and daddy.'

Frustratingly, a number didn't turn up today despite reminders. Very unfair and costly for our hosts, who had put in the time and covered the costs of a splendid fare. One Gardener said she had, on a previous occasion, arranged a formal event for a select few for a significant birthday. Some of those who hadn't bothered to reply turned up, others who said they would, didn't, and others who said they wouldn't, did. It was the last time she attempted such a celebration.

As we were leaving, host said basements here were at a premium, when normally that type of accommodation was relatively cheap, because of access to these wonderful gardens and the benefit of their relative security – children can play unattended.

30 May

Invitation to address the Welwyn Garden Horticultural Society – can only do next March. They opened the request with, 'A little bird is rumoured to have said that you will be standing down from your role as Master and that... as you are an amazing raconteur.' How can I decline such a request? Egotistical moment!

Also, an invitation from the Ukrainian Ambassador to a dinner to thank us and others in the liveries for our support to be held at Grocers' Hall. They are a remarkable nation. Hitherto my only direct contact was with a Ukrainian couple who were my landlords during my first year at university – delightful and hardworking. Most of my memory of that year was of one student in the same accommodation who believed in flying saucers, took me to a northern convention, bought a CD of music purported to have been recorded from an encounter with a UFO and proceeded to play it constantly. The other occupant was a student from Wales who spent his time either weeping, this being his first time away from the Principality, or singing Welsh songs as if he were an aspiring opera singer.

Nice email in reply to mine thanking yesterday's host for our garden party in London. 'My mother enjoyed meeting both of you... I have greatly enjoyed your term as Master. You have set the bar very high.' This means a lot to me, but especially the acknowledgement of the hard work which goes into a Master's Year.

31 May
SUPERBLOOM

To Superbloom at the Tower of London for a preview.
Sewed over 20 million seeds in late March, early April
and hope to have them blooming in time for the Platinum
Jubilee next week, but as they say, 'Working with nature
is unpredictable.' The challenges of the soil types, a cold
window corridor off the Thames, the recent very dry spell,
the unseasonably cold nights – there were more nights with
frost this year in April than in February. The dry spring
meant only 33% of average rainfall in April and not much
better in May. Watering only a qualified success, the winds
off the Thames dried the surface of the soil. No water,
no warmth – not a good start for the project. In one area
more balanced conditions and protected by the ancient
walls and the results are plain to see. Already the sighting
of a rare insect, the first such sighting. Superbloom is now
making considerable and rapid progress with additional
seed scattering. Bees pollinating where previously there was
only the scandalous empty grass expanse of the moat. There
will be a three month bloom period and annually – how
nice and rare for such an initiative to be a permanent one;
so often they are transitory and the memory soon fades.
Some plants will fare well one year and less the next, and as
we know this cycle will vary dictated by nature or tweaked
by gardeners.

Whole moat area, which is vast, sewn by hand in only five days. Anxious to avoid compacting the soil.

Interesting observations already from the seed test bed on what seeds do particularly well here – initially, red poppies are the star – now a matter of ensuring the poppy has its place but does not dominate. The organisers have a mental map of the moat; know where the puddles appear, where the deep depressions are, the latter especially good for seeds. Already found that if seeded densely there is more success. One expert from Hampton Court said seeds need friends of other seeds to flourish. Total cost about £3.5m for the construction and movement of ten thousand tons of soil. Overall costs will be even greater but compared with the benefits to mental health, general well being and for the sake of nature, this is a bargain on all counts. The New York Highline was one of a number of inspirations. Music played in the beds, not something I appreciate, but others seemed to want it. Was quaintly defined as 'audio fertiliser'.

Before leaving London in the heavy rain, good for the seeds, less so for me, caught in the downpour. A quick look at the Elizabeth Line, recently opened. Cathedral style stations, what seemed like endless well lit platforms, all so wonderful. Superbloom and the Elizabeth Line together made me proud to be British. Less so when viewing the neighbouring buildings to the Tower of London. Many could be anywhere, insensitive, unresponsive to their location, but there is a faint glimmer of hope looking at the immediate South Bank where new grouping of buildings at

least look, from this distance, with water inbetween, to be almost working. But then, who am I to comment?

3 June

Very grateful to Prince Edward for tomorrow's invitation to the Platinum Party, a concert to celebrate the Queen's jubilee. However, I think he owes me one. On the day he was born, I was behind the locker at my school, at the back of the classroom, with the radio up against my ear, reappearing to announce the happy royal arrival, to be welcomed by the arrival of the Form Master. I spent the first hour of HRH's life in detention. I told him.

4 June

PLATINUM PARTY AT THE PALACE

Checked trains, severely disrupted, a woman under the train. Poor her. Poor us. Decided to go to the nearest Tube. On way, road closed, but still went through somehow. Had pre-booked the car park but found no slots available, asked official to help, noting free slots being reserved for office workers but being Saturday, most were empty. He agreed to release one. I said I would tell the Queen of his kindness. He said he wanted an OBE. I said I would try and get him a CBE.

On platform, update on the suicide attempt by overhearing a conversation. She was pulled off the track alive, ran off, helicopter, police seeking her.

At entrance to St James' Park snake queues for miles. Seek chance to use 'high-tech' loo – a misnomer. Long queues for food and drink. Never seemed to find the right queue, wanted fish and chips, told that was the shorter queue. Was in the queue for Pimms, then beers, burgers and even water before eventually being directed correctly. 20000 present, made feeding the 5000 seem hardly a miracle. At fish and chips stall advertised water, great relief, but ran out of that. Consort said couldn't, wouldn't, survive without water, only fizzy drinks now available which she couldn't tolerate. Meanwhile, checking Test score, most interesting stage, England needing 85 to win with 5 wickets in hand, usually easy but not against New Zealand and with our batting lineup. Root still in – went to my school. All should be well.

Seats among the very best. Many standing around the statue, and would have to do so for six plus hours. Sat beside, I believe, global CEO of Duke of Edinburgh awards. Once asked to find ambassadors for the scheme, Prince Edward to interview the candidates. I asked our secretaries to practise their curtseys on me. Consort said others more worthy than me to be given complimentary tickets – true, but such is life.

Inevitable messages from predictable celebrities – stars of stage and screen, of track and playing field. One from David Beckham – quite unnecessary. Walked to nearest tube. Consort said I didn't know where I was going amongst the milling crowds. Of course I did, pointing to the Cabinet War Rooms as we passed them.

6 June

After extensive correspondence, greatly assisted by two fellow Gardeners, decided not to proceed with the idea of helping to rejuvenate the English Garden at the Vatican. Was it meant to be a woodland garden – records are unclear, and would we be taking on too much, despite suggesting only an advisory role?

7 June
FAIRCHILD LECTURE AND SUPPER

Fairchild Court at Salter's Hall. Told their garden, although pretty, is not pollinator friendly. A special occasion, musical chairs for office holders for the next year, plus election of new Court Assistant. Before, over coffee, one senior Past Master mentioned the Platinum Jubilee service in St Paul's, commenting on how well the Archbishop of York had done, stepping in only two days before, writing his own sermon, replacing the Archbishop of Canterbury, who had Covid.

Past Master said he had a niece who performed in the newly commissioned anthem, that the composer was tough and demanding in rehearsals but fair. He mentioned the previous Archbishop of Canterbury, said he once spoke to him about 9/11, saying he was there when the attacks took place. The former Archbishop said he was too and had rushed to the scene to help. The conversation was, therefore, between two who had direct experience of that fateful day.

Same Past Master said he once spoke to Tony Blair,

asking him which politician he most admired. I guessed it. Attlee. But surely, despite Attlee's many successes, as Churchill's wartime deputy, founding of the NHS, independence for India, passing of the Town and Country Planning Act etc, that record is now revisited and is the fruit of many labours. NHS was proposed by a Liberal, instigated by Churchill a Conservative; Indian independence was rushed and botched; Town and Country Planning Act was a CPRE initiative.

Court discussion – a lot about cost of dinners, reluctance of people to commit to events, ways of mitigating costs, that there may be the possibility to negotiate rates down as the halls and caterers want our business, food sometimes perceived not to be value for money, but most thought there was not much room for flexibility nor for negotiation. Buttonholes for flowers discussed, could be dropped to save money, funding given by one generous liveryman, but only to cover two formal events a year, we have four. Buttonhole arrangements don't work well on dresses, hangs and stains, so stems must be wrapped adding to the cost.

All committees active, vigorous, successful.

Comment on result of recent elections to Court of Common Council, 40 out of 100 are new, apparently unprecedented, plus 25% turnover of those on the Council of Common Aldermen. Suggested we invite those who are not attached to any livery to an event or two.

My Master's update slot, mentioned recent open gardens success on a relatively modest scale, few livery attended,

better though than the original idea of a big formal dinner with an auction to make the real profit or avoid a deficit. Not the year for such events. Mentioned launch of our e-letter called e-Trowel. Predict it will be a permanent fixture. Touched on recent visit to Rome. Said I attended Platinum Party at the Palace, complimentary tickets via Prince Edward, that we had the best seats.

Quoted that my former PA had said, 'I always think of you when I see the Royal Family. Cut from the same cloth.'

An update on the Camden Highline.

Inducted new member, family attended with a little ceremony. Memorable to those involved. I can remember well my own.

Chair of one of the committees absent, attending blue plaque unveiling to Fanny Wilkinson, in Shaftesbury Avenue; she planned over 70 public gardens in London alone in the late 19th century, many still in existence, albeit and inevitably much changed over the years. She put the male gardeners in their place saying, 'They occasionally imagine they know better and they are often stupid and pig-headed.' I had been invited to the ceremony; pity the dates clashed.

Then to St Giles Cripplegate, annual Fairchild lecture and this time also the unveiling of a new stained glass window to Mark Catesby, a friend and business colleague of Fairchild, who had three children buried in this church. The connection between Mark Catesby and Thomas Fairchild was strong. In addition to being close friends, Catesby was

an executor of Fairchild's will and was left a funeral ring by him. Fairchild propagated in his nursery plants Catesby had collected on visits to America and from where he also sold copies of Catesby's important book, 'Natural History of Carolina, Florida and the Bahama Islands'. The Gardeners' Company a subscriber to the book, which was described by a contemporary as, 'The Most magnificent work I know of since the art of printing has been discovered'. Brief introduction about Catesby by Sir Ghilean Prance, a knight surely just back from Camelot?

Asked the Chaplain to dedicate the window, he and I proceeded to the spot. Holy water sprinkled liberally on the window and, on occasion, on myself. Felt suitably uplifted. Designer of the window also designed the other two adjacent, one to the founder of the City of London Girls School, other commemorating the marriage of Oliver Cromwell controversially in this church, to Elizabeth Bourcher. She got her way, she had the money. Brief talk by the window's designer: colour red difficult to replicate, only one place in UK and one in Germany, described the depictions of plants, animals and birds incorporated in the design.

Lucky I spoke to Clerk before the service. Previously given a different reading, thought it rather inappropriate about the empty tomb at Easter but went along with it as there was a reference to the disciples and to Mary Magdalen mistaking Jesus for the gardener and later calling him Master. Had brought along my own Bible given when I

joined the Carmen. Lovely red leatherbound, reminding me of how, when at university, I read the Bible from cover to cover.

On way to supper, spoke to my Steward. A Lap. She said they had their own Parliament despite being spread over four countries, including Russia. I said surely it has no substance. Russia, for instance, would take no notice. She implied or wished otherwise. Said their flag has a sun to symbolise the midnight sun.

Supper at restaurant adjacent to Wax Chandlers. Gave brief speech. In homage to the window dedicated today, I referred to my love of stained glass. In a small church, (at the end of one walk I do along the Icknield Way where Romans once walked) there is some stunning, rare medieval glass, depicting the birds of the vicinity, lapwings etc all now long departed, with a stone windowsill nearby saved from the local leper colony – biblical connotations. Nearby, a recently dug grave of a child, its teddy deteriorating a little more each time I visit, the grave beside someone who had greatly exceeded his three score years and ten, together they rest and for eternity, with the window, its green colours symbolising hope, renewal, nature, faithfully presiding over all. I hoped the Catesby window will do likewise for centuries over the bustle of a busy metropolis.

The walk starts from a village where George Orwell once lived and ran the sub-post office whilst using the adjacent farm as the likely model for *Animal Farm*, a novel which infuriated the former Soviet Union before slipping back into the folds of rural England – job done!

Mentioned that the supper was in Gutter Lane, that I once worked nearby, company then called Cooper Bros. (became Coopers and Lybrand, then PWC), that the partnership tried to get the Corporation to change the name of the lane to Coopers Lane. Reply back – change your name to Gutter Bros. I liked that, a silly, arrogant request.

Ended by offering, with deference and modesty, a piece of advice to the newly appointed Master-elect, looking at sundials over the years can be anything but edifying, usually about how we waste precious time, that it is later that we think, that we will soon be customers of our Hon. Chaplain, but one dial – I think from an Oxbridge College garden – sounded a note of hope:

> *'Shadow and sun, so too our lives are made*
> *Yet think how great the sun, how small the shade'*

Over supper, spoke to our lecturer, who had been our guide in Rome – just back from Spain. Impressed by their trains and especially a 28 kilometre tunnel. Also said he once knew Jane Fawcett, who told him her statue rather than that of Betjeman should be at St Pancras, that she had saved the building from demolition. I mentioned the other, new statue of two lovers. Saw it in the paper one morning, on the ground looked like one lover on top of the other. Disapproved of that, but the statue hadn't been put up when photo taken. A relief. Young children will see it, as will old people.

Also at the supper, spoke to the vicar who had officiated, thanking him. Showed him my wooden crucifix, which I keep on occasion in my pocket. Could also have mentioned the verse from a favourite hymn, 'Just as I am though tossed about/ With many a conflict, many a doubt / Fightings and fears, within, without,/ O Lamb of God, I come'. He said he had once heard of a parishioner who wasn't sure of his exact height. He thought it was six foot and asked a friend who said, 'You can be either 5ft 11 or 6ft 1. You can't be six foot. Our Lord was six foot.'

Thought of the people here tonight as I left, one more name, mine, soon to be added to the long list of Masters, becoming in time merely a name, at best a dusty reference to a past of little direct relevance or interest, how one's modest journey goes from Freeman, Liveryman, Spade Bearer, Renter Warden, Upper Warden, Master, Immediate Past Master, Past Master, Senior Past Master – dead!

8 June
DYERS' COMPANY DINNER

To Fishmongers' Hall as guests of the Dyers' Company, their motto 'Bringing Colour to Life'.

Arrive early in order to change into black tie, and whilst sitting in the hall notice that everyone else is arriving in white tie. The invitation said evening dress/mess dress, decorations. A new description to me – hence the mistake – but still felt acutely embarrassed.

Above me in the entrance hall, a large portrait of the

Earl of St Vincent, otherwise, pictures mainly of dead fish. Adorning the centre, a lampshade of a shoal of fish all in glass, large, spectacular, appropriate. One Dyer arrived on a disability scooter and, despite his age and the wishes of his wife, did a fast lap around the central table. In the cloakroom, elderly Dyer having difficulty with his cufflinks. Helped him. Said he was able to do them before lockdowns, but not now, that this was the first formal dinner of the Dyers since then. Asked why at Fishmongers tonight when they have their own hall. It seats only about 80. This surprises me, they are number 13 in the hierarchy and claim they should be one of the Great 12. They have tried to resolve the matter over the centuries by proposing having a lunch with the Clothworkers, alternating between their two halls with a silver hatchet passed between the two liveries as a cordial gesture. Hence the phrase 'To bury the hatchet'. The ceremony, in its present format, dates more recently, from the end of the Second World War when it was felt by those who had survived that there was no room for further conflict and still be at loggerheads.

The Barge Master of Fishmongers' found a white tie and few seemed to notice that the Master Gardener was not on this occasion representing his Company properly. At the reception, spoke to a female Dyer, recently admitted, said the Company had for a long time been reluctant to admit women, but the prospect of their first female Prime Warden (their name for Master) was still someway off, one reason being that the Dyers' trade historically had relied

upon urine, hardly a feminine touch. She was a qualified dyer, had worked for big companies, took me through the debate at the end of the 19th century over the merits of synthetic versus natural fibres explaining how she had personally helped write the standards for the profession now adopted globally. She mentioned unexpected demands for dyes, for instance, flags warning of dangerous bathing conditions must not be allowed to fade easily and therefore require a special dye. She spoke of a fellow female Dyer, not present, who in order to qualify as a Dyer, regularly travelled between Devon and Leicester to attend classes. She designed the parachute for the Mars landing and formulated its correct colour.

Spoke to another guest, an archaeologist and husband of a Dyer. Most current work is rescue archaeology, for instance, at Dyers' Hall where they wanted to renew their lift which meant in turn digging deeper where there were Roman remains. Still granted permission. Said with HS2, so many new sites discovered and their role was to record rather than prevent construction. Asked whether modern technology could do the job of an archaeologist without digging, he said in certain cases yes and that that was preferable, as digging inevitably is damaging. Asked if we could expect to discover/resolve more of the great historical stories and romances via archaeology. I had Cadbury Castle in Somerset in mind, rumoured to be Arthur's Camelot. He said no reason why not.

We chatted further. There was an inter livery yachting

event at Cowes last week, they had competed, as had their daughter. However, the daughter was pirated away by the Innholders, who went on to win. No doubt that will simmer over the years, erupt, need a future Lord Mayor to intervene and be settled via a quaint new ceremony.

Before proceeding to the main hall for dinner, took my customary peep at the Annigoni portrait. Sat between the Consort, we had previously met, she a garden designer and very charming, and on the other side a member of the Cazenove banking family, equally charming. She said Cazenove had saved Barings three times in history, but that one of the Baring family had recently highjacked Grange Opera, legitimately but caddishly, taking all the money, mailing list and endowment. She said only one Cazenove allowed to work in the firm, they don't want the appearance of it being dominated by the family.

Four speeches then an opera singer who said her mother was present and so she had to be careful about which love songs she chose. No one opposite me, top table curved, but further down a couple, she proceeded during the evening to shuffle to be opposite. Husband recently hit on the head and had lost some of his memory. She from Edinburgh. Said they had their Guilds, just like Glasgow and so do, apparently, both Aberdeen and Paisley. The number of Guilds and their locations seems to grow by the dinner. The Principal Speaker asked me if I was once Chair of CPRE. That surprised me. In all honesty, I didn't recognise him. Later I realised from a comment he made that I had visited

his office on business, the office being opposite to where the Shard was going up, then just above its protective barrier but said it seemed to add a floor each week and was, therefore, rising rapidly.

Despite exemplary hosting, I felt inconspicuously dressed, especially being one of only three principal guests. Even the Master of Ceremonies wore two medals. The third principal guest was Master Shipwright, introduced as having nine children. Checked with her afterwards, she had five of her own and four inherited from her current partner. Great character – hopefully we will keep in touch via the camaraderie of the former Masters' association for our year. Certain guests welcomed: one the head teacher of the Dyers' school, another the manager of their Alms Houses, she came with her wife and daughter.

Loving cup and speeches over, resumed conversations to left and right. My Cazenove friend came from New Zealand, but no trace of an accent. Her great grandfather fought in the Somme. I always find that odd, a conflict so far away. The family had left the Old World to create a new one away from the dynastic tensions of decaying empires. She said Australia doesn't know what it stands for. Is it an Asian country or mainly a Commonwealth one? Asked did she come here to marry a Cazenove? No, he went to New Zealand to marry her. Asked a former Prime Warden of Dyers' did he have his portrait hanging on his livery wall? No, the hall was too small. It would mean taking one down to make room which would not go down well.

As I was leaving, one wife said frustratingly to a friend that her husband didn't hear a thing all evening, refused to turn on his hearing aids, complaining they made too much noise.

On the train home, an embarrassing moment. I got up just before the train had reached its destination and somehow (possibly due to the hospitality of the Dyers), I fell on to the lady standing, who in turn, toppled over onto the lady seated opposite. I ended up on top of the said two ladies. I tried to explain that this was not my normal behaviour.

9 June

Having breakfast when the telephone rang. It was the Consort calling from our daughter's house, asking if I had remembered to clean out and feed her six guinea pigs and the cat. This reminded me of how on a previous occasion when she was away, I was driving home from the station having attended a livery function, knowing that I still had to feed and keep company with our then menagerie of two sheep, two cats and two rabbits. I was followed by a police car. I didn't realise it was one, despite the flashing lights. I ignored it with a clear conscience and continued on my way, turning in due course up the lane, which in turn leads to our drive. Alas, so did the police car. I thought it prudent to stop. So did the police car. 'Didn't you see my flashing lights?' 'Yes, officer. But I thought they were your headlights going over the bumps in the road.' That did it. 'Is this your

car?' 'Yes, officer.' Wasn't it obvious? 'Do you live here?' I was asked to take a breathalyser test, and despite being a responsible sort, I was worried. I puffed. 'If you don't puff harder, I will have you taken down to the police station.' I crossed myself and puffed harder, and passed. Then three more police cars converged on the spot. I asked whether their presence was coincidental. 'I called them because you had failed to stop, and I assumed that you were a potential troublemaker and dangerous.'

Eventually, the little misunderstanding was resolved relatively amicably. The policeman gave me a lengthy document on my rights and responsibilities under the then EU law. I am now more familiar with what is a police 'stop on account', 'a police stop and search', on what information I am entitled to be armed with before the search takes place, of the method of search, what happens after the said search and whether there are any exceptions to providing a record of a 'stop and account' or 'stop and search' and how I can complain. The future Consort away for only one night and I attract four police cars. She chose not to understand. I think I will apply for Mastermind and have 'stop and search' as my special subject.

10 June

Request from the Upper Warden to check his draft Resolution for my year. This will become the scroll which I think most Masters hang in their downstairs loos. I was happy with most of it, the Clerk asked me to include a

family crest. I said I don't have one, but if I did it would be a slug rampant. Presumably, most of my predecessors have a crest, as do most Masters of livery companies generally, usually recorded in stained glass or with shields on the walls of their halls.

13 June

Today is the Saint's Day of St Anthony of Padua, the Patron Saint of Lost Causes. Known as the Hammer of the Heretics for his persistent preaching. Finding heretics unsympathetic, he preached to fish instead. When he was exhumed, 336 years after his death, in 1231, his body had decomposed but not his tongue!

Rather tired as my year ends. St Anthony of Padua becomes ever more attractive to me.

14 June
HIGHGROVE

It is three years since I first discussed this visit to Highgrove with Charlie – not the real Charlie. We had a splendid visit today conducted around the garden by Camilla – not the real Camilla.

The opening comment from our guide was that we should have been here last week – how often is that so – or next week. I never seem to visit a garden, especially in my year as Master, at the right time.

The house was once owned by Maurice Macmillan, son of Prime Minister Harold. A relatively modest house,

partly rebuilt following a fire, added to over the years and embellished accordingly. It has an uninterrupted view to Tetbury church, part of an agreement, a memorial to a previous owner of the house in memory of a son who died in the Napoleonic Wars. Why buy this house? So many other gems in *Country Life* each week. This one, near the road, rather routine compared with others in that elevated category, and the now great gardens were then a graveyard for tractors with a vista verging on the routine and ordinary. The house itself allowed to be rather overwhelmed by overgrown climbers, HRH likes to peer through them, noting the birds, smelling the scent.

This is the only evidence of an eccentric image of HRH I held about Highgrove prior to today. Otherwise, this visit is a treat, a gem, a privilege, each garden room logically progressing, merging into another, the walled garden the very best of its type, neither too big nor too small, the planting regime clever, the 17 acres cultivated within the overall 30 acres of the estate constitutes Arcadia.

The first delight, the Shand Gate, in memory of a late departed, much lamented, conservationist brother of the Duchess of Cornwall. Full sized carved wooden elephants near the reception area a recent gesture to his essential and effective work. The gates were made from abandoned ironwork from 18th century India, a fitting entrance to a secret place for HRH to ponder the official boxes of his office.

As we strolled, a fellow Gardener and I reflected on the war in Ukraine, of how it was possible for a war of that nature to be going on at this moment, in the same world.

Colour everywhere, including yellow benches. HRH likes colour. 27 different rhododendrons and azaleas. A bust dedicated to the pilot 'who fought the Red Baron', the latter being the clever, infamous, First World War pilot. HRH loves his delphiniums, is President of the Delphinium Society. We saw a ten foot specimen as we entered the garden. His attitude is to recycle as much as possible, even hardware, compost, and allow plants within a liberal interpretation to do what they like. One glorious plant, 'Devon Wizard', supplies HRH with his buttonholes. Spectacular yew hedge designed by Roy Strong, clipped late in the season to allow birds to nest and pests to flourish for their food supply. Cedar tree once stood proudly nearby, one of the initial reasons for buying the estate. Since died, built an oak pavilion on the spot, left three oak saplings to do their bit. They are now large trees that have grown through the roof of the pavilion. Balsa planted in 2015 by Prince George, his first horticultural venture. Plenty of box in form of parterre. Hopefully pest resistant type, but we shall see.

Close to the house, a magnolia growing over the windows, also a lovely blue clematis named after HRH and just out in time for our visit! A very rare exception for my visits to gardens. Beautiful sundial garden designed by the late Lady Salisbury; I would be content with just that.

Plantings generally near the house principally for their scent.

Lots of pots at Highgrove, pots within pots, clever idea, an easy means of replacing displays, saves a pot from cracking. Idea of HRH: indeed all ideas emanate from the Head Gardener – HRH.

Near kitchen garden an Egyptian gate with Egyptian hieroglyphics which translate as, 'The flowers in the garden reflect the stars in the sky'. It was carved by students from the Prince's Foundation, busts on top a bit like Temple Bar of old, but this time of those whom the Head Gardener admires, including one of Miriam Rothschild, who gave him wildflower seeds. A friend gave me some of her seeds once, but mine did nothing. One figure in the wall beside the gate of Tigger, a favourite Jack Russel of HRH. Walled garden a gem, flowerbeds shaped to honour saints George and Andrew, homegrown willow used for poles or steps or ledges for hedgehogs and toads who might otherwise be stranded in the pond. Heritage Seed library features here, HRH exchanges rare species with their seedbank. Inevitably, a few projects fail: 60 tree ferns given by Australia and New Zealand for his 60th birthday, most have since died following a severe winter. Nearby, slate portrait of Charles and Camilla and of the Queen Mother in her favourite gardening hat – with twin pearls. I said to one beside me that when we were in Fiji in 2004, where the Consort was born, and visited the hotel where she spent her last night before emigrating to England in 1952, a security guard

said that they were still sad at the demise of the Queen Mother. I said that she had died back in 2002, no, she said, we are referring to Queen Victoria! The Consort is a Fijian Princess – probably the only one in our livery history. I will check. Four acre wild garden, unusual regime, poor soil never knowingly cultivated, cut late with scythe to avoid compaction, assisted by hay from a nearby meadow which in turn had never been cultivated and therefore a rich supply of wildflowers. Truly splendid, worth a visit just for that iconic offering.

Grazes area with Shropshire sheep, one of the Rare Breeds. He is patron of their society – had a try at other breeds before choosing the Shropshire.

In the Trumpery, figure of a leprechaun to help keep out evil spirits. Hopefully it will work when the Head Gardener ascends the throne. Long golden yew topiary in the garden before he acquired the estate, now a dominant feature, not my favourite. A path, filled with thyme in profusion, so when walking wafts of scent all around. Halfway along two mighty wine jars from Spain delivered with the message to 'Prince of Wales, Tetbury', initially delivered to the local pub. Sundial a present from the Sultan of Oman, HRH given a choice, that or some racing camels. I would have chosen the camels. Near end of tour, scented rose 'Jude the Obscure', I said I didn't think the original Jude would have smelt as nice. Then the Carpet Garden, via Chelsea, only got silver there, brave judges. Would have won gold in 2022? Lovely in the form of a Turkish courtyard garden –

shade, water, tiles, colour, symmetry, scent. A deep red rose 'Bloody Marvellous'.

Thanked our host. Said HRH has many titles: HRH, Prince of Wales, Heir Apparent, Earl of Chester, Duke of Cornwall, Duke of Rothesay, Earl of Carrick, Lord of the Isles, Great Steward of Scotland etc but penultimate best is Liveryman, Worshipful Company of Gardeners. Best of all brother of a former Master Gardener! Gave him one of our shields depicting Adam in the Garden of Eden.

Over lunch, sitting opposite a fellow Gardener, alas, just put down his Portuguese Water Dog, bred to retrieve fishermen's nets, but this one had an aversion to water. Their two children, when young, being godchildren to a former Lord Mayor – also a former Master Gardener – would be invited along with the Lord Mayor's other godchildren to his Lord Mayor's Day and many other Mansion House functions. Told by another that the Worshipful Company of Innholders was the only livery that has a Michelin star.

In shop, soap £15 a bar. We Gardeners might wash only once a year, but we know the true price of soap. Lovely table for sale, just what we are looking for, made by a former student of the Princes' Trust, but again exceedingly expensive.

Another asked what I would do after my year is complete. I mentioned a conversation I had had fairly recently with a near neighbour who had won Strictly and was a judge on Britain's Got Talent. I had said that I was taught at my all boys' school to dance a waltz with a chair – and could dance

presumably with a four legged woman – and that I might attempt that on her show. She thought that was a very a good idea. Also, contemplating walking from John o' Groats to Lands' End, and if I wait two years, and complete it, I will be the oldest to do so. Might also attempt to see the film Bambi, previously have not felt up to it because I know it is so sad. A third option – neutering Tom cats.

16 June
DRAPERS' HALL LUNCHEON

Luncheon for Masters and Clerks. In their courtyard garden pre-drinks with Masters of Stationers, Bastketmakers and IT. Mentioned that my Master-elect will be installed at Stationers' Hall, that my wife's uncle, C.P. Snow, had a launch for his book on Trollope (published by Macmillan) in that hall, that Harold Macmillan (the former Prime Minister) said a few words – fumbling, embarrassing, but clever. Commented on Macmillan's performance to the person beside me. She said he was play-acting, had been rehearsing it along those lines all morning – she was his niece. Master Stationer said Macmillan had the unique role of reopening a livery hall – he was a Stationer – in 1957 after war damage.

Master IT said that Dame Stephanie Shirley had given them £5 million towards a new hall of their own. I knew her. She told me many years ago, and no doubt to many others, that she was getting nowhere in business when calling herself Stephanie so she changed her name to Steve and

business came in. Carmen have also just opened a new hall off Fleet Street and I was a Carman myself and at the time of my gaining my freedom with them was told they were seeking a new hall all those years ago. Both IT and Carmen Halls are small, seating around 50 each. Master IT said his aim was to get an extra 40 plus freemen into his livery each year. Of course, liverymen numbers will be capped.

Met Master Draper, mistook him for another Master. Told him I had written to thank him for his hosting a dinner the previous week and, clever I thought, I enquired after his mother. Wrong Master, but he kindly didn't let on, merely saying his mother was a Gardener and I could have spoken to her direct. Surely she must be well over 100!

At lunch, sat next to Past Master Draper and opposite another Past Master of the same livery. The former was half Finnish, and when first in this great hall as a young man and English not his first language it was a formidable and lonely experience, just him in front of the Court. When doing National Service in Finland, he was part of a crew of a minesweeper at the time of the Cuban Missile Crisis attempting to block the Russian fleet in the Baltic. Only knew that the worst was over when the crew saw Russian warships returning from Cuba with their missiles intact. He said Finland was an effective and efficient military nation, had mined the neutral zone between Russia and his country, a fact known by Russia and respected by them, that they had invested in some of the best and most up-to-

date weaponry. He said that when the former Soviet Union collapsed, most communist countries reduced their military budget by half, whereas Finland, never trusting Russia, increased its military spend. In Finland, all new schools and houses have steel doors and air raid shelters. He said all five current political leaders of the parties are women, that the country's approach to Covid was no official lockdowns, but rather to rely on the good sense of an educated nation. He thinks it has worked. He said the best source of global opinion, even exceeding the BBC World Service, is Finnish Station.

We got on exceedingly well. He gave me a truncated version of his life story, which was interesting, of how he answered an advert for a German speaker familiar with at least one Scandinavian language. He got the job. Located to the UK. Met his Finnish wife in Woking. Subsequently ran some major companies; both his sons also married Finnish women. Then he said, 'I love you. You know what I mean!' I think so.

Then spoke to my left. Clerk of the Apothecaries. Previously CEO of a medical journal on clinical guidelines. Didn't understand a word he was saying, but a very pleasant lunch companion, supporting the same unusual surname of the son of a former colleague on whose board I sat as a non executive director. He denied being that person; he should know. He said one of his Past Masters would turn up at each event with a different 'niece'. As bad as some of

the Renaissance Popes. He said the SAS has a cream which is effective against midges. Actually an Avon cosmetic product.

Opposite was the other Past Master Draper. Commented on the broad church of membership of the Drapers and glancing down the table, there were Past Masters who were Admirals of the Fleet, a headhunter, food retailer, former MP and others. He said it meant there was sufficient in-house expertise for most purposes. Current Master then spoke, said some of us may not be familiar with the Ancient Society of College Youths. He was correct there. Founded 1637, not a full livery, almost made one on more than one occasion, preeminent church bell ringers. His father had been their Master before the Master Draper was even born. He commented on the Drapers' involvement in the refurbishment of some of the bells of St Paul's, that ringing the two highest rings on Easter Monday with that ancient society was a highlight and a privileged treat.

Near me, to left of the main entrance to the hall, a lovely statue of a woman, right hand outstretched, lighting flooding her breasts.

The Queen is a Draper.

Left with spirits uplifted and with the beauty of operatic singing which had accompanied our meal ringing in my ears.

Went home via Holland Park. Passed Russian Residency. Saw someone on their steps. With Ukraine in mind, I said to him that their 20th century thuggery in the 21st century

was a disgrace. On closer observation, he was wearing a baseball cap. He could have been a contract cleaner.

17 June

Invitation from the Fishmongers to celebrate their 750th year since the granting of their first charter. This will be their first scheduled event of a very full programme. Unfortunately, I cannot attend.

20 June
BARBECUE AND FOUR GARDENS

Had to take the Consort to A&E as she has a serious condition that requires urgent treatment – possibly an operation. Worrying.

Early evening, another Master's commitment – oh dear!

Initially, worried that this evening's visit to four gardens attached to livery halls might include roof gardens as I have a phobia of looking up at high buildings. Illogical, daft, increasingly inconvenient as the City throws up more skyscrapers. Thankfully, due to zoom no need to attend many committee meetings at the offices we use in a building almost opposite to the second highest skyscraper in Europe.

Assembled early evening on the terrace of the Barber-Surgeons' Hall with drink in hand, passing a sign on the front steps – 'Blood donor centre today'. Their Clerk says they still practise bloodletting. Spoke to a garden designer, indeed the one who redesigned the courtyard garden at Merchant Taylors' Hall, one of this evening's gardens.

She said she wished she was also a plantsman. Some of her assignments have been to create privacy in urban gardens plus individuality without causing too much shade.

Another joined us from the Saddlers', again a garden on our list tonight. She spoke of the frustration that her livery has with some horse owners who select saddles with the comfort only of the rider in mind at the expense of the wellbeing of the horse. Also, in this hot weather, she heard of a horse being kept in a vehicle with air conditioning. Nearly killed the animal.

The talk explaining the Barber-Surgeons' herb garden was fantastic. The herbs are incorporated in a ruined basilica, built by Emperor Hadrian in AD 120, part of the Roman wall, which, in fragments, can still be traced from Blackfriars to the Tower. I was surprised how much of the wall survives, tucked away, adding to the beauty and sense of place of livery gardens.

Amusing and knowledgeable discourse on the herbs, what the great Sir Hans Sloane would have called, 'A garden of useful plants.' Their uses were legion: for dyes, to rid of stinks and smells (such a problem right up to the last century), to cleanse tapestries, to keep water drinkable on ship voyages, to speed recovery from wounds inflicted by the Infidel on the Crusaders (in practice increasing the chances of liver cancer), for sore throats, as a cure when bitten by serpents or for expelling worms, for diabetes, to reduce anxiety, to reduce gout. The guide pointed to one herb and said it reduced wind after consuming the guide's

son's Italian mother-in-law's cooking. He referred to a well known 18th century Master Barber who, on enquiring how an old woman seemed to have been cured of congestive cardiac failure, concluded that she had used a concoction given by a gypsy. It was a formula based on the poisonous foxglove. This Master went on to have a number of 'charity patients' to further experiment on. Over all these early delightful evening conversations, nodded elegant roses, a variety first cultivated incredibly by the Persians as early as the 12th century BC.

A hall has been on this site since 1308, few can claim such longevity, but up popped a number of hands to claim an even longer record, including the Apothecaries (someone said the Goldsmiths can also claim a considerable record). There is a recurring theme in the liveries; which is the oldest, regardless of their position in the precedence – they can be up or down depending upon the politics of the day, the finances of the King etc. A similar theme is the survival of the livery halls, many, of course, were devastated by the Great Fire of London or were destroyed in the Blitz. In the case of the Barber-Surgeons', one of their halls was saved from the Great Fire by its garden, designed by Inigo Jones.

On to Salters' Hall, suitably refreshed in body and mind. Tight schedule. Duke of Kent arriving shortly to plant a tree as part of the Queen's Platinum Tree Canopy on his way back from Ascot. Garden not overtly pollinator friendly and they are aware of that, aiming to rectify matters shortly. Otherwise a splendid spot, relatively large. The Roman wall

is the boundary on one side, high and ancient, and on the other, a 20th century Grade II Brutalist masterpiece, the seventh hall of that livery, this one opened in 1976 and both hall and garden designed by David Hicks.

Then on to Girdlers' Hall, the smallest livery, they haven't produced a girdle – not female garment – since 1520 when Henry VIII started to wear trousers with pockets. Original hall destroyed by the Great Fire and another by the Blitz, on both occasions the Girdlers took refuge in the Armourers' Hall opposite, which, despite being so close, escaped those two devastations.

The masterpiece of the hall is the Girdlers' Carpet, now safely in situ, but has had a number of travels since being made in the 17th century, including ending up in the Metropolitan Museum of New York, the V&A and in a bank vault during the last war. On one occasion, it was even lost. Generally recognised as the finest Persian carpet in existence anywhere; 224 hand tied knots per square inch of surface; 16 knots per warp inch and 14 knots per weft inch, so there was no excuse for not being duly impressed – and the carpet is approximately eight yards by two and a half yards. No wonder those working on such a challenge were somewhat reluctant weavers, 'We perceive by experience of a few bespoken here, that the tardiness, slowness and poverty of the workmen to such that it is endless labour to bespeak them, and those bespoken to cost dearer than others readymade'. The Company's coat of arms, which is in the middle, faces the wrong way, as too did the Company's

motto – now rectified – 'Give Thanks to God.'

In their garden, a long wall planted to reflect the colours of that carpet, and nearby a mulberry tree. 'Caught red-handed' is a phrase originating from those stealing the mulberries – the juice stained their hands red.

Spoke to a Master who said when he was out walking in the City, an American female cyclist asked the way, saying she gets lost, London changes so quickly, much more so than does her native New York. I said I once had a boss who said, 'Cranes on the skyline means jobs and wealth on the ground.'

Chatted to Mistress Draper. She was impressed I had remembered to send her a book that I had co-written on the countryside. Said she had dipped into it and would read it in retirement. She looked pretty young.

The Master Salter and his Mistress joined us. Installed only three hours ago at Court.

On the way to Merchant Taylors, spoke to a Master who had attended last week's two day gathering in Sheffield for our year as Masters to plan the structure for the years ahead. Over 100 attended. I was one of the few who didn't due to livery commitments. We will be calling ourselves the Platinums. The Cuttlers of Sheffield proved generous hosts. Their hall, their third, built in 1832, is bigger than even that of Goldsmiths, a planned symbolic gesture as they happened to be wealthier than the Goldsmiths at the time. Hard to believe that any Guild or equivalent could ever be

thus.

As we approached Merchant Taylors, I noted that it is close to the dreaded second tallest skyscraper, but filled with drink I could even admire the towering steel edifice of the 21st century as I could again later as it loomed into a clear blue sky above an exquisite court garden. At one time, the courtyard floor would regularly flood, causing damage and inconvenience to the structures below, but with the redesign the opportunity was taken to install a large tank for irrigation and protection. Previously, the wives would water the plants whilst the men luncheoned.

The hall and complex are vast, rather institutional, the main hall having one of the highest ceilings imaginable and, whilst impressive, was dark and heavy in feature, with a gallery housing an organ loft and opposite the venue where the monarch would dine alone. Before the alcoves were built, the monarch would not see the assembled company below. Location of the first rendering of 'God Save the King'. The Master took me and a few others on a mini-conducted tour. One room feminine in style, wallpaper all hand painted in the 1930s and lovely, then via an assortment of rooms and under the gaze of many Masters to the kitchens so large, but still in use, the oldest kitchens with that status in London and via steep steps we visited a 14th century chapel, vaulted, deep under Threadneedle Street, at what was once the actual street level. The hall, surprisingly, was never burnt nor bombed, has medieval material behind the panelling and a piece of Roman wall

incorporated near the kitchen.

Finally, to Saddlers' Hall for a tour and a barbecue. The present hall, lovely, becoming, homely. I wandered freely, encouraged to do so. 'Not in there, Sir. That is the ladies' powder room.' Looked to me like a prospect of a very pleasant lounge. Previous hall a little nearer to Cheapside. After the Blitz and the hall's destruction, the livery cashed in on former strawberry fields in Hammersmith to help pay for their next hall, and swapped land with another neighbouring livery. Also, they were paid ten shillings by the government which had issued them with a Compulsory Purchase Order to widen Cheapside. The note is still displayed in a case.

The barbecue in the courtyard was wonderful, better than my last effort using a set I had inadvertently reversed over in my car. Thereafter the meat at one end of the tray was overcooked, the other almost raw. Sat beside Master Apothecaries. Her husband is Clive Anderson. When Clive James died, she received many notes of sympathy. Her father, an eccentric from North West Territory who, when back in England was gloomy about our prospects of survival, marched to ban the bomb, moved to rural Gloucestershire, pursued different fads with limited success and Master Apothecaries, as a child, would listen to the radio, note the weather forecast and put straw under his strawberries if necessary. She felt our two liveries shared much in common, even the Chelsea Physic Garden – a creation of theirs. She suggested that the two current Masters should meet each

year, adding that she personally would like to join my livery. I will pass on the first idea and action the second.

Tried out a little experiment tonight. Realised that the taxi from the station to our house late at night, charges an additional £1 to go up our drive, I pretended that I lived at the bottom of the drive, got out, hid behind a bush until the taxi had departed and then walked up to the house.

21 June

The Consort is still in hospital having various surgical procedures carried out. I know she's in good hands, but I am nevertheless concerned.

22 June
HOLE PARK AND SISSINGHURST

My last two formal offerings as Master.

I do have a problem today. The Consort will be discharged early afternoon, a wretched saga for her. She is not pleased with my decision to go ahead with the garden visits. Understandably so. She has arranged for our daughter to collect her.

The father of the owner of Hole had died two days ago aged 95, the flag at half mast. I gather their first grandchild was born in April. A matter of all the changing scenes of life.

Only the middle section of the house built in 1887 remains. Owner said the sections demolished were of no real architectural loss, although he thought permission to demolish would not have been granted today. At least he

was not lumbered with a white elephant. He only had the pleasant challenge of finding the means to finance his lovely garden. Indeed, I gathered later that it was the fourth house on the site, reminiscent of the number of livery halls on or near their current locations. Windmill on the horizon, belonging to the owner, I passed it arriving at the house, one sail being replaced, damaged in a recent storm, costing over £12,000 to be met, hopefully, by the insurance company.

Mature magnolia in front of house. Owner commented on its exquisite scent, being so lovely it should be bottled. Obelisk at the end of the park viewed from the house – a copy of one at Chevening, the official residence of the Foreign Secretary. Agapanthus near the house of stunning deep blue, unique. RHS consulted and trialled, but doesn't flower in its first year, so of no commercial merit.

Present owners bought the house and estate in 1911, both sons fought in the First World War, one dying at Ypres, lovely ornate iron gate to commemorate that sad but all too typical event. The new owner, recently back from the trenches, although a survivor was a changed man. He ceased working for his lucrative dairy business and focused on the estate – a therapeutic gesture. Journal entry of 1922, 'I have a garden.' At time of purchase merely a large estate, a rural location, but no horticultural gem. Edwardian rather than interwar in feel, no overall or recognised Edwardian garden designer, hence on nobody's list of 'must visit'. I mentioned the great grandfather of one of those present today, the oft mentioned Mawson. The owner seemed not be familiar

with that name but was keen to find out more.

We passed a long, ambitious, spectacular, recently replanted herbaceous border. Noted the yews – cuttings no longer required for cancer research, no reason given. Use electric cutters where possible, for environmental reasons, but no good when it rains, so petrol alternatives part of the armoury. Brown patches high up in the yew hedges caused by mice. At end of grass terrace, statue from the Great Exhibition, 1851, a masterpiece, originally in a cross aisle at the Crystal Palace, acquired for a song from a back garden in Dartford. Clever cheap solution for a wall as a dam at the end of the pond – bricks in metal cages and a balustrade purchased on eBay. Carp in the pond. One Gardener said in Germany, they eat carp as a ritual on New Year's Eve – surprised they see the New Year in. In one area, a collection of wisteria, changed cutting regime. Almost a matter of brutal cutting back. Despite what the textbooks say, the plants flourish. They close the garden in July and August so the family can repossess it. And even on days when open, it is closed early enough to be enjoyed by the family, including the swimming pool. Ceased hosting weddings, experiencing the last wedding guest leaving after midnight is an experience and sight from hell.

Once an area has flowered, no attempt to replant for further colour for that year, another area takes up the baton, with a constant backdrop of variable foliage.

Wildflower meadows mowed at different times in different years to encourage variety, giving others prece-

dence for a change. Playing God. Orchids introduced with limited success. They need certain fungi to thrive or even survive.

In the woodlands, being in the weald, an ancient convention to maintain a certain number of oaks, traditionally to build battleships. Most popular annual event is to see the bluebells in the woods, somewhat incongruous, being the only part of the garden left to nature, where the gardeners themselves play no part. Brings in the visitors and helps to maintain the rest. Not open enough times to cover all costs, to do so would entail engaging a PR firm and playing a whole new game. Past the bear carving, done by a local teacher, has become so popular that she has sufficient commissions and now carves full time. Last part of the garden being revamped to celebrate their centenary, a challenge as there is nothing symmetrical; gates, house, other buildings etc all out of kilter.

At lunch sat beside the owner's wife, a relative of the famous Cherry Ingram, who lived locally to Hole. Known for his visits to Japan at the turn of the 19th century and saving many varieties of cherries when Japan was ripping them up in the name of misplaced conformity. His efforts helped make cherries fashionable worldwide and enabled them to be reintroduced to Japan. Not many are left in his own garden, a combination of neglect and the simple fact that the cherry tree is a relatively short lived specimen. Wife thought she had one or two of his trees in their garden. I said I had read the recent biography on Cherry Ingram.

Mentioned in the book, that one of the cooks serving breakfast for kamikaze pilots, had recorded that all the lads were very young and on the day of their fatal flights, were without exception ordinary terrified boys. There was little or no evidence of the desire for heroic sacrifice on behalf of the Emperor.

To Sissinghurst in the afternoon, Grade I, former home of Vita Sackville-West and the diplomat Harold Nicholson. Head gardener welcomed us, recently returned having resigned three times over the last 30 years – the lure of the gardens and the ambience of the place draws him back. Can see why. He mentioned the ways they were bringing the garden more truly back to its original concept; one designed by two amateurs, a sleeping beauty surrounding a castle tucked away in the weald of Kent. Chatted to a Past Master, said he could see where Prince Charles had got some of his ideas for Highgrove – I said a matter of standing on the shoulders of giants. A happy state of nature all around, combining different garden rooms all within the context of the incomparable weald, the ancient buildings, including the Elizabethan barn which housed Prisoners of War from the Seven Year's War (1756–63). Controversy about Delos garden renovated, but it was part of the original design, an idea of the Nicholsons from their Greek travels. Otherwise I agree. I thought it was a bit out of place. I sat on a committee with the former head gardener for the National Trust gardens, not specifically Sissinghurst, got the impression from him that the Delos project had doubled

the garden area, was a carbuncle and had diluted the overall garden feel. Surely not so.

Vita died 60 years ago this month. Her spirit lives on, is present in this loveliest of lovely places, I was expecting her to accompany us at any moment.

Private tea afterwards. Christmas cards for sale in the shop, despite being the day after the longest day and being a very hot day to boot.

23 June

Due to attend dinner at Grocers' Hall by kind invitation of the Ukrainian Ambassador to the UK as his country's way of thanking Britain for their fulsome support. Alas, postponed. A particular shame as I, and no doubt others, wanted to show our support for that plucky, kindred spirited nation. I would have hoped that my time in a Russian prison would have given me a special empathy and connection with my host and the undivided attention of all the Masters present.

I once addressed a conference in Moscow only weeks before the fall of communism. Told not to change money in the official exchange locations, so I went to the GUM Galleries, their main department store, along with a fellow delegate. A young, glamorous woman followed us, something sadly which doesn't happen in the UK. We were approached by a man who asked if we would like to change some money. Rather! Thank you very much. I then exchanged some money. Strangely, he seemed nervous.

He quickly told my friend to follow him up the grand staircase, whilst I remained at the bottom. A little later, my friend returned alone at the bottom of the other sweep of the staircase. I went to join him. As too did the glamorous lady. She announced that she was a KGB officer and we were marched briskly across Red Square. I was laughing. It was all so silly. But we were locked up for 45 minutes, interviewed, released, and I returned to the hotel where the leader of our group had already been informed of the incident. He said we had been very unwise, but I said we had been following his suggestions. He said, 'Yes, but you should not have done it in front of the Kremlin,' adding that I would be punished – I would not be allowed to return for ten years. I had no plans to. I thought Moscow was a dump.

24 June
ARMED SERVICES DAY

Their flag flying proudly over Guildhall. An impressive march past by the Regulars, viewed on the side by the cadets and various Masters. Suitable words of praise for our Armed Services, and rightly so. Arrived just in time to be met by many questions: Why wasn't I at breakfast? Why was I absent from the Council Room when voting took place? Why didn't I attend one of the lunches? First I had heard of any of that. I felt a combination of frustration and annoyance, missing out on so much. No idea whose fault.

Spoke to Master Tax Adviser. She reminded me that one of hers is my Renter Warden and therefore a future Master

Gardener. Said that last year in the heat, four people had fainted on parade. I said how impressed I was by the band leader, petite, utterly efficient and professional, at one time standing stock still then leading the band's rendition of '633 Squadron', 'I vow to thee my country', and many others. The words for the latter written by a member of my former club who happened to be British Ambassador to Washington at the time. A great club. Once got my umbrella stuck in the lift doors, pressed the alarm, no one came despite hearing the sound reverberate throughout the club. In due course, a member came, said he and others had heard the alarm, didn't know what it meant and so ignored it. Eventually extricated and proceeded to my room to change. Later, on my return, told I was in ill omen, older members in the absence of a lift were unable to ascend the stairs and so couldn't stay the night as planned. When I dined next at the club, nobody raised the matter, honouring the club's motto 'Sodalitas Convivium'.

After the march past and over a buffet lunch, spoke to some of those in uniform, thought they were cadets, all looked young, but they were the Full Monty. Asked why they joined the Armed Services, was it because these days with constant conflicts the Armed Services were again in the centre of our lives and thoughts? No – excellent training, transferable skills and a good pension.

Also invited today to celebrate the Shrieval Election, when the new Sheriff is elected, held at Guildhall. Alas, cannot make it.

28 June

SCHOOLS' FAIR

To Guildhall for the Schools' Fair where we exhibit. Just before entering, make use of the statue *Beyond Tomorrow,* which has a plinth ideally positioned to deposit a briefcase whilst putting on a tie. Today I wore my best suit – an infrequent occurrence these days – more dinner jackets and white tie or informal. The tailor who measured me, also worked for the Vatican, said my inside leg measurement was the same as Pope John Paul II, since then made a saint. Impossible to convey the feeling of having that intimate association with a modern saint. We chatted and she said she had just come back from Paris with her boyfriend who had at last proposed to her!

On the half-landing at Guildhall in a glass cabinet, a display of items given to a former Lord Mayor, Sir John Stuttard in 2007 on a visit to the Middle and Far East – a chess set from Kazakhstan, a crystal ornament from Qatar, a Chinese dog/ dragon in a red box and a mirror with mother of pearl design, both from Korea. Can imagine the conversation between the Lord Mayor and Lady Mayoress, the latter saying, 'Those items are not coming into our house. Find another place for them!' Our stand is impressive, conveying the array of horticultural careers – plant breeder, garden designer, wildlife officer, planthunter, fruit and vegetable grower, sports turf manager, garden writer, nurseryman, landscape contractor, amenity manager, taxonomist, crop physiologist, tree surgeon, park

ranger, landscape designer, greenkeeper, biodiversity officer, florist, plant centre manager, consultant, lecturer, arboriculturist, internal landscape designer, grounds maintenance manager, garden historian, cemetery keeper, environmental educationalist, garden photographer, marketing horticulturalist, agronomist, propagator – and gardener.

To get our relevance across to a young audience, we had posters with: 'No plants, no planet', 'Tomorrow's world in your hands,' 'Horticulture today, a high tech industry'.

Amongst those assisting on our stand, our current Nuffield Scholar and the top student from Kew – latter telling me of his recent promotion from the lake to the rhododendrons and that he was hoping to plant hunt in the Far East, in particular, in order to secure some of the 30 varieties on the rhododendron red list, thereby helping to secure their future via Kew. Some were drought tolerant for our modern times. He mentioned the mechanism to replenish the lake via the Thames, despite a trace of salt in the water in the Thames at that point. Found a land based fish unique to Kew. No one knows exactly what they are.

Opposite, Worshipful Company of Management Consultants with strapline, 'A modern Livery', but then, with all our career opportunities, so too are we. Further along, the Worshipful Company of Horners, their modern emphasis, 'Striving to promote STEM based subjects' and the Cooks with my new friend the Master Cook, like a town crier saying to her audience there will always be jobs in her sector as we all need to eat. So many other Worshipful Companies

present – Shipwrights, motto 'In the Ark safe forever', Air Pilots (I hope they are safe too!) motto 'Our Way Is By The Heavens'. Surely a bit ambiguous! Clockmakers, Saddlers, Bakers, Entrepreneurs (not a full livery quite yet), Educators, Marketors and Basketmakers. And mottos galore!

Have received an invitation to a reception at the Woolwich Garrison Church in aid of the Commonwealth and Ghurkha Garden fundraising campaign, in which we are playing a part. Duke of Gloucester to Officiate, but alas, cannot attend. The church has had bad luck – bombed in both World Wars – we forget that London was also bombed in the First as well as the Second World War. The director of the fund knows my brother; were both Recorders – a small world. Joanna Lumley had apparently campaigned for the wrong cause on behalf of the Ghurkhas.

6 July
CAPEL MANOR GRADUATION

Last official function as Master, and the day before the Installation of my successor. To Capel Manor for the Student Awards and Graduation Ceremony. Was given a reserved parking slot, couldn't find it and ended up at their Dog Grooming Centre reception at the back of the building. The college has an impressive record of training people; over 57,000 since opening in 1968, presumably not all dog groomers.

Over coffee before the ceremony, spoke to a Gardener

who was a former Minister of State, a Dame, now a sprightly 86. She said that during the war, when she was three, her father was continually supplied with petrol when all their neighbours had to lock their cars away. He did secret official work, which took him all over the UK. She never ascertained what he did. He went to his grave with that secret. When she entered Parliament in 1983, she was one of only 23 female MPS across all parties, four of them lied about their ages, often by a year or two, one by ten, and now each year in the newspapers, their wrong ages are quoted and perpetuated. At one stage, she set up a charity to get aid through to Romania. Most foreign aid, including hers, was banned. She persevered, internationally exposing this inhumanity, and won.

One of the college trustees said his friend had a dog which was a cross between four breeds. The friend got it registered, it cost him four times the usual amount, and it would have been cheaper to have called it a mongrel.

I put on my badge of office for the last time, feeling quite nostalgic. The clip broke. I resorted to a safety pin to attach it, kindly offered by the receptionist. The second time in my year.

Spoke to the patron of the college, Lady Salisbury. Kind comments about our recent Spring Court dinner. She said at their daughters' weddings, Lord Salisbury refused to have speeches, neither from him, despite him being so accomplished, nor from the best men and grooms. I can

understand that as a general rule.

The Principal Speaker at today's ceremony had been Environment Secretary in the Thatcher era holding the portfolio for longer than anyone else. Despite also being a former party chairman, he said that neither he nor his son, who had been an MP, and was an up-and-coming one – before losing his seat at the previous election, had voted for the Conservatives at the last General Election, branding it the Brexit Party.

Speaker talked about climate change, of how cows are singled out as culprits, but that all of us here are adding to the methane (I avoided looking to my left and right); that Capel graduates will help heal the earth and keep it habitable. He referred to two great women pioneers in climate change; one highlighting the evils of pesticides, the other the importance of respecting and enhancing the quality of soil, adding wisely, that there are also many men who have contributed equally. It is so important to balance the message. I have heard male graduates walking away from ceremonies, asking what their relevance was today, as a speaker rattled on about equality.

Sitting on the platform, watching the students collect their awards, being reminded often that many of them would change the world for good, or as the speaker so aptly put it, 'They shall know the difference.' Many were overweight, three were gender neutral and one man wore make-up. Variety of names, the best being Ocean Bellanfanti.

The Master of Ceremonies often had to say that a

student could not be with us today, and as I was wondering why, we were told it was because many had secured jobs already.

Afterwards, given a tour of the outbuildings with the Masters of other liveries associated with the college, including the Saddlers, Cordwainers, Loriners, and Coachmakers. All are training people; their skills are still sought.

In the stables, a protective covering, not to assist any horses, but to protect the floor, which was listed.

In the grounds, shown the cherry trees planted to commemorate 150 years of friendship with Japan. Tell that to those of the Forgotten Army. I was told that another garden to visit was the Drag Queen Bar!

I spent the last evening as Master sewing on a new clip for the badge. I did so using the presentation pack given to me by the Master Needlemaker.

I find myself in a reflective mood. What was this last year all about? Certainly, a year like no other. Twelve months suspended from routine, separated from some friends, part of a roller coaster of events and commitments, easy to bore others, yet unique and exciting.

Seems that some Masters will make their livery and the associations linking the Masters of our year, his/her main purpose in the immediate future. I feel the need for space, so I think I'll wait before joining in fully.

Some Consorts enjoyed their year, others less so. A few seem to have negotiated a deal to commit to a minimum

of events. One Consort told me she never wants to hear another word about her livery again! A few want to be Masters themselves, probably of another livery.

Sometimes the most help comes from those who are the least obvious.

Tradition has a strong hold on deliberations; even new liveries with modern purposes, such as the Information Technologists, absorb the medieval precedents of others. Only once did I detect that the Great Twelve might regard the others as inferior – overhearing a conversation.

Charity remains key to the Corporation and to the liveries' own charities, often making significant differences. I wonder what difference the grants I have made to charities this year as Master Gardener will bring. Much, I hope.

Easy to feel guilty accepting invitations to expensive dinners knowing the livery will be paying and there is little or no chance of reciprocating either in my year or by my immediate successors; there are simply too many Masters and invitations.

On the general subject of speeches, the relative poorness of many of them was less a surprise than a disappointment. The tutorial prior to becoming a Master was helpful – don't let your audience be anxious on your behalf, keep it simple, short sentences, be concise, avoid pomposity, you never know who is in the audience so be careful, be aware of body language, when you stand up count to five, vary your pitch, everyone wants it to work for you.

Can see why some pass the chance to be Master; time

consuming, expensive, a need to speak regularly, and nigh impossible to undertake unless retired or have a generous boss and understanding colleagues. But for me, an opportunity to be seized – no downsides, no regrets.

7 July
INSTALLATION OF NEW MASTER

I stopped for a newspaper at my local station kiosk, spoke to the usual person and couldn't resist telling him where I was going and why. He had never had the benefit of a good education but is a great crossword player and even wordsmith, self-taught, self-motivated. Given a different start, our lives might have been reversed. Said his ageing mother could remember the names of 18 of the 20 families living in her block of flats but would forget what her son had just told her.

Presided over my last Court with very mixed emotions and participated in the installation ceremony reversing the roles with the Upper Warden succeeding me. Before that, introduced three new members to the livery. I said my last act as Master had been to sew together the ribbon for the Master's badge. I was then escorted back to the ranks of the Court between the Past Master, who was a devil for the detail of protocol during my year, and one of the newly introduced livery women, a former Mistress Distiller, for whom I will act as mentor. The said Past Master whispered that one of the Assistants was not wearing a tie. I said it was extremely hot. She said, 'We do have a protocol.'

She then said that the Assistant to her left was wearing a sleeveless dress, which was also, apparently, incorrect. But I do worry that dress protocol such as this may be dated.

Before dinner, enjoyed the beauty of the gardens of the Stationers' Hall – a balmy evening, plenty of Pimm's.

Outside, a woman slipped her arm through mine and said, 'Wasn't that a wonderful evening?' and then realised I wasn't her husband.

Stationers' Hall was the location for the first performance of Shakespeare's 'A Midsummer Night's Dream'. The final words of the play, spoken by Puck:

'So, good night unto you all.'

How very apt.

ACKNOWLEDGEMENTS

All books involve a lot of work and contributions from others. I would like to thank in particular: Stefanie, the Consort; Todd Swift my publisher; Vincent Keaveny, the Lord Mayor of my year; Jeremy Herrtage, Clerk to the Gardeners Company; Helen Potts, Court Assistant; Jonathan Matheson, Court Assistant; Laura Miller, Clerk to the Chamberlain's Office; and my editorial assistant, Zoë Jasko.